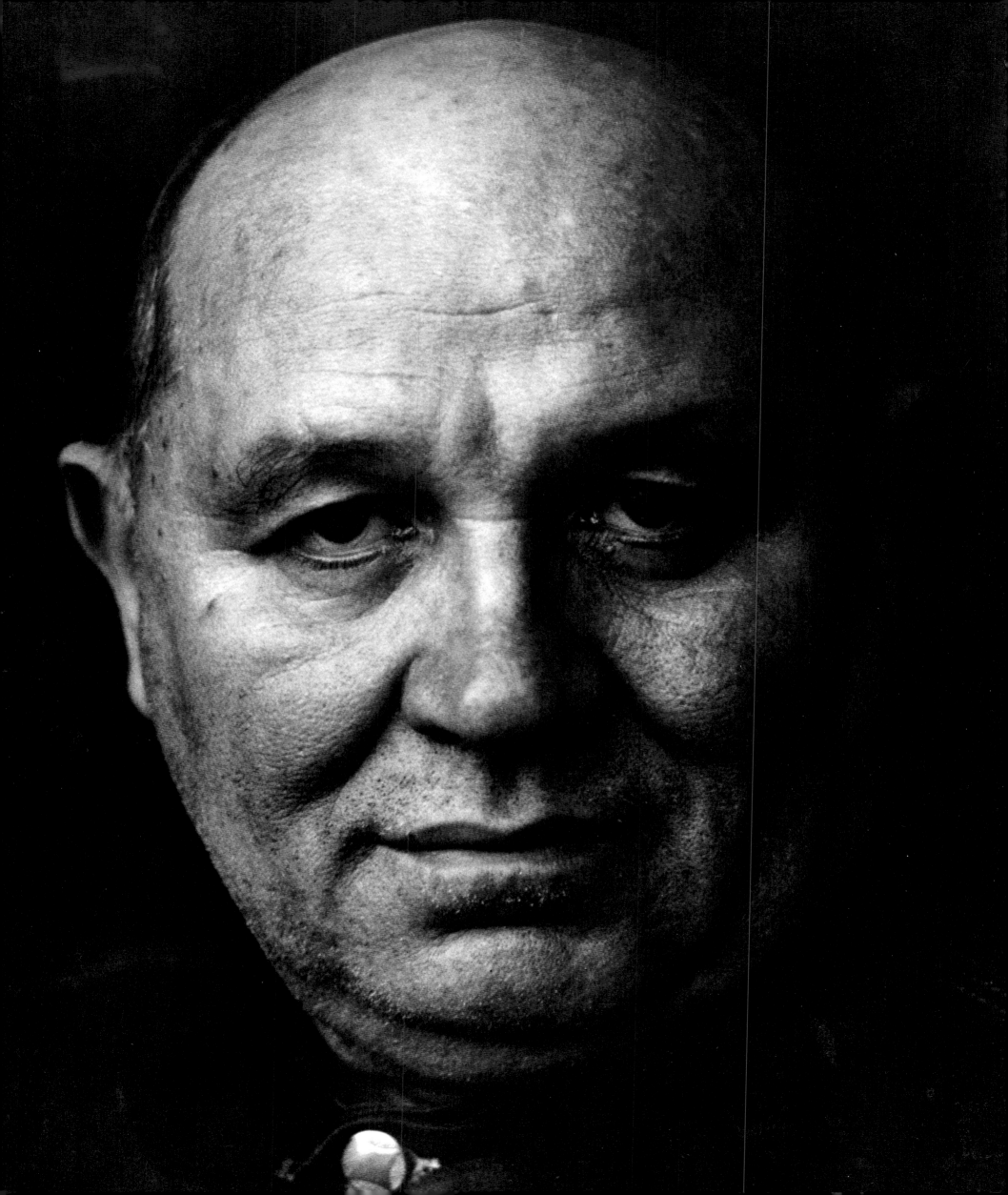

TEXT BY **M. BUNCH WASHINGTON**

WITH AN INTRODUCTION BY JOHN A. WILLIAMS

THE ART OF

ROMARE

BEARDEN

THE PREVALENCE OF RITUAL

HARRY N. ABRAMS, INC., PUBLISHERS · NEW YORK

TO BESSIE, J. BEARDEN, AND CURLEAN C. SHELDON

Library of Congress Cataloging in Publication Data

Washington, M. Bunch.
 Romare Bearden.

 1. Bearden, Romare, 1914– I. Williams,
John Alfred, 1925–
N6537. B4W37 759.13 72-4399
ISBN 0-8109-0033-5

Printed and bound in Japan

CONTENTS

LIST OF PLATES

*Colorplates are marked with an asterisk**

INTRODUCTION

"I work out of a response and need to redefine the image of man in the terms of the Negro experience I know best."

Romare Bearden said that a long time ago. It is exactly what thousands of black artists are saying today. If the collective human experience of the people of this nation is to be truthfully described, it can no longer be drawn as a totally white experience. It was never a completely white nation; it will never be a completely white nation.

Bearden addresses himself to this point when he says, "I have some interest in the truth—at least in presenting my view of what it is."

His truth is both personal and black, black because he could not help it and personal because, working out of that skin, he must stamp BEARDEN across his time, rein it in, and change its direction. It is a cliché to say that he desires a black truth, but essentially this means that his art, by its very presence, must alter the white truth that abounds not only in this land, but throughout the world. Black truth *projects* upon white consciousness another, more truthful image of man. Clichés are not without thundering validity.

Bearden's works give us first and foremost an archetypal black man whose journey through the hell of America is pronounced in every line of his face, body, and background, in every subtly arranged plane. Looking at Bearden's work, I seem to be looking at subjects distorted by the soft movement of water in a shallow creek. In those "distortions" I see the black psyche pulsating mysteriously with contradictions of joy, defeat, victory, endurance, and this in relationship to the whole of humankind.

There is no measuring, not by any yardstick yet devised, the amount of thought, work, and experience that brought Bearden to utilize the concepts he now displays in his paintings. But, after so many years in Harlem, in Europe, in Greenwich Village, digging with black eyes and ears, feeling with a black heart, he has arrived with his gift to us. What is more important, as though keeping sidereal time with the events that have affected this nation in the last fifteen years, he has arrived at the proper moment, when the whole crest of black awareness rushes back against the tide to break it.

What do I know about "Romy"?

I met him three years ago. He is a big man, gentle to the point of being shy. That, however, is deceptive. He does his thing so quietly that you don't know he's just gone ahead and done it. He is his own man, owing no other man anything.

We discussed at that first meeting the possibility of our working together for a large magazine for which I had been writing for three years. Bearden would illustrate what I wrote. He had a keen interest in the Caribbean, where his wife, Nanette, hails from. There was not much interest in our project at the magazine. I cite this not because I have an ax to grind, but because it may make you understand better the obstacles black artists have had to face. Not only was the magazine not interested in our project, but it was no longer interested in me. There had been a change of editors, and this one decided he would no longer publish material by or about black people. The magazine was now going to concentrate on the "beautiful people." Blacks were not among them.

Of course, Romy needed no explanation. He simply returned to his job on Long Island. He is a black man and such experiences are part of the daily lives of Negroes. They do not escape it because they are painters; in fact, they feel the edge of the knife even more keenly. Painters, like moviemakers, deal with the images of things, of people, and audiences and many critics do not *like* to see the images that are a reflection of a reality they have always denied. But they fail to see in Bearden's work the triumph the painter sings that black people have survived in spite of everything.

He himself is a survivor. He was born in Charlotte, North Carolina, and after public schools graduated from New York University with a science degree, having majored in mathematics. He had done cartoons for the school paper and for the *Afro-American*, a weekly newspaper. At the Art Students League (for he had decided that teaching math was not for him) he studied with George Grosz and was introduced to artists like Kollwitz and Daumier, whose work was mostly social commentary.

There was much social comment then, during the Depression, and young Bearden saw that "art techniques were simply the means that enabled an artist to communicate a message—which, as I saw it then, was essentially a social rather than an active political one."

Politically, it was a time of expediency. The Fascists chomped up Spain, bit off Ethiopia and parts of Middle Europe, and the great powers let them. At home, black people were a silent, suffering, lynchable minority. We were, to be frank, content with our lot because we were unable to do anything about it. True, people were run off farms; true, the first poor people's march on Washington (composed of veterans) took place. No one was lynched when the banks took the houses; none of the veterans were lynched for asking a bonus for service in World War I. Only black people, some of them veterans, were lynched.

Then came World War II and Bearden went to it in the American pattern, in a segregated army. He became a sergeant in the 372nd Infantry Regiment, a unit that had garnered hundreds of medals fighting with the French army in World War I. In World War II it was seen to that the 372nd would not repeat its earlier deeds. Eleven years Romy's junior, I know of that war and know that nothing so embitters a man, nothing turns him around quite so much, as to be placed in a situation where he is the defender of a democracy that has already proved to be his most vicious enemy. To be embittered is to be involved in the process of *un*learning and, at the same time, *re*learning.

These, perhaps, are some of the experiences that produced the painter Romare Bearden and drew forth his own quiet and forceful declaration of war:

"I cannot divorce myself from the inequities that are around me."

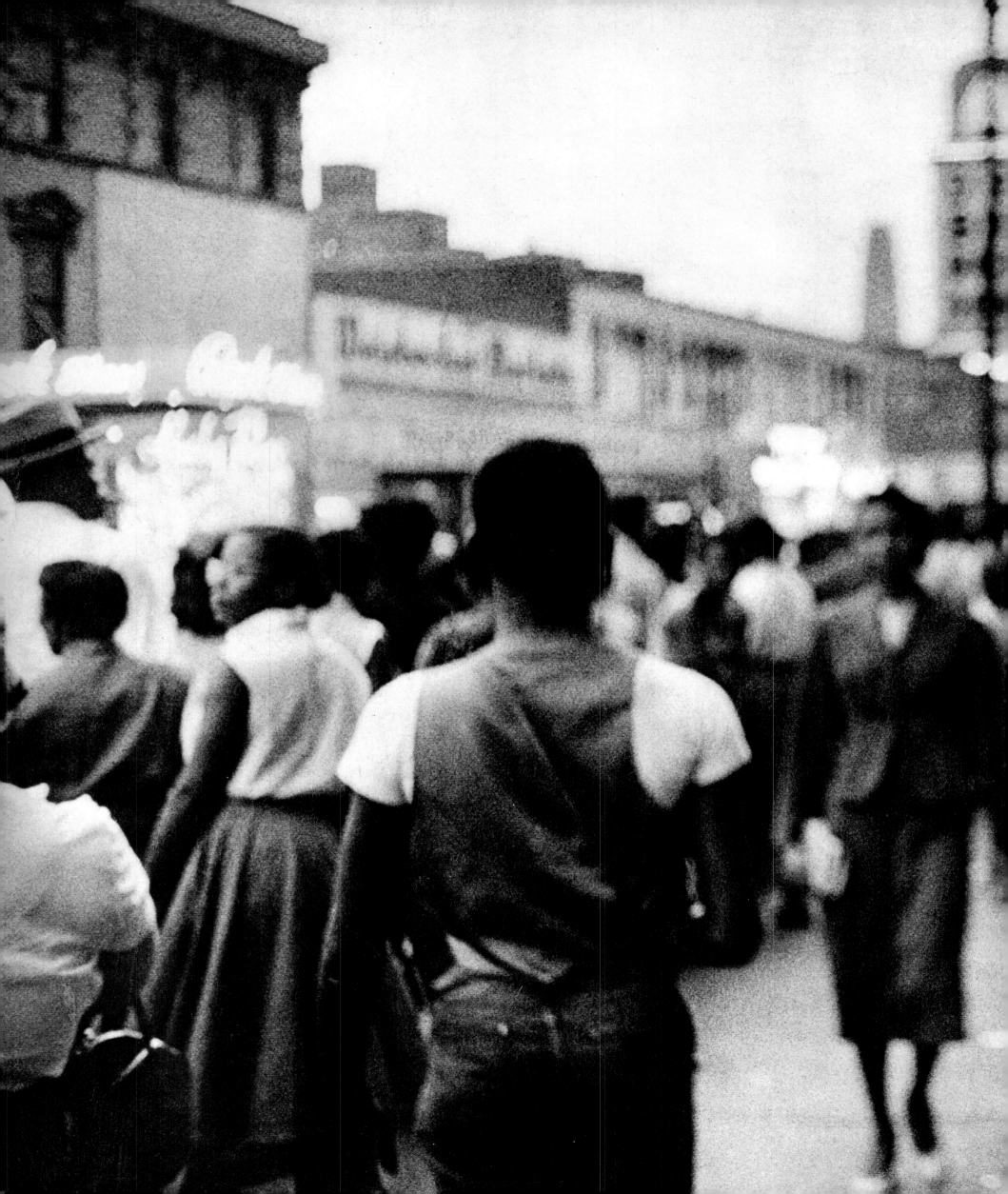

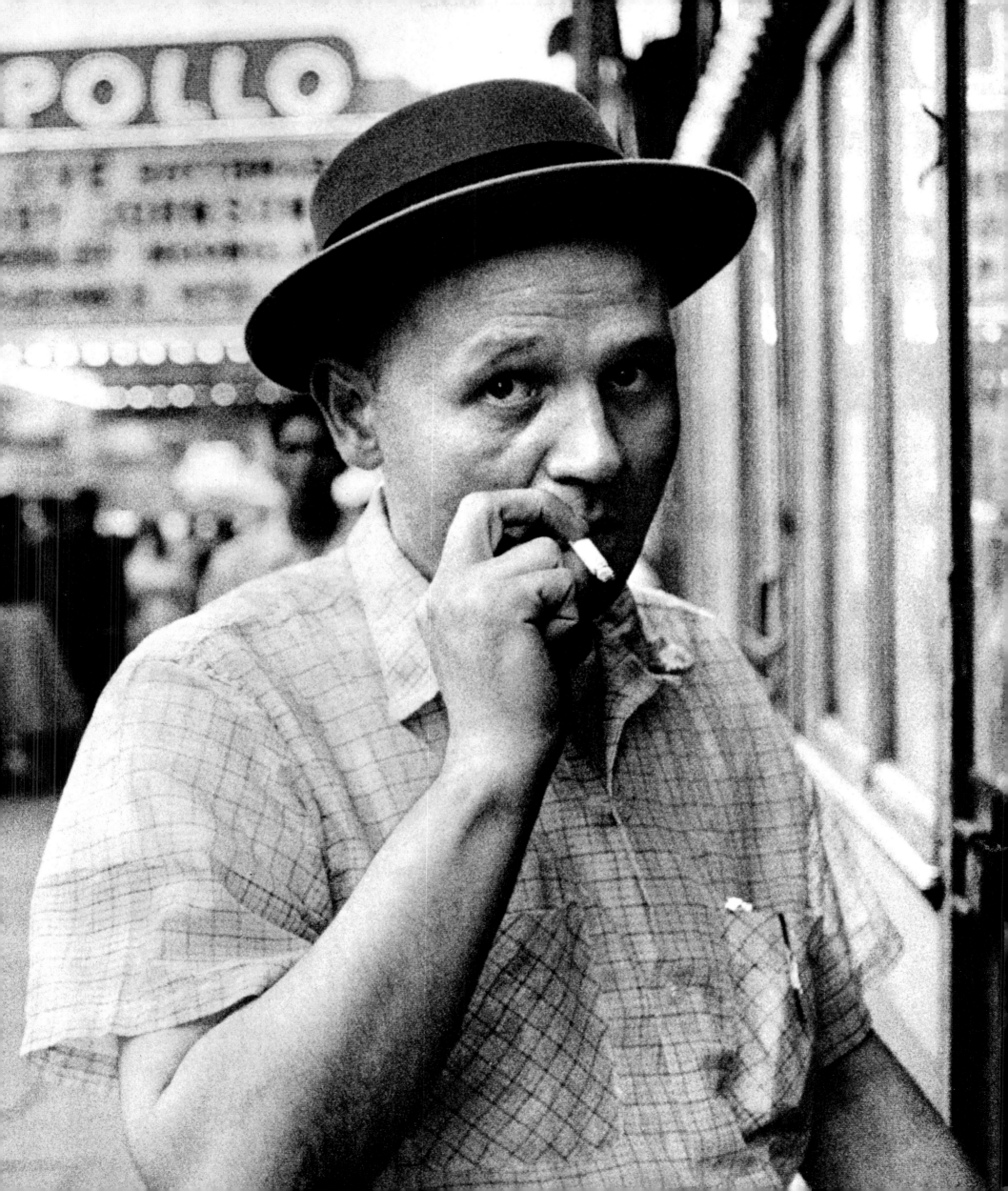

Every artist must make his statement. That is, in fact, much of what being an artist is all about. More important, every artist demands the statement from himself. He must, therefore, make himself vulnerable. He must make choices. He must say, Here I am. Know me. Hate me. Love me. I will no longer be ignored. I will be counted.

Bearden.

By 1950, now thirty-six, Bearden was studying in Paris, well on his way to drafting his statement. He was there to paint, but as a writer learns from reading, so Bearden learned more from studying other painters than by painting himself. Before the war he had worked almost exclusively in tempera. Then the watercolor influence of Grosz gave way to oils, which became thinner, almost like watercolor.

The montage appealed greatly to Bearden, perhaps as a reflection of life the way it had kaleidoscoped before him. He painted and glued, then "tore sections of the paper away, always attempting to tear upward and across the picture plane" until some motif appeared. Afterward, he added more paper and color to finish the painting. Behind this method lay his in-depth studies of the compositions of Vermeer, De Hooch, Rembrandt, as well as the Japanese portraitists and the Renaissance works of Duccio and Lorenzetti. From the Cubists—Picasso, Braque, and Léger—he took back what was rightfully his. Cubism sprang from the sculpture of black Africa. But as far as Bearden was concerned, the Cubists misunderstood the use of space. His modifications are personal and in keeping with the statement he had to make. He says: "I do want my language to be strict and classical, in the manner of the great Benin heads, for example." Thus his cubes were stretched into rectangles; he stretched out space.

Bearden in recent years has emerged as a genius of collage and projection; he has employed some aspects of the documentary film, and he tries to see what the camera sees. Beyond what we see at the first glimpse of a Bearden painting is the rectangular structure, the planes of which are either shifted slightly or greatly exaggerated. "Fractured" is the term the artist uses.

Ostensibly, most of his works seem to feature faces, the faces that peer out of

their planes as though looking right through you. There is a superficial similarity in those black faces, which possess, even without the masks Bearden utilizes so deftly, masklike, stricken qualities. They seem at once to accuse and to suffer from some unnamed terror. But Romy's paintings are of course more than just faces.

Once a songwriter, Bearden is close to music. Time and time again we see figures holding guitars. He has chosen this instrument to depict timelessness, for the stringed instrument is perhaps the first one devised by man for the purpose of adding music to his life.

Stringed instruments abound the world over, from the most remote islands to the most crowded cities. It is perhaps something of a curiosity of musical history that the guitar is one of the earliest to be found in ancient cultures, and is still with us today. The guitar is an instrument loved by the most backward American hillbilly as well as the most musically sophisticated. If we think of the great Spanish guitarists with the echoes of Africa in their strings and fingers, we naturally classify the guitar as a classical instrument.

Consider the best of modern music, and the guitar becomes both a driving rhythm instrument and an instrument for fanciful solo flights. Mondrian saw modern popular music as rigid formations; Middleton sees it as fluid. Bearden puts it where it should be—with people. *Jazz 1930s: The Savoy* and *Jazz 1930s: Grand Terrace Ballroom* place us even closer to Bearden's love for music and the men who make it.

I think Romy's attachment to music relates very much to his work. I think of music and musicians when I look at a Bearden projection or painting, seeing in it the same "distortions" I heard in the music of the forties and fifties, which was the music of a new jazz much closer to the vibrations of black people than anything that had gone before. The assonances and dissonances. Musicians like Howard McGee, Charlie Parker, Miles Davis, Thelonius Monk, Sonny Stitt, Sonny Rollins, John Coltrane (plus a newer, younger contingent) blew in "color," projected upon what was ordinary, acceptable, usual, mundane—white—a different sound, a changed pattern that was augmented, diminished, and shaped by the personal and group experiences of the black men involved. They seemed to distort sound in order to re-create it.

Bearden is a lover not only of music, but of history, too. The worst kind, for he is a secret tippler of history (by which I mean that which has been black-conceived as well as that which has been white-conceived). He knows his history and applies it in much the same manner as a mathematician uses his figures. With such a sense of sureness he has juxtaposed—inserted into classical postures—his ordinary, broken black subjects and scapes, as in *The Annunciation*, for example, or *Two Women in a Harlem Courtyard*, or *Mother and Child*. Here, as in music, he is augmenting, adding another dimension to what we have always found to be pleasant and constant. Bearden lifts the much demeaned, much pitied, and often feared American black to a position of the highest humanity, and the poignancy is shattering. But there is something else: the Dogon masks utilized in *Mother and Child* possess, in addition to poignancy, an extremely eerie quality, a confrontation with the familiar which has suddenly become unfamiliar, even threatening.

It is possible that history lies wrapped in the cocoon of ritual; that could explain Bearden's attention to ritual. It is like an umbilical cord tying peoples together in the same performances in which they find strength. In another painter this interest in ritual would be curious; in Bearden it is simply another facet of his interests and personality.

A number of his projections and paintings are called *The Prevalence of Ritual*, and they depict variously a baptism, a funeral, a conjure woman, train watching, and other examples of black life. Some of that life is rural, some of it urban, but all of it has that continuity of mystery we have come to know through Bearden's use of colors, parts of photos, and rectangles; they are a Bearden colophon. We know that Bearden's own life in part, and the lives of his forebears in much larger part, encompassed rural southern living. Does one escape completely from such memories?

No. Not Bearden. In fact, he attends to these depictions of black life and living with utmost care. But trains intrude upon some of the rural scenes; they have a twofold meaning. The trains are the new technology rushing through the cropland, numbering its days; and they are the vehicles with which many Negroes will move from the cotton to the concrete north—to *The Street*, perhaps, or *The Dove*.

Bearden makes you aware of the difference. Space suggests more space in the

paintings of the rural South, while the Harlem scenes burst upon you, people, faces, eyes, going in every direction, tenement windows not quite concealing still other faces, other eyes. Here the journey from the cottonfields has ended; here are a transplanted people who barely recall their rituals, but no matter, new ones are to be found, as in *The Illusionist at 4 P.M.* and the *Two Women in a Harlem Courtyard*.

Romare Bearden has said that it was not his "aim to paint about the Negro in America in terms of propaganda." Rather, he paints his people "as passionately and dispassionately as Bruegel painted the life of Flemish people in his day."

It seems to me that Romy's dispassion lies in his years'-long search for the precise manner in which to render his people passionately. Surely the men with whom he shared his Harlem studios in New York were not dispassionate, but were some of the most passionate black artists of that time and, some of them, of today. Into those studios at one time or another walked Jacob Lawrence, Richard Wright, Claude McKay, Charles Alston, Ralph Ellison, and Mike Bannarn. All were in search of the tools with which to make their statements. Perhaps Bearden helped them; perhaps they helped Bearden. In any case, the tools were discovered, the statements made, but none has said what Bearden is saying today. He is indeed unique. He is the man who said, "I do not need to go looking for 'happenings,' the absurd, or the surreal, because I have seen these things out of my studio window on 125th Street."

Seeing and interpreting are two different functions; passing on one's interpretation to others is still another. Therein lies an artist's uniqueness, his ability to share with others what he has experienced, for "painting, art, is about something," Bearden has written, and it is something palpable and meaningful. It is, in fact, Bearden sharing Bearden.

The young black poet Don L. Lee says, "Each poem is the poet." If this is true, it follows that each Bearden painting is Bearden. His statement. His view. His past, present, and future.

And because it is Romare Bearden, all this is exhilaratingly healthful. "His people" are not only black; in the final analysis they are all people, and a

stronger, wiser, more vigorous people because the painter chose to "redefine the image of man" out of his own black experiences. Bearden has immeasurably enriched us with his work; we mirror what we are to him: fractures, juxtaposed planes, flat colors, masks, and parts of photographs. We are then many parts, many angles. To understand that, as Bearden does, is to begin to become whole, which is what truth, forever a fraction, is really all about.

John A. Williams
December 16, 1969
New York, N.Y.

THE ART OF ROMARE BEARDEN

M. Bunch Washington

The Art of Romare Bearden, the art of the last ten years, has shown the faces, the expressions, the lives of American black people as they have never been shown before. (. . . I can remember the first time I saw his "projections" and montage paintings. It was a startling experience, holding in my hands the paintings of another artist, at that time unknown to me, that expressed a great deal of what was in my heart and consciousness. Hearts and consciousnesses. Mine, and, I am sure, the hundreds of thousands of black men and women in the immense stone and steel metropolis outside. Stone and steel outside, stone and steel inside. Inside outside all.)

Blacks and whites and grays . . .

Paradoxically, with the aid of black-and-white-and-gray photographs, Romare's work has come to speak (now in the full chill of the computerized age, with see-through skyscrapers, interplanetary travel looming out of demystified nights, and the white frost of universal violence perverting most visions, most dreams with oddly sterilized blood); his work, after many years of "cumulative destructions and new beginnings," orders, clarifies, and makes classic our social reality.

The social reality, the deceptive, crimson, and pregnant social reality of the sixties, can be seen clearly through these eyes. The eyes of a people and a man unique in the intense, deeply integral quality of their humanity, and, lest we forget in the present din, unique in their suffering, their power (. . . one can only cry today, if the tender soul desires power). And, as always, their unerring humility, powerfully, time after time after time, raises them, illuminates them. Romare Bearden writes:

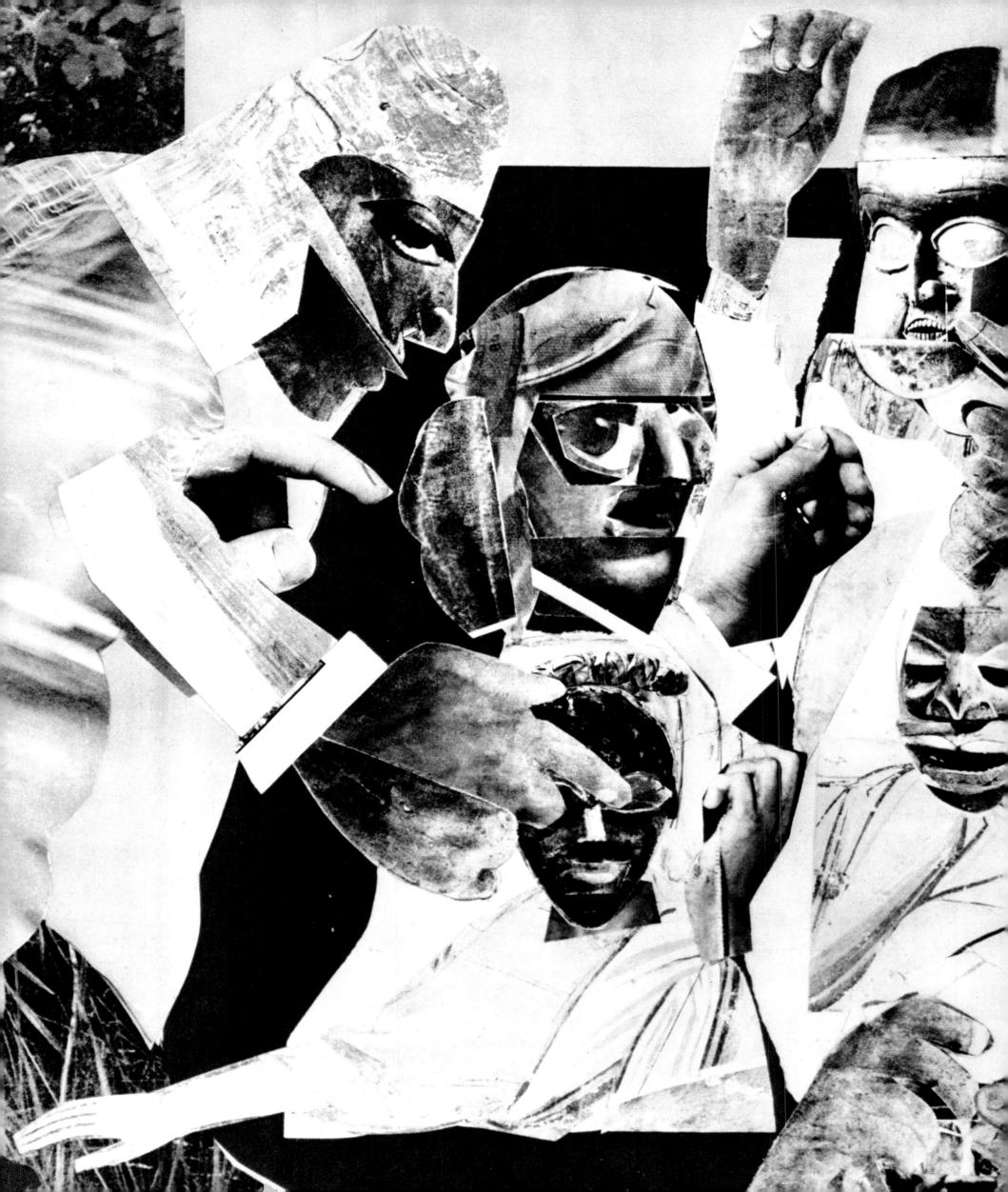

This work represents
some consolidations of
some memories, of
some direct
experiences
from my childhood on
to the present.

Direct experiences . . .

I will only ask the question and extend it once. What can the "direct experiences" of a painter who has been painting in White America for over thirty years be like? And what happens if he is considered "black"?

sudden black power,—awful exactness
from the fairest old man to the darkest child,
black-american-artist, rock jazz
myths, and red lights burning animals,
lighting Illusionist *at* 4 P.M. *and black*
faces forcing Rockets to the Moon.
with trains traveling downward out
of the picture plane. Benin bronzes,
The Prevalence of Ritual *several times.*

Mysteries
The Conjur Woman as an Angel
The Burial
The Annunciation
Edmonia Lewis

Susannah at the Bath *which for the world and time*
was subtitled the prevalence of ritual.
consolations, consolations maybe . . .

sudden black power, awful exactness
being composed, consummated in simple,
and profound, ordinary black people.
from the fairest old man
to the darkest girl child.

Quietly, closed off in my part of the house, late, way in the back of night and at the top, with just the windows slightly cracked in order to reassure any softly whistling, lone, and unseen black man walking in the shadow of the shadows outside, unseen I remember coloring, for the thousandth time, a face, a page, a space.

The record player plays . . .

Philadelphia, my art-school days in the barren City of Brotherly Love; 1961; the man's educational system has reached a point of collapse for me or I am losing my mind. Everybody tells me I am losing my mind. The record player plays . . .

I am weak but Thou art strong . . .

Songs escape out into the night . . .

please let me sit down beside you
I've got something to tell you
you should know . . .

. . . to surround roving knots of young men in the flat, countrified black ghetto people in Philadelphia call "North Philly." I had long since stopped painting really, the reality of the act of communication was words then, only rarely colors; but now, remembering—remembering now, remembering then—I can see the forms mutely looking out at me. The faces and the forms mutely looking out at me.

I've got something to tell you
you should know . . .

24

south street, philadelphia, 1964.
(the prevalence of ritual, the baptism)

o.k. when the last golden trumpet,
silky staccato south street immobile.
after the last of the hot, gray
cigarette smoke has risen and disappeared,
in the same slot that time left,
last night in the same bodies and clubs,
linked to the great fugue of voices and rapid breath,
inseparable from the haze of orange lights
and beauty of the musicians, the bizarre gestures,
is the ritual of man united in agony, joy, and wine.
masked phantoms playing the everlasting game
eyes smarting and with crisscrossed sex
in the night places, guarded
by the blinking red lights
the fair-skinned waitress
a huge hand seen, oh,

(mad, can I sell you my anguish?)

a huge hand seen
on a furrowed brow
breasts provoking life
lavender mules, so-called cadillacs
silently screaming in motion
through cross streets, subtly scourged
with several faintly royal pulsating bodies packed
in its upholstered bass-filled belly.
the mutterings of another terror-struck messiah,
wailing the eternal blues from a world of vivid churches,
in live eating places, another idiot; fertile oasis rooted in hard tar.
in every place and creature that is alive,
last night, and again today
again, and again, and again.

A face for the millionth time

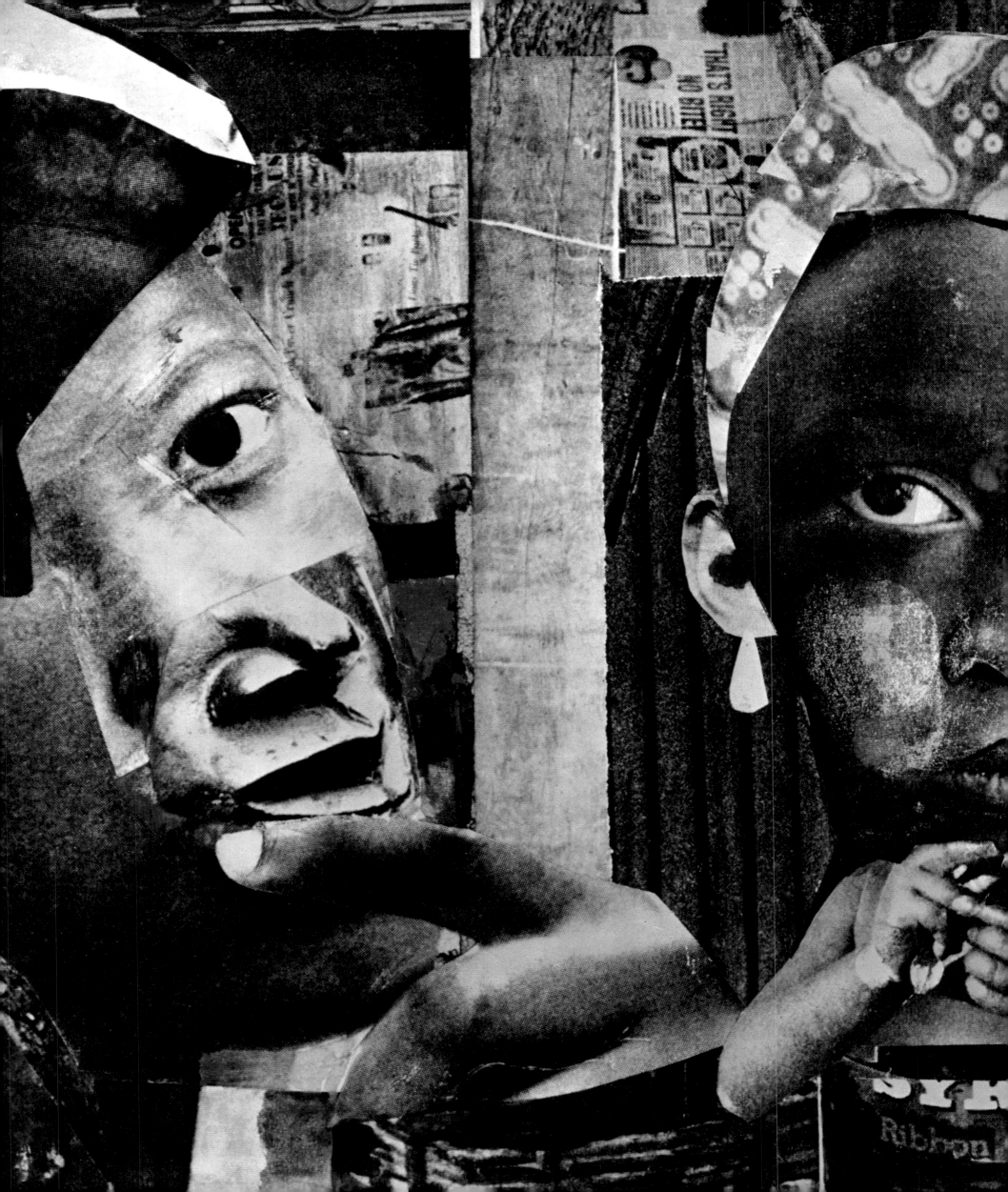

*I've got something to tell you
you should know . . .*

*south street, philadelphia, 1964.
(the prevalence of ritual, the baptism)*

I fled from Philadelphia. I fled from myself. When I arrived in New York City I found myself filled with a bitterness, a frustration, and a cold, cold anger that was fed by the considered realization that the majority of the people and institutions, white people and white institutions, in this city, the most populous, powerful, and diverse in the Western world, wanted, institutionally and spiritually, to subject and destroy me, and people like me, with their colossal collective, materialistic banalities; wanted to force upon me and my kind their brand-new advertisement of and for themselves; wanted me to accept, utterly, in my soul—that part of a man or a people that holds their father's music, their father's vision, their father's art most dear—wanted somehow to force upon my spirit the agonizing contradictions of their own dehumanization, violence, and despair—as if I didn't have my own.

It was the same as Philadelphia, magnified 100 percent. The tall trees, the sky, and grass were replaced by concrete, asphalt, and steel. The human quality, isolated as it was, of Laughlin Frame Shop replaced by the mechanization of a New York City frame-factory, where artists were required to think and act like art machines, obediently creating vacuums under polished glass. The soup cans, painted plastics, women's underwear, dog biscuits and such being seriously and soberly framed would be interrupted occasionally by a peerless so-called modern Western work of art, which was separated, locked in, and framed, airtight, in the blinkless sterile system of the American lords and priests of the "art world," as it and they were escorted silently, antiseptically through the factory, locked within themselves.

The incredible predicament I found myself in at that time can only be understood by one who has experienced, somehow, the manifold dilemmas and contradictions of a black artist, or *any* artist, for that matter, who finds himself surrounded by a fantastically materialistic, profoundly alienated and oppressive, memoryless white culture. And, thank God, there are many people, black and white, who *have* come to understand. Romare Bearden is one of these

28

people. And that is why he is so very important. He has understood this predicament as it applies to the artist in general and to the black artist in America in particular. This understanding accounts for the tremendous shock I experienced when I first saw his work in (of all places) the frame-factory, the work of an American artist, a black artist, who understood what I had studied at the Barnes Foundation; who understood my need to return to my black cultural roots without denying what I was, what I am; who understood the interlocking nature of *all* truly creative traditions, from the East and the West; and, more than that, one who *acted* in such a simple and direct, yet beautiful and disturbing way; acted, it seemed to me then and even more so now, out of understanding, in such a harmonious and compassionate way, free of hatred in a country full of hate, free of vanity in a country full of vanities.

I will never forget the last day I worked at that frame-factory. I had two jobs to do, Motherwell and Bearden. The huge Motherwells were off in their frames by a fraction of an inch, and for that the black foreman fired me. But it was a startling experience, holding in my hands the paintings of an artist I did not know that expressed so much of what was in my heart and consciousness. So startling. The foreman had spoken not a word about Bearden. But Bearden himself spoke, over the din of the art-factory, across the years and time that separated me from him and him from *his* roots.

The art of Romare Bearden, the art of the last ten years, has shown the vital relationship of American black people to Africa in a way that is most graphic; mixing, composing, creating a sea of faces and masks—American faces, African masks—this art has shown the vital relationship of American black people to themselves in a way that is most illuminating; it crystallizes, with a quality at once static and moving, a profile of a man and of a people at perhaps the most decisive moment in our history; an inner profile of a people truly unique, not in their suffering alone, but in the *quality* of their suffering, silently for the most part, revealing a relationship that influences every aspect of American life and every aspect of the nation's beauty and strength (—look closely, America, and tell me, quietly, who is weak and who is strong).

At the Barnes Foundation I had learned to look at a painting in the same manner as a scientist looks at and studies the physical world. The paradoxical Bearden. He has come to us with a reinterpretation of the Cubists; more, a reinterpretation of the source of Cubism, and a reinterpretation of America,

with a shockingly simple use of the traditional that is as simple as a photograph (photograph!) yet as profound as a Benin mask, as full of strength as the towering and humble Rouault and as lyrical as Matisse in his direct use of color: a natural fusion of values as diverse as human flesh and brocade cloth, burnished mahogany and the luminosity of deep waters—these, together with transferred (and real) values from African, American, and European sources so numerous that it would be useless to attempt to mention them all here.

Who is this man? Who is this man who has united in so penetrating a way Europe, Africa, and America? I didn't meet Romy until years after I had first seen his work. I remember, however, standing in a dark telephone booth on Avenue B, talking to him, trying to thank him for bringing me out of the frame-factory and back to painting and art (the common and transcendental art of the everyday life of American black people), and I only remember the extreme kindness and friendliness in his voice. Recently, during all of the meetings occasioned by this book, and in conversations with many people who know him in many ways, I have observed many outstanding qualities, which can best be conveyed in the words of Bahá'u'lláh,[1] as written in the *Hidden Words:*[2]

O Son of Spirit! My first counsel is this: Possess a pure, kindly, and radiant heart, that thine may be a sovereignty ancient, imperishable, and everlasting.

That is the feeling I got from Romy's heart, and that, I think, is the beginning of his greatness.

And as to the matter of all the times during the thirties, forties, and fifties when he was gathering together the wherewithal to continue, to arrive with what John Williams speaks of as his gift to us, his people's gift to us, free from bitterness, rancor, or hate, when he was trying to discover a way to *see,* and to express, some of the qualities we should all see in black people, but without excessive anger or excessive love or excessive anything:

O Son of Spirit! The best beloved of all things in my sight is Justice; turn not away therefrom if thou desirest Me, and neglect it not that I may confide in thee. By its aid thou

1 Bahá'u'lláh (1817–1892), Founder of the Baha'i World Faith.
2 *Hidden Words*, one of the more than 100 works revealed by Bahá'u'lláh.

shall see with thine own eyes and not through the eyes of others, and shall know of thine own knowledge and not through the knowledge of thy neighbor. Ponder this in thy heart; how it behoveth thee to be. Verily justice is My gift to thee and the sign of My loving kindness. Set it then before thine eyes.

Think, America, and be fair, at this time in our history how many hearts could a Romare Bearden inflame? And how many hearts can he calm and educate? In paintings he has chosen to be just, he has chosen to educate, not through great and mighty people alone but with plain, downtrodden, simple, black people. A tremendously crucial, divinely symbolic people. Although he knows more heroic black figures than any man I know, he nevertheless has chosen to bring us that which we need most in a most beautiful and profound way: his vision of his people, his vision, therefore, of all people.

O Son of Spirit! Ye are my Treasury, for in you I have treasured the pearls of My mysteries and the gems of My knowledge. Guard them from the strangers amidst My servants and from the ungodly amongst My people.

This Romy has done, and in so doing he has had to understand many traditions; he has had to gather many far-flung gems from those places his mind and heart have visited, all the time turning many a head away from the chrome racisms, technological madness, and stainless-steel souls that have become our domestic curse; away from the bombast of a Madison Avenue run amok; away from those things, plastic and sterile, that we are surrounding ourselves with, which can only foster plastic and sterile people.

O Son of Justice! Whither can a lover go but to the land of his beloved? And what seeker findeth rest away from his heart's desire? To the true lover reunion is life, and separation is death. His breast is void of patience and his heart hath no peace. A myriad lives he would forsake to hasten to the abode of his beloved.

The "abode of his beloved." Romy has traveled the roads of this country and abroad and returned (never having left) to his people. He has returned to illuminate for us visions we have lost, visions we have never had; dreams, rituals and black faces, recapturing their meanings. . . .

O Son of Spirit! I created thee rich, why dost thou bring thyself down to poverty? Noble I made thee, wherewith dost thou abase thyself? . . . Turn thy sight unto thyself, that thou mayest find Me standing within thee, mighty, powerful and self-subsisting.

"Self-subsisting." Today, America questions everyone concerning race, nationality, allegiance. Are you a black painter? Do you want to go *back* to Africa? Don't you love America? And if so, "how much?" Every question hides a secret venom, every answer a betrayal. (Think clearly, America, and value those things that bring you and every nation greatness. Think clearly, and do not fail to recognize your strength and the forgotten giants in your midst.)

O Children of Men! Know ye not why We created you all from the same dust? That no one should exalt himself over the other. Ponder at all times in your hearts how ye were created. Since We have created you all from the same substance it is incumbent on you to be even as one soul, to walk with the same feet, eat with the same mouth, and dwell in the same land, that from your innermost being, by your deeds and actions, the signs of oneness and the essence of detachment may be made manifest.

"Deeds and actions." I remember rushing uptown one afternoon, late as usual, to meet Romy, finding him smiling in the light rain, his arm around a slight Japanese man, his eyes full of understanding, our own business forgotten, while he struggled with an artist from a faraway land and a language he did not know. Not for me, and, I'm sure, not for any of the reasons I would have, but purely for the joy of it, purely out of his overwhelming concern. With Romy it cannot, it could not, be different.

Bahá'u'lláh's words come to me now as I remember that afternoon and the two of them, beaming across at one another, chatting. . . .

Myriads of mystic tongues find utterance in one speech, and myriads of hidden mysteries are revealed in a single melody; yet, alas, there is no ear to hear, nor heart to understand.

Who is Romy, America? Tell me.

DRAWINGS AND PAINTINGS 1940-1971

PLATE 1

THE ANNUNCIATION. 1942. COLLAGE, 30 × 47 1/2″. COLLECTION THE ARTIST

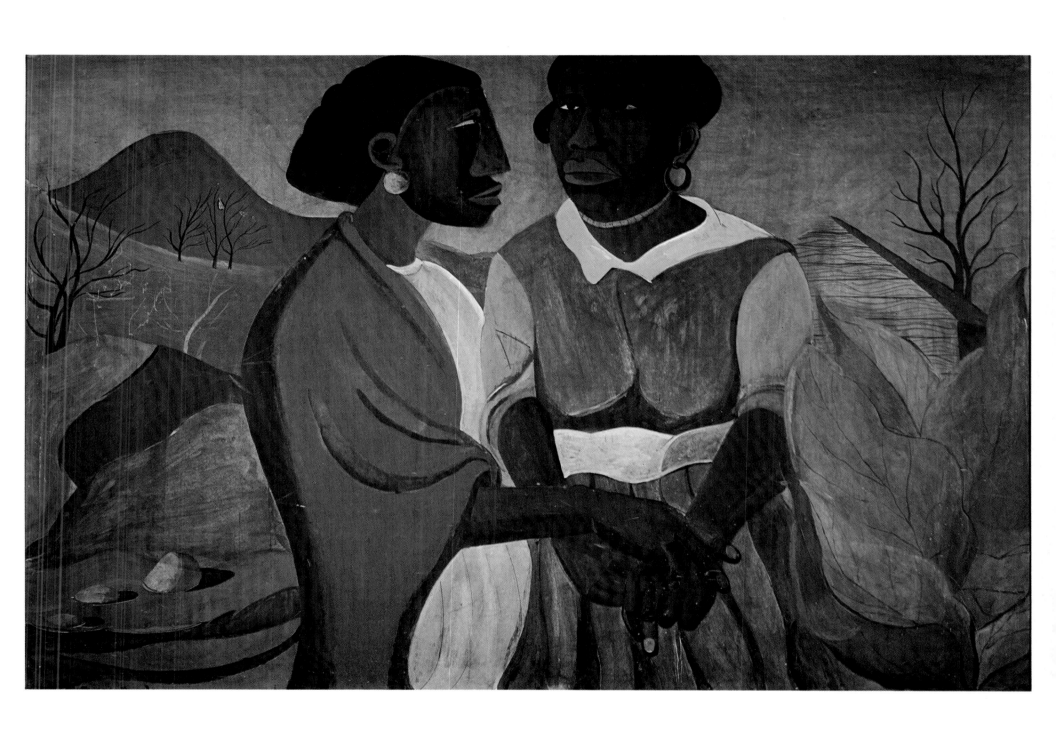

PLATE 2

FROM THE ILIAD. 1947. WATERCOLOR, 24 × 18″. COLLECTION THE ARTIST

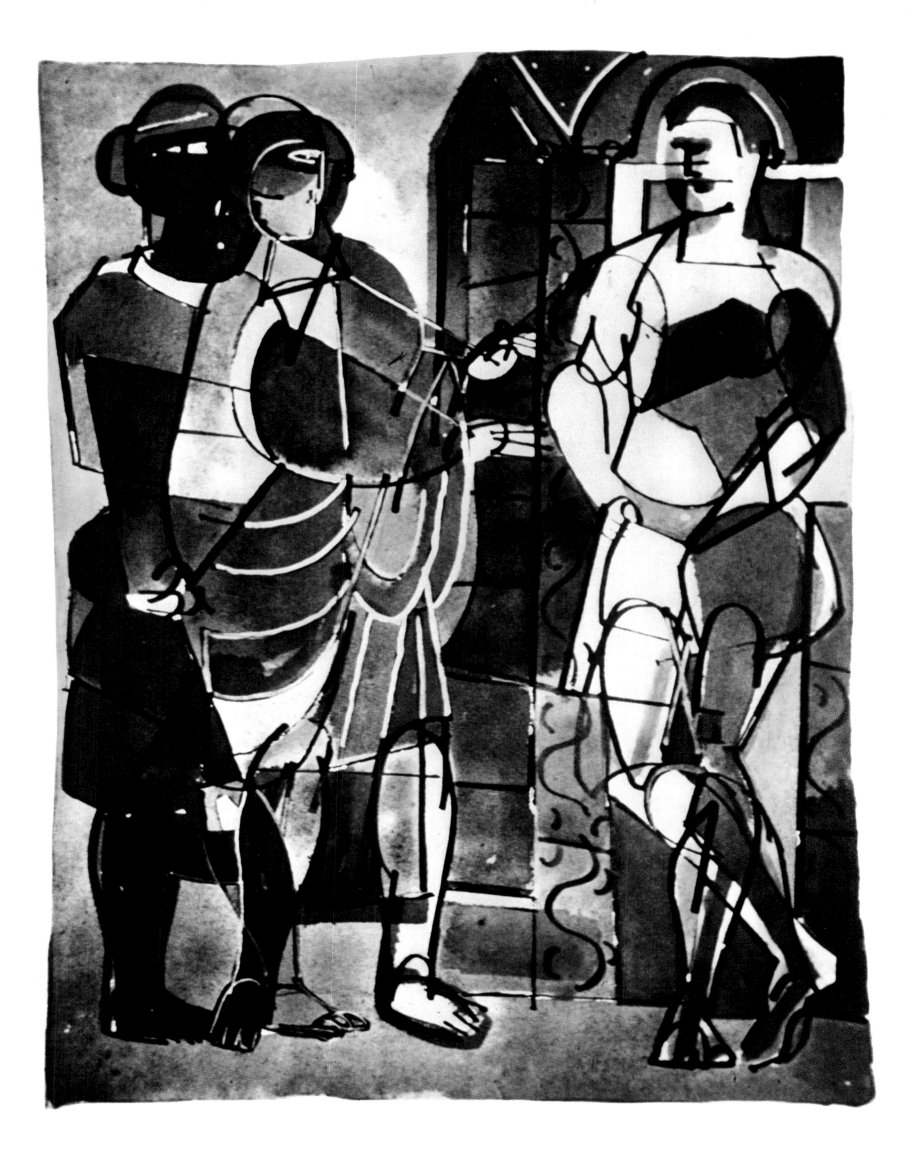

PLATE 3

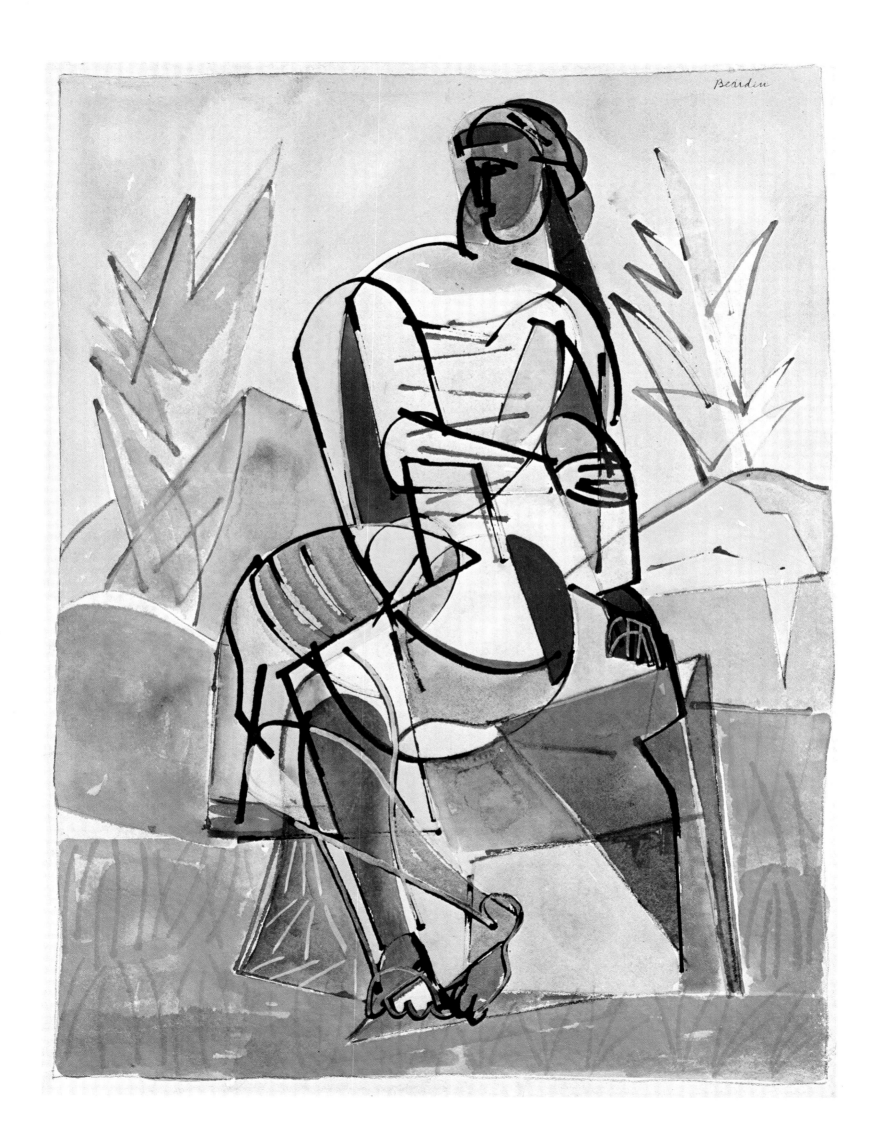

PLATE 4

MOUNTAINS OF THE MOON. 1956. OIL ON CANVAS, 40 1/2 × 31 3/4″. COLLECTION BARRIE STAVIS, NEW YORK CITY

PLATE 5

UNTITLED, NUMBER ONE. 1961. OIL, 60 × 50″. COURTESY CORDIER & EKSTROM GALLERY, NEW YORK CITY

PLATE 6

UNTITLED NUMBER TWO. 1961. OIL, 50×40″. COURTESY CORDIER & EKSTROM GALLERY, NEW YORK CITY

44

PLATE 7

THE PREVALENCE OF RITUAL: THE BAPTISM. 1964. COLLAGE, $37 \times 48''$. WILLIAMS COLLEGE ART MUSEUM, WILLIAMSTOWN, MASS.

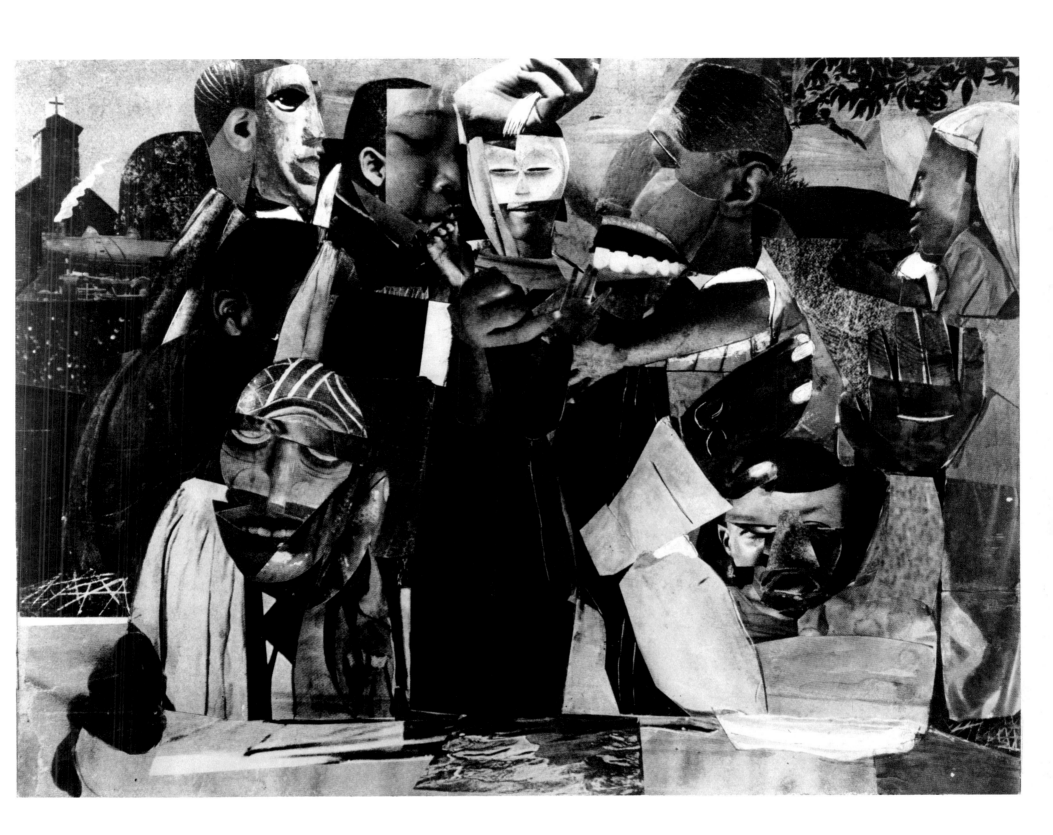

PLATE 8

THE PREVALENCE OF RITUAL: THE CONJUR WOMAN. 1964. COLLAGE, 12 × 9 1/4″. COURTESY CORDIER & EKSTROM GALLERY,
NEW YORK CITY

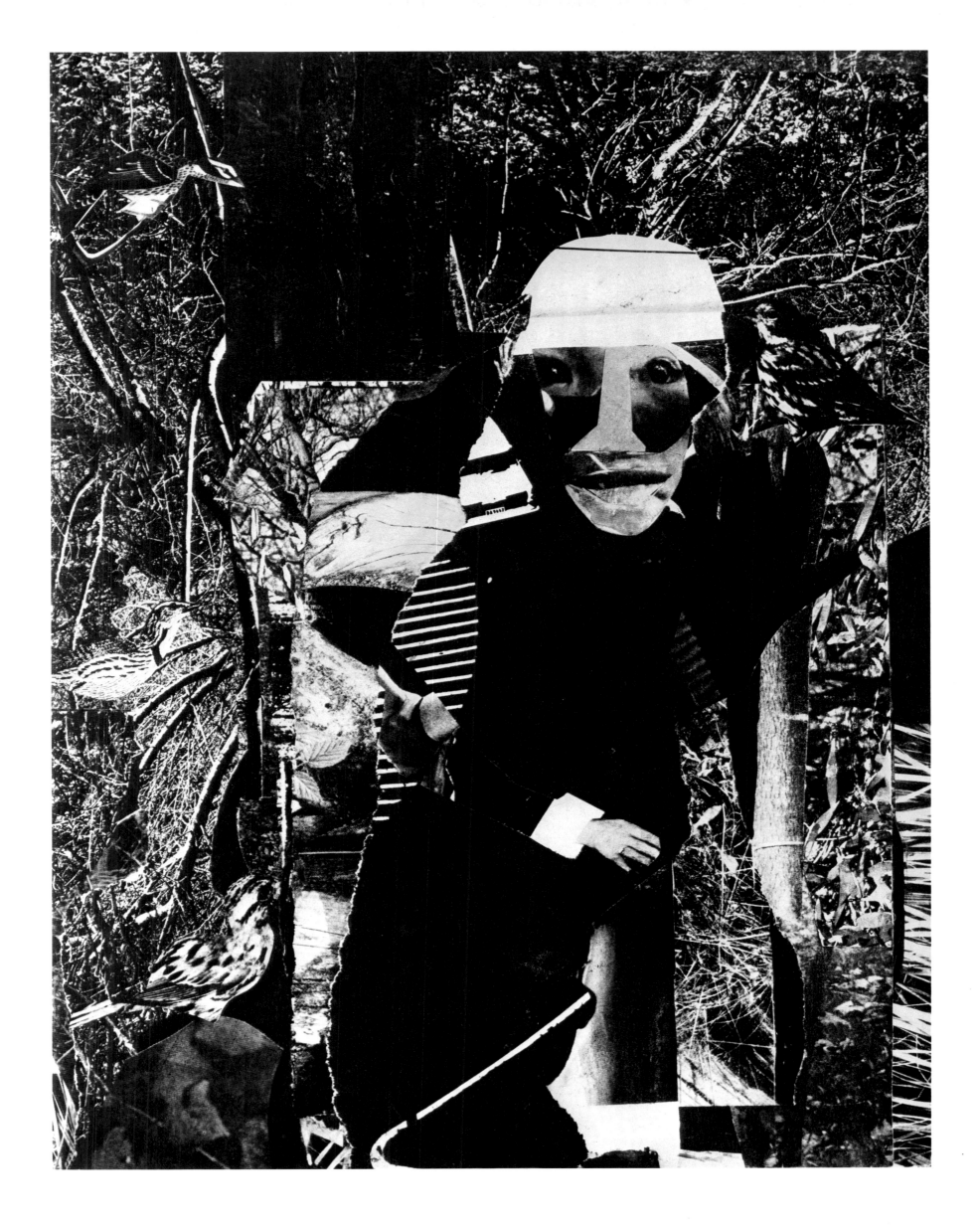

PLATE 9

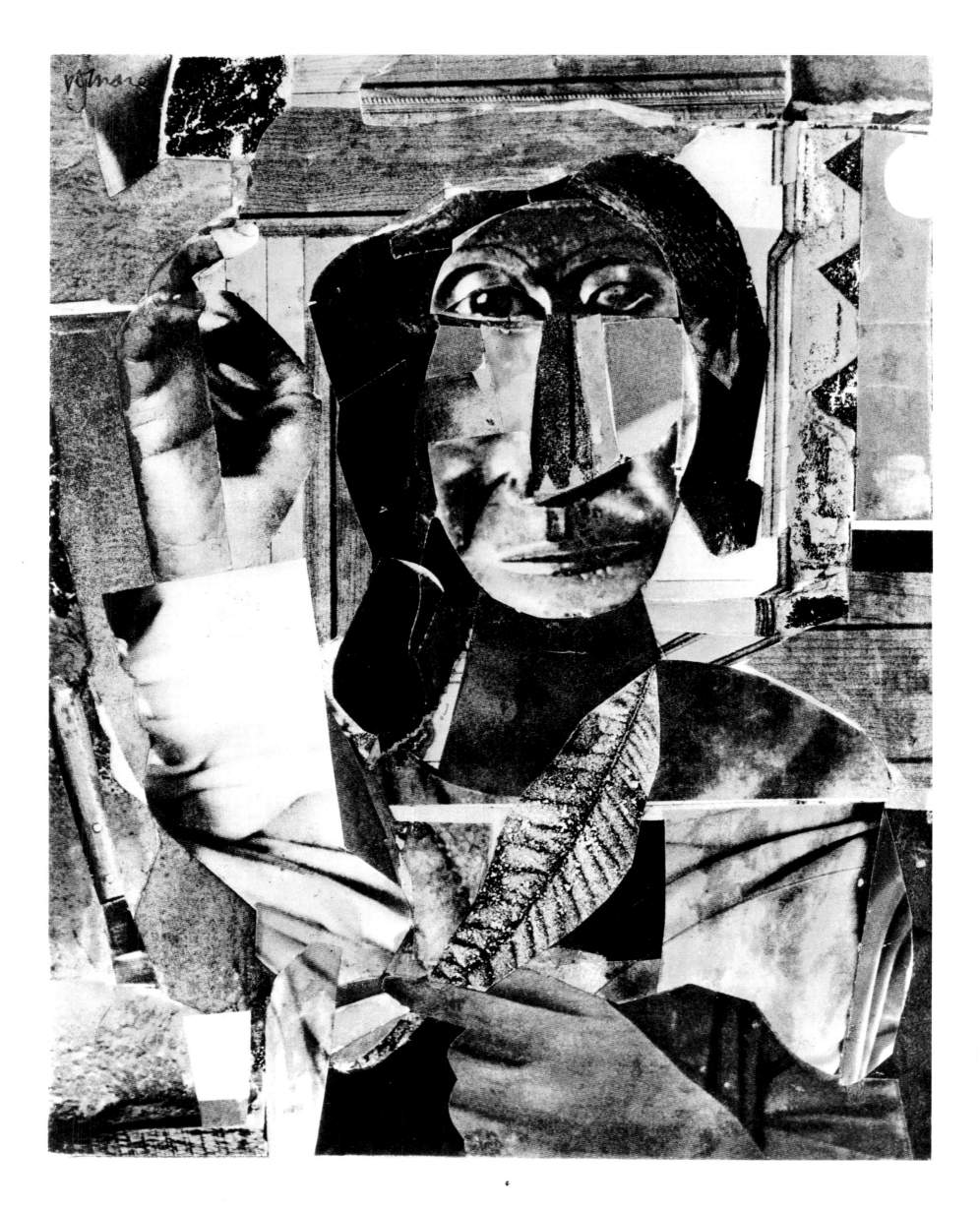

PLATE 10

CONJUR WOMAN AS AN ANGEL. 1964. COLLAGE, 40 × 30″. COURTESY CORDIER & EKSTROM GALLERY, NEW YORK CITY

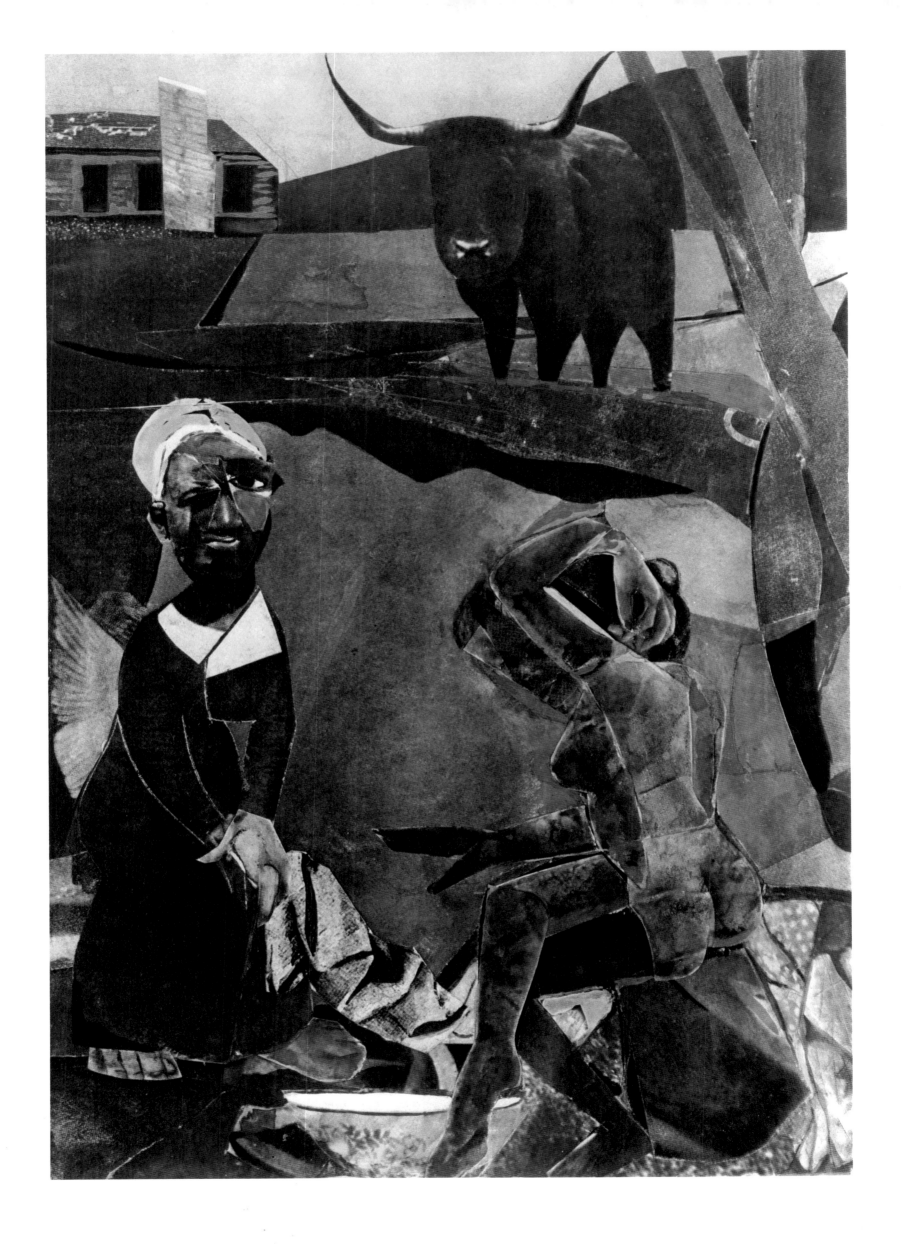

PLATE 11

EVENING: 9:15; 417 LENOX AVENUE. 1964. COLLAGE, 21 × 27″. COURTESY CORDIER & EKSTROM GALLERY, NEW YORK CITY

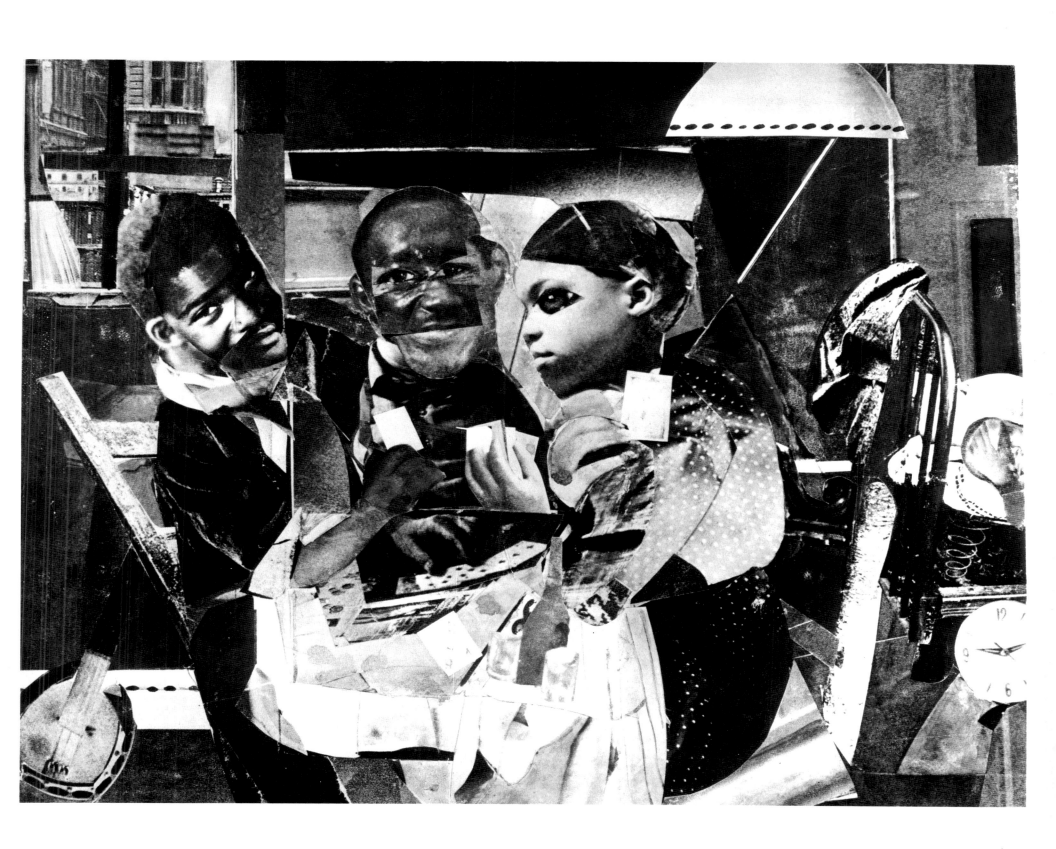

PLATE 12

BAPTISM. 1967. COLLAGE, 22 × 18″. COURTESY J. L. HUDSON GALLERY, DETROIT

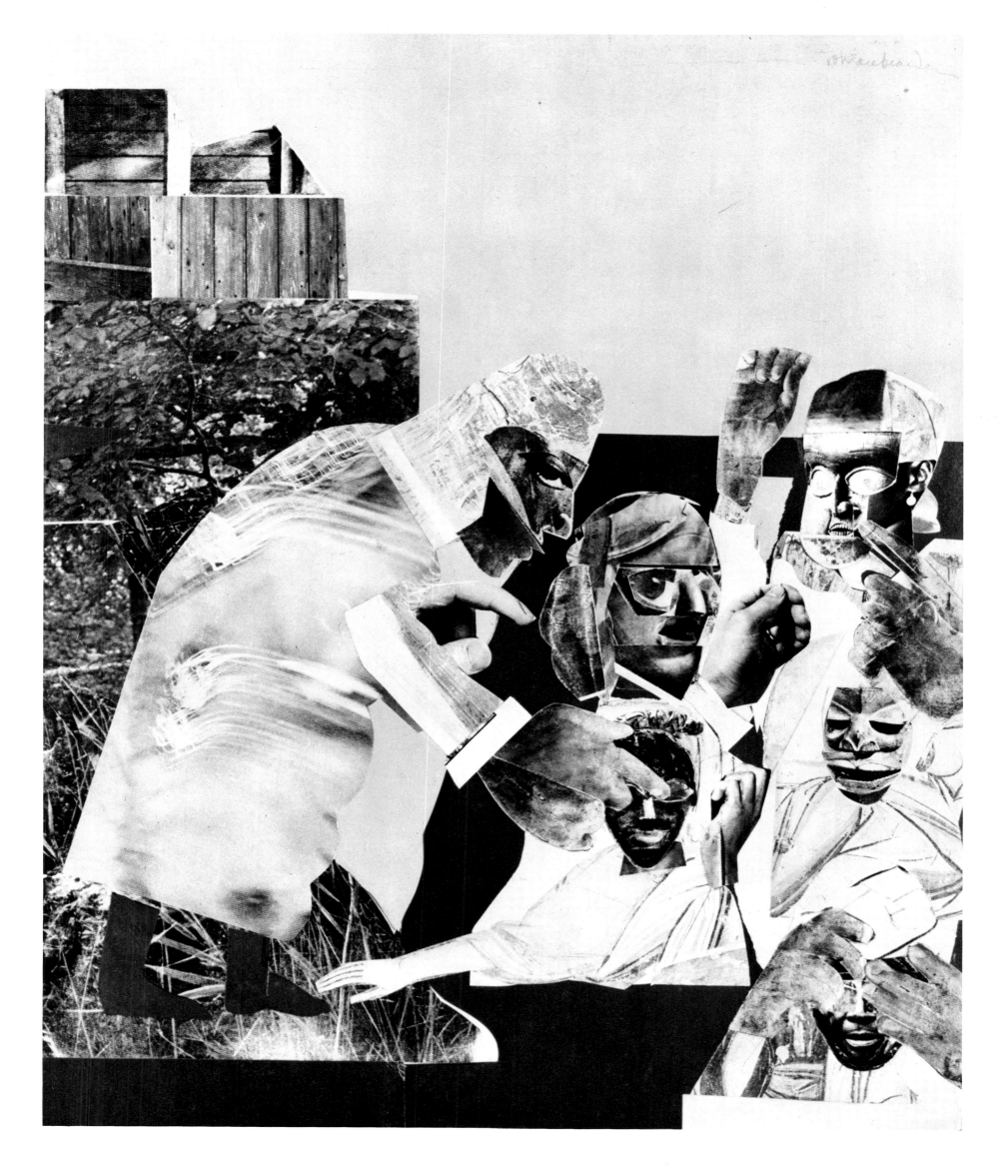

PLATE 13

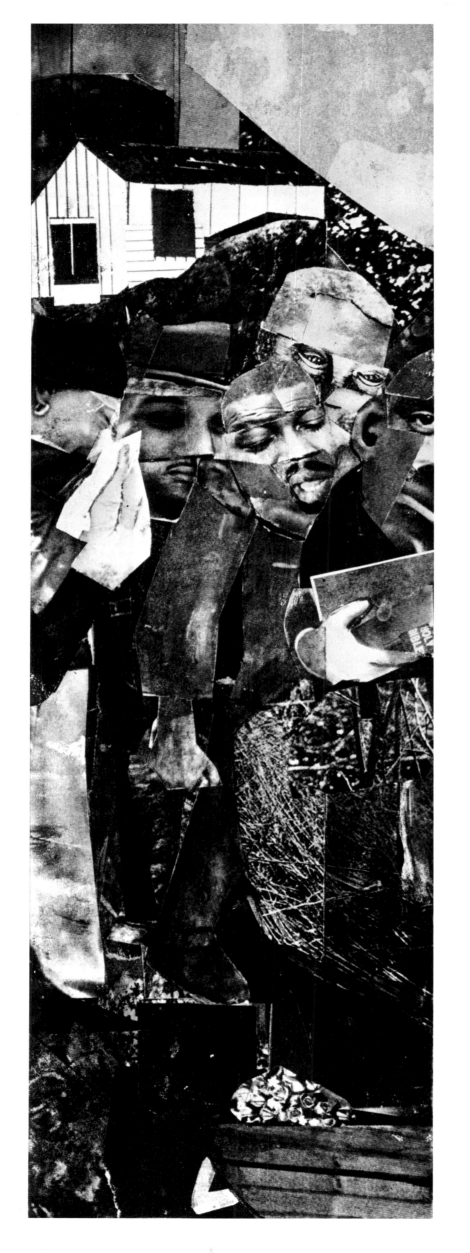

PLATE 14

THE STREET. 1964. COLLAGE, 9 5/8 × 11 3/8".
COURTESY CORDIER & EKSTROM GALLERY, NEW YORK CITY

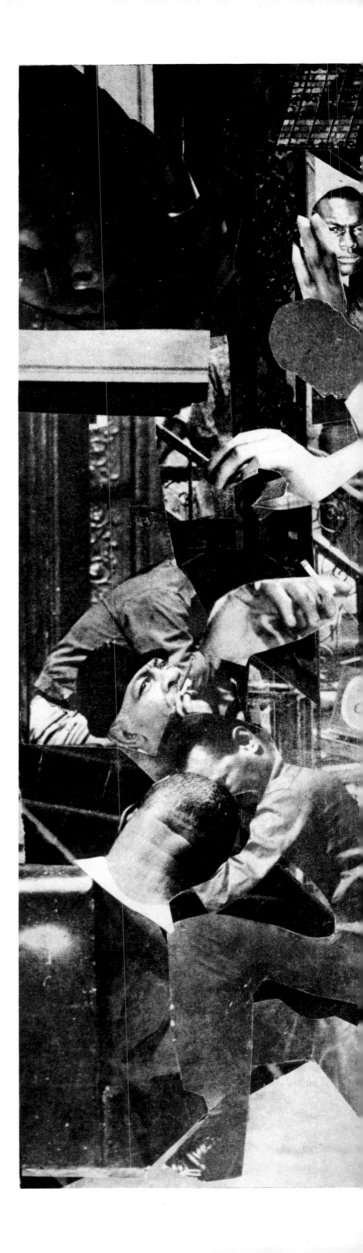

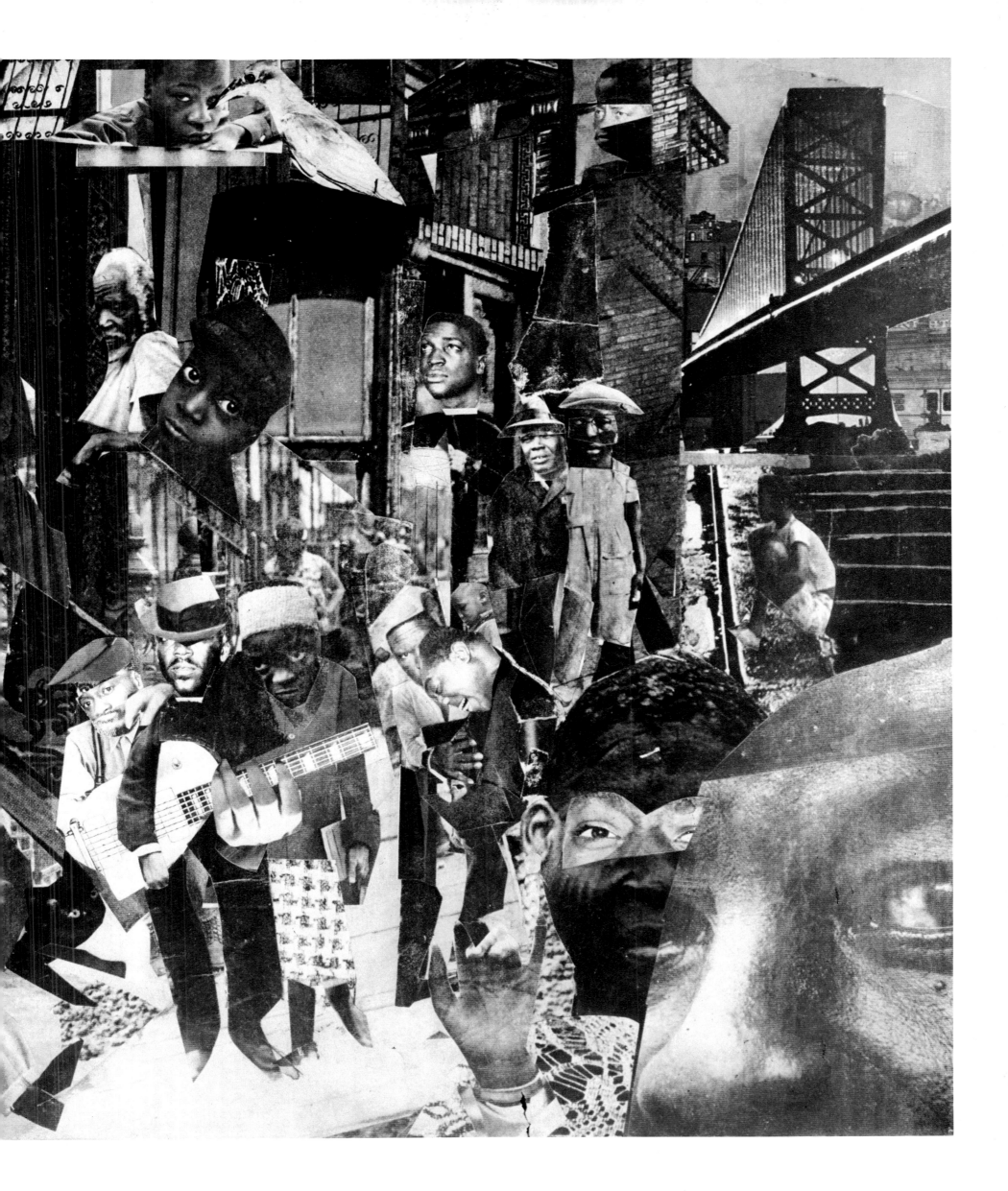

PLATE 15

TRAIN WHISTLE BLUES, NUMBER ONE. 1964. COLLAGE, 13 1/8 × 10″. COURTESY CORDIER & EKSTROM GALLERY, NEW YORK CITY

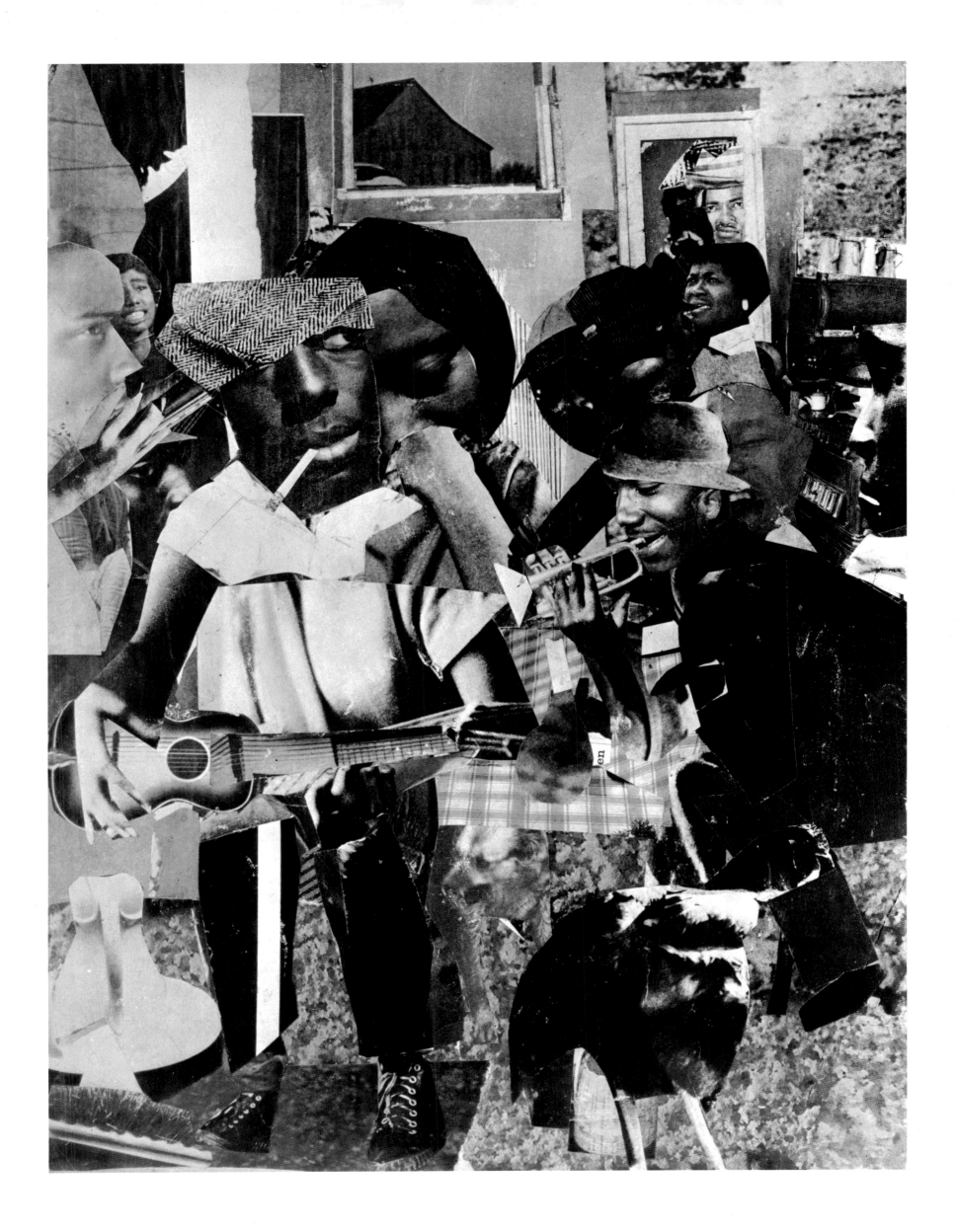

PLATE 16

TRAIN WHISTLE BLUES, NUMBER TWO. 1964. COLLAGE, $27 \times 36''$. COURTESY CORDIER & EKSTROM GALLERY, NEW YORK CITY

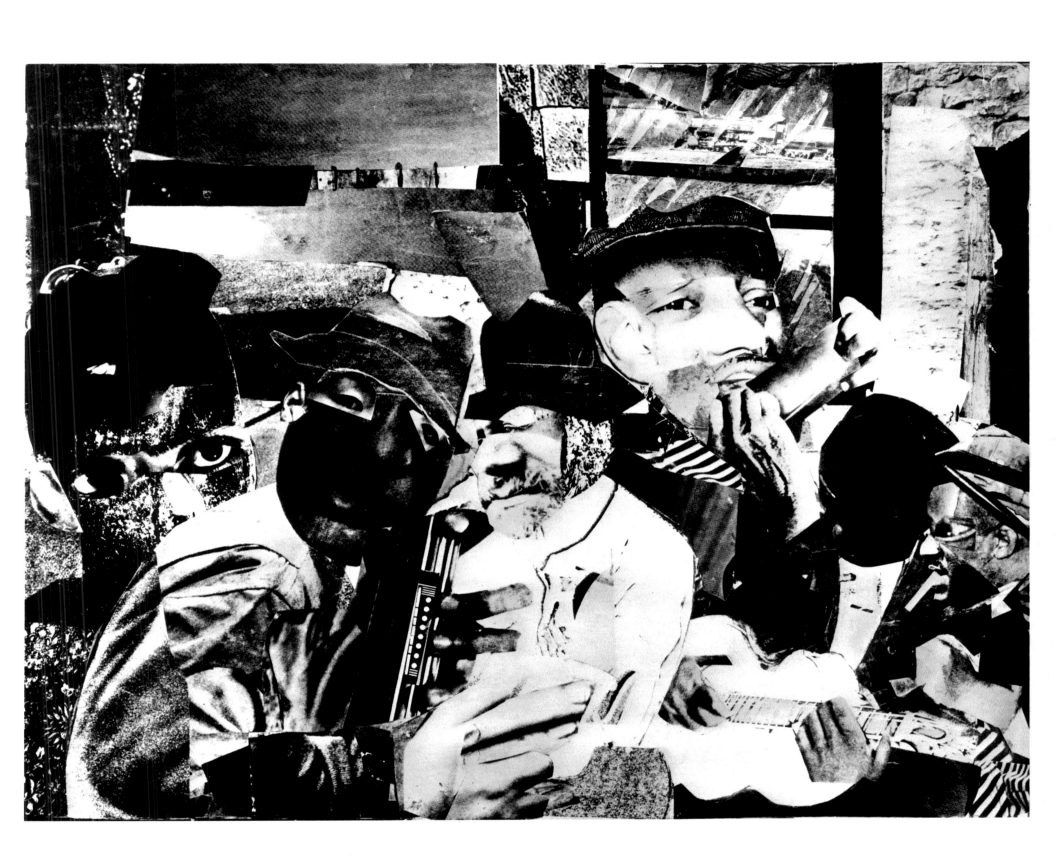

PLATE 17

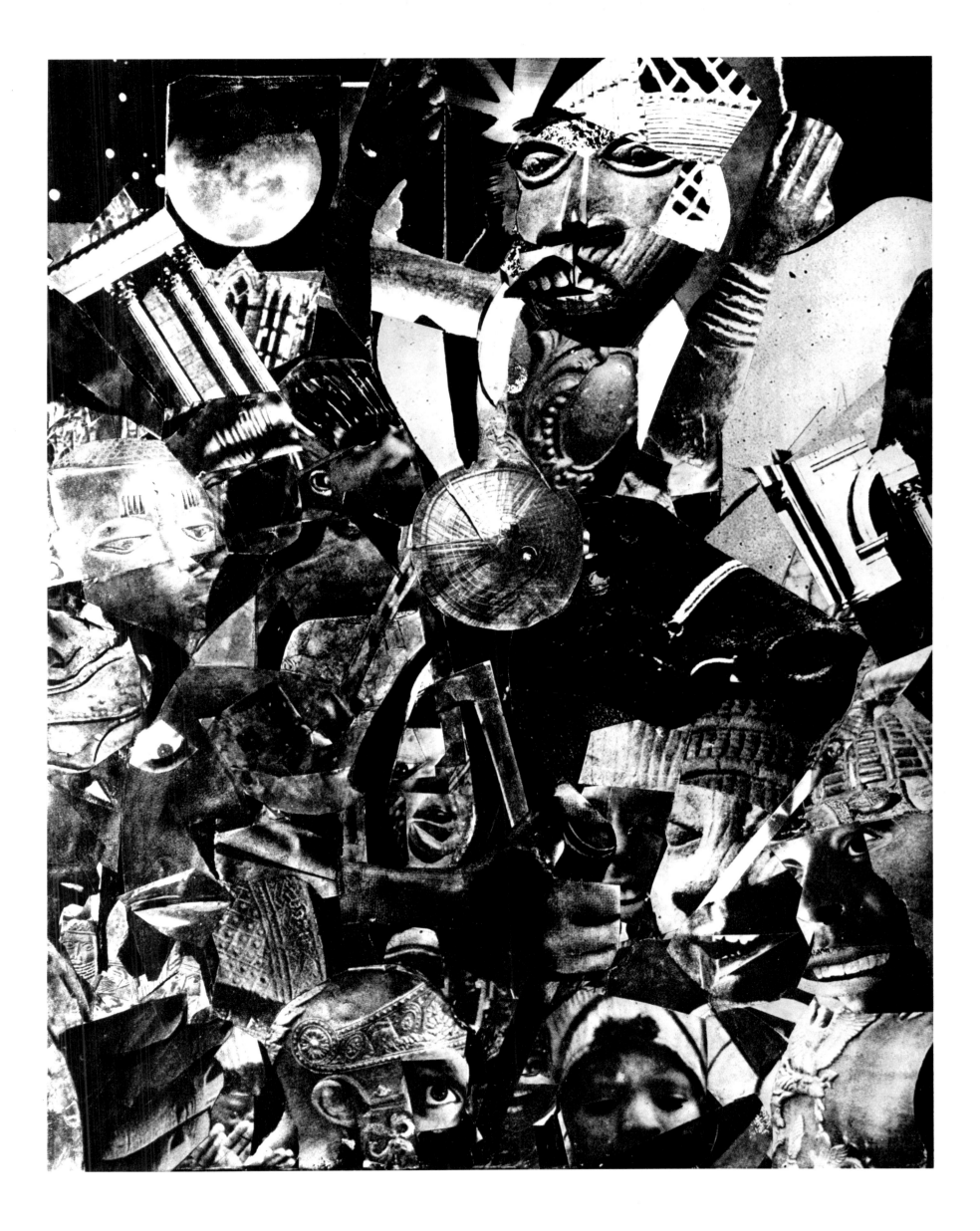

PLATE 18

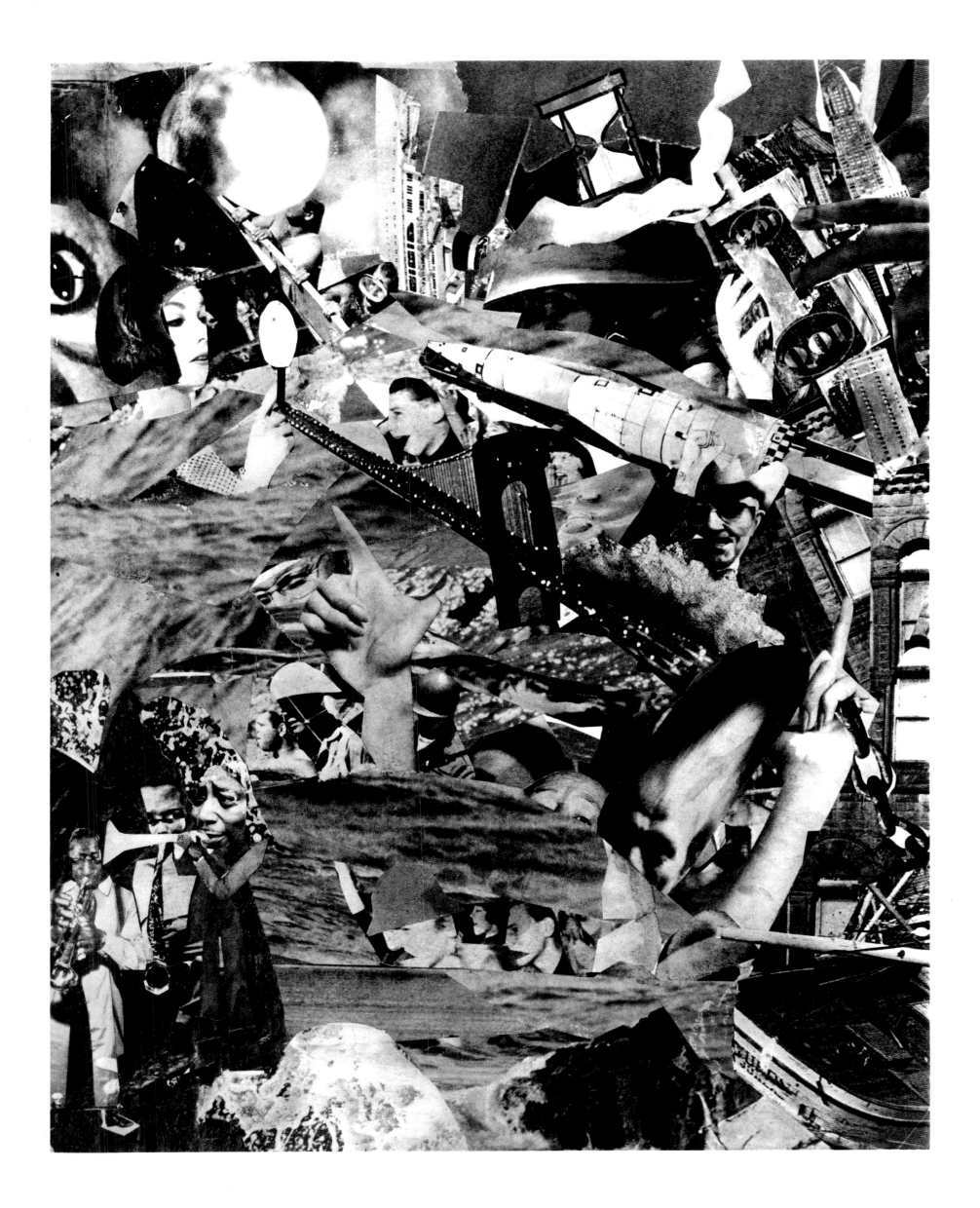

PLATE 19

JAZZ 1930S: THE SAVOY. 1964. COLLAGE, 8 3/4 × 11 7/8″. COURTESY CORDIER & EKSTROM GALLERY, NEW YORK CITY

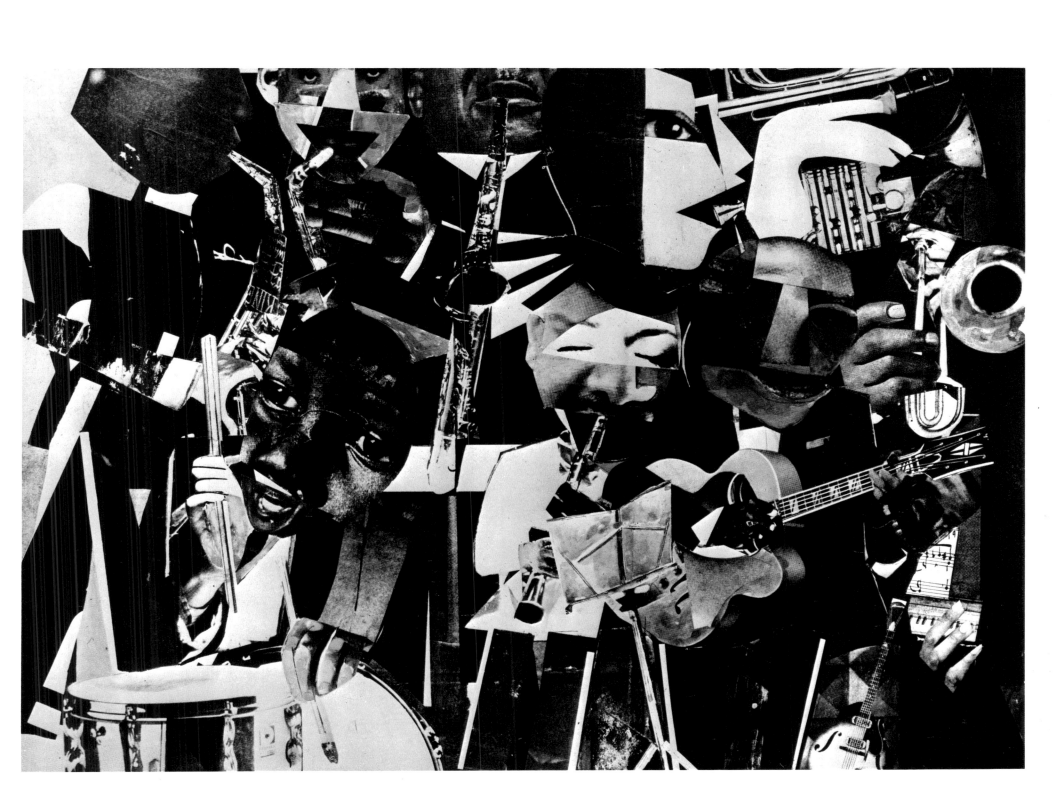

PLATE 20

JAZZ 1930S: GRAND TERRACE BALLROOM. 1964. COLLAGE, 8 3/4 × 11 7/8″. COURTESY CORDIER & EKSTROM GALLERY,
NEW YORK CITY

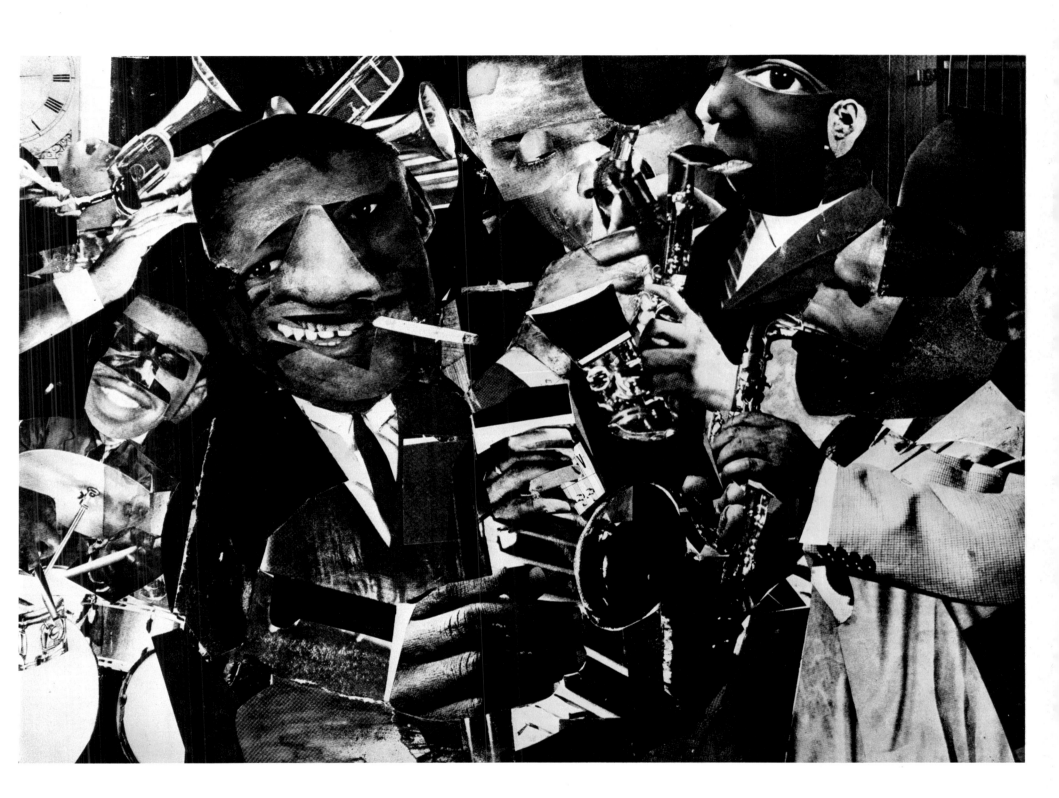

PLATE 21

KING AND QUEEN OF DIAMONDS. 1964. COLLAGE, 16 × 16″. COLLECTION FRITZ SALOMON, PARIS

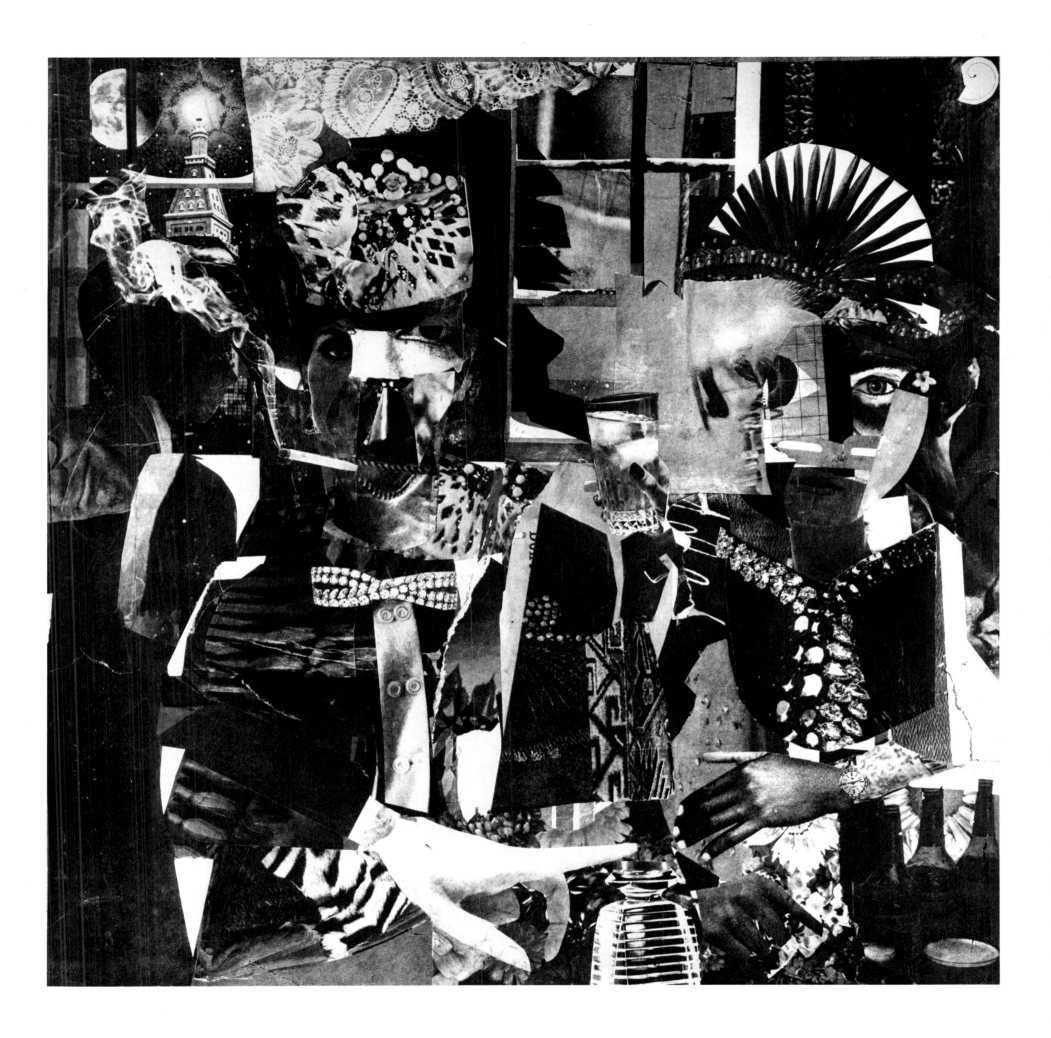

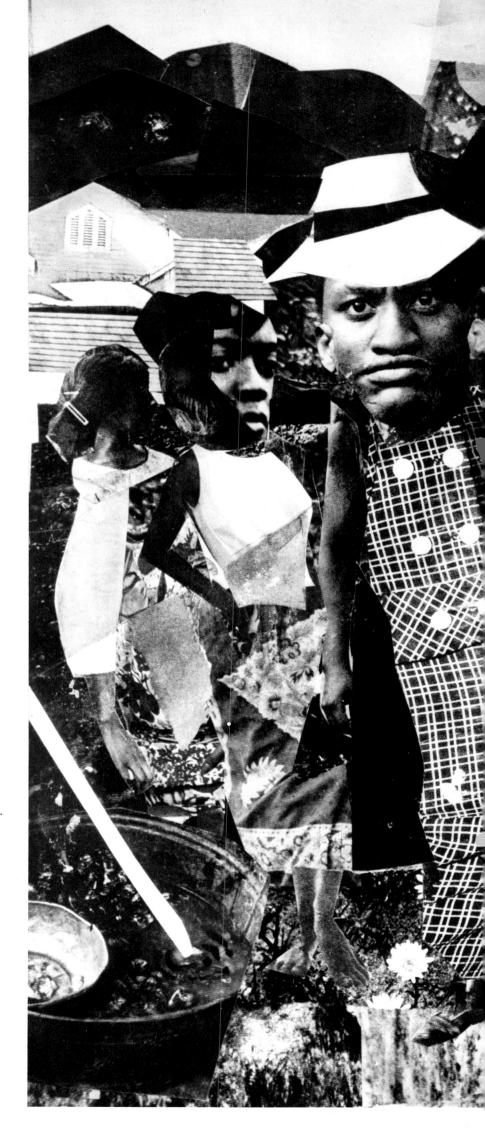

PLATE 22

WATCHING THE GOOD TRAINS GO BY. 1964. COLLAGE, 9 3/4 × 12″.
COURTESY CORDIER & EKSTROM GALLERY, NEW YORK CITY

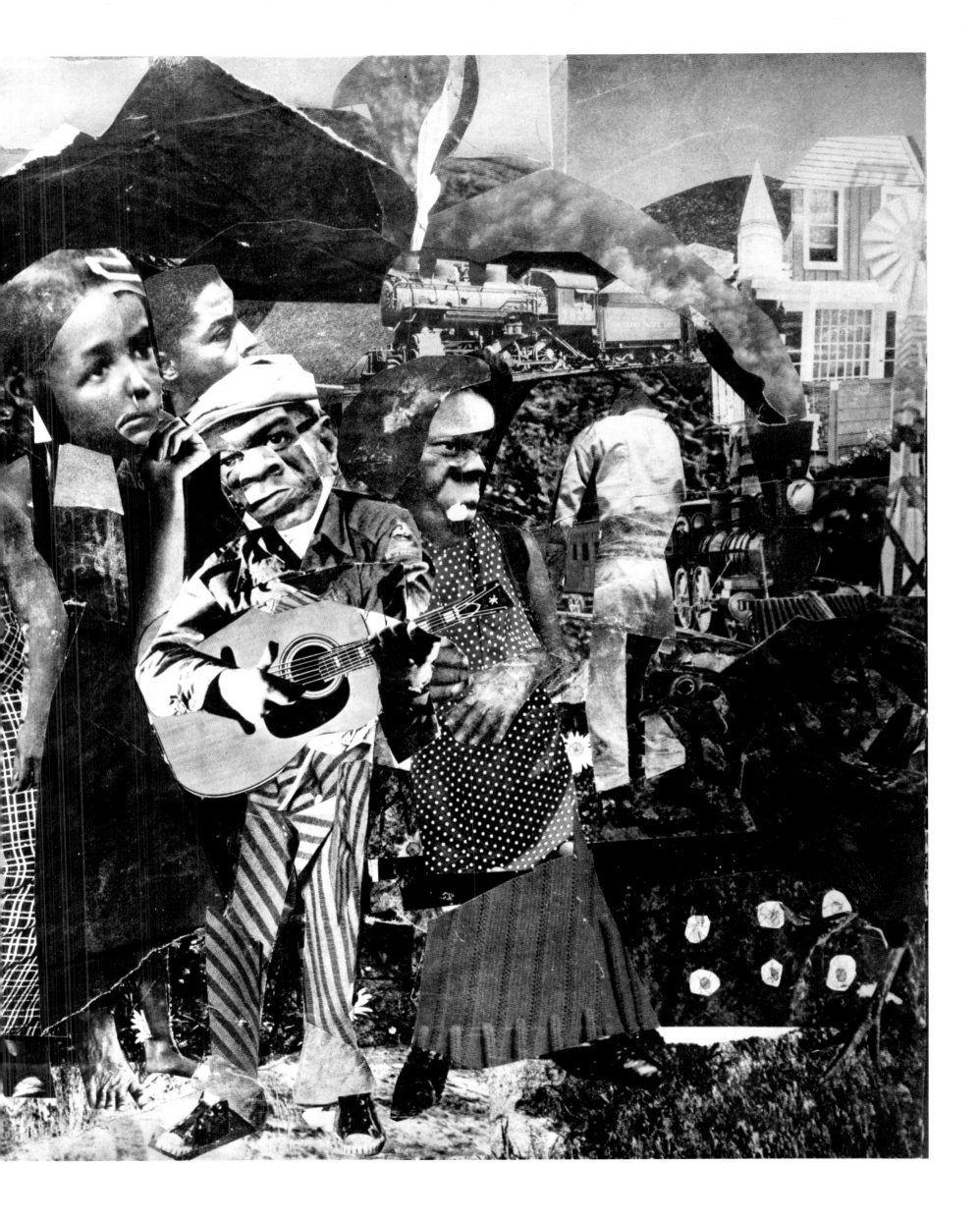

PLATE 23

TWO WOMEN IN A HARLEM COURTYARD. 1964. COLLAGE, $15 \times 12\ 3/4''$. COLLECTION MR. AND MRS. JIM MOSLEY, PHILADELPHIA

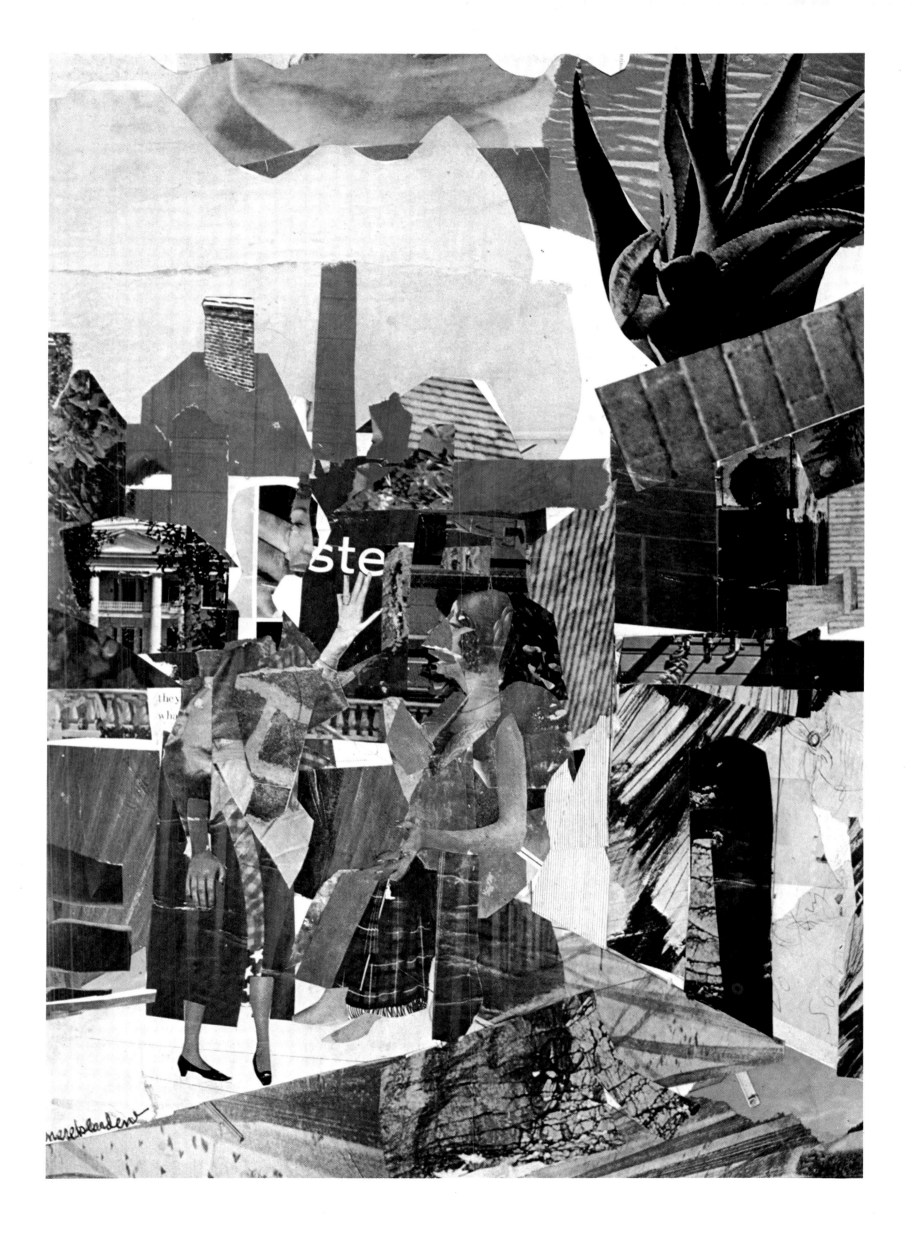

PLATE 24

UPTOWN LOOKING DOWNTOWN. 1964. COLLAGE, 11 5/8 × 15 1/8″. COLLECTION MR. AND MRS. RICHARD CLARKE, NEW YORK CITY

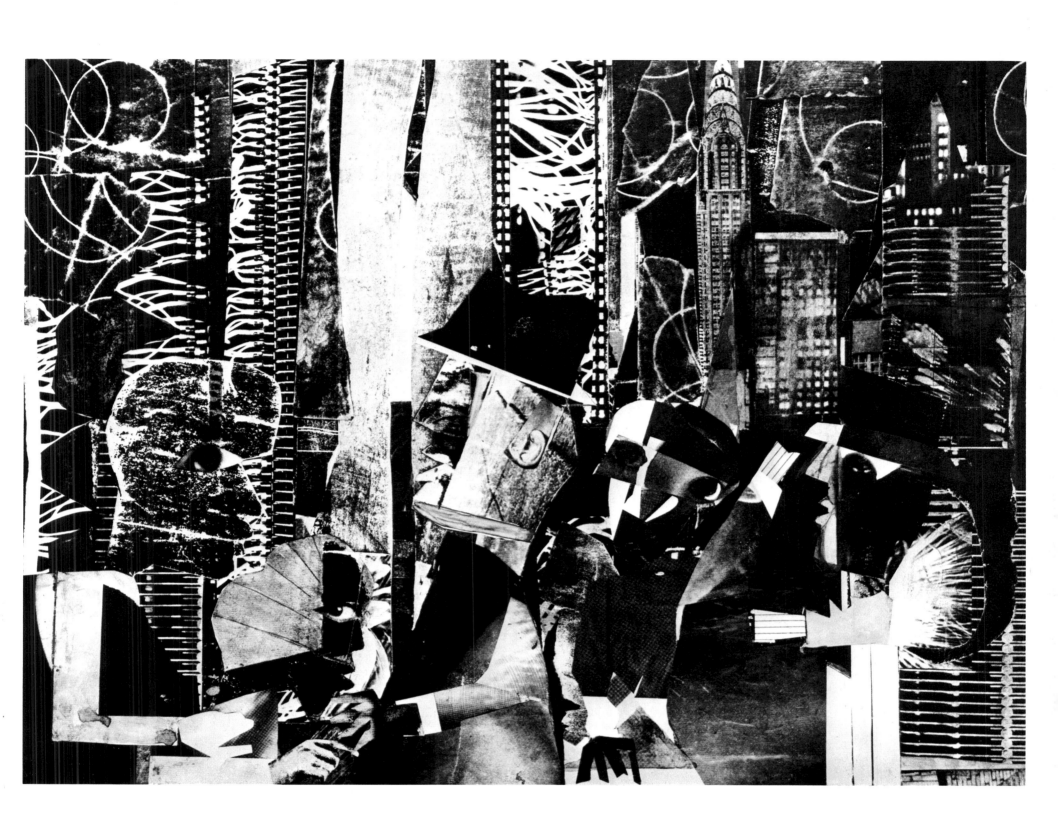

PLATE 25

PITTSBURGH MEMORY. 1964. COLLAGE, 9 1/4 × 11 3/4". COURTESY CORDIER & EKSTROM GALLERY, NEW YORK CITY

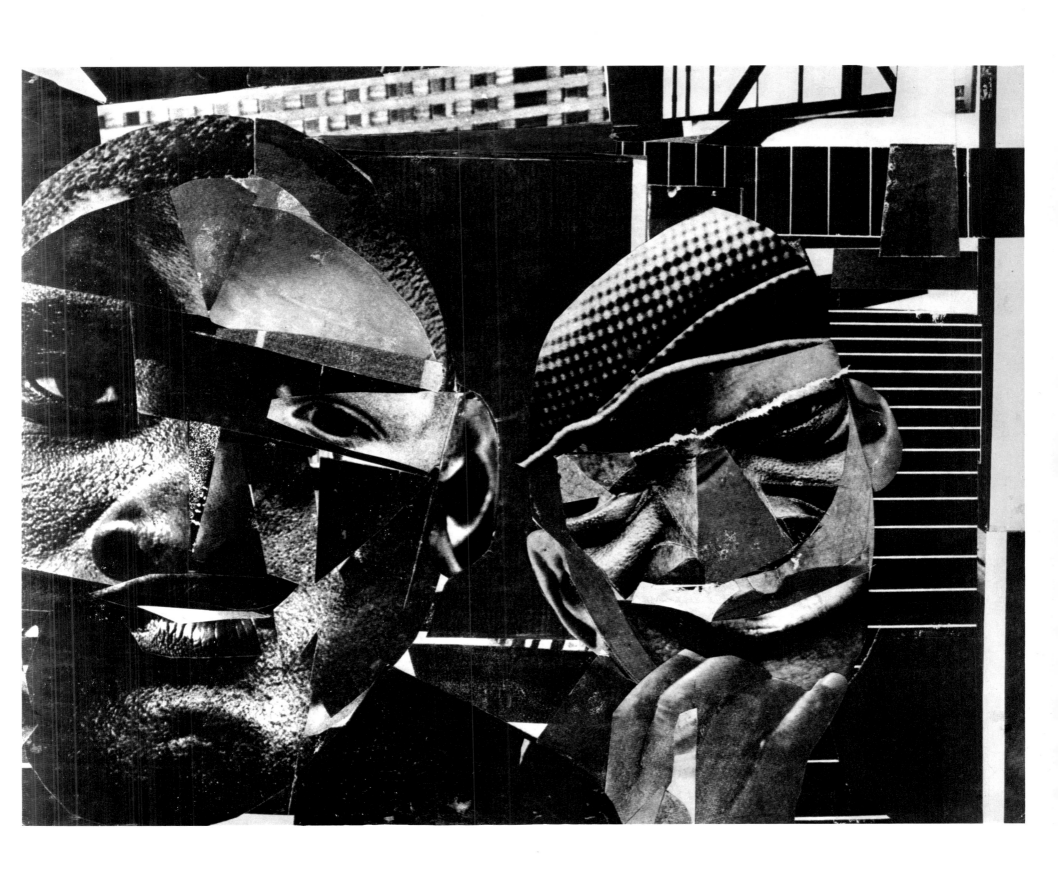

PLATE 26

MYSTERIES. 1964. COLLAGE, 9 1/2 × 12".

COURTESY CORDIER & EKSTROM GALLERY, NEW YORK CITY

84

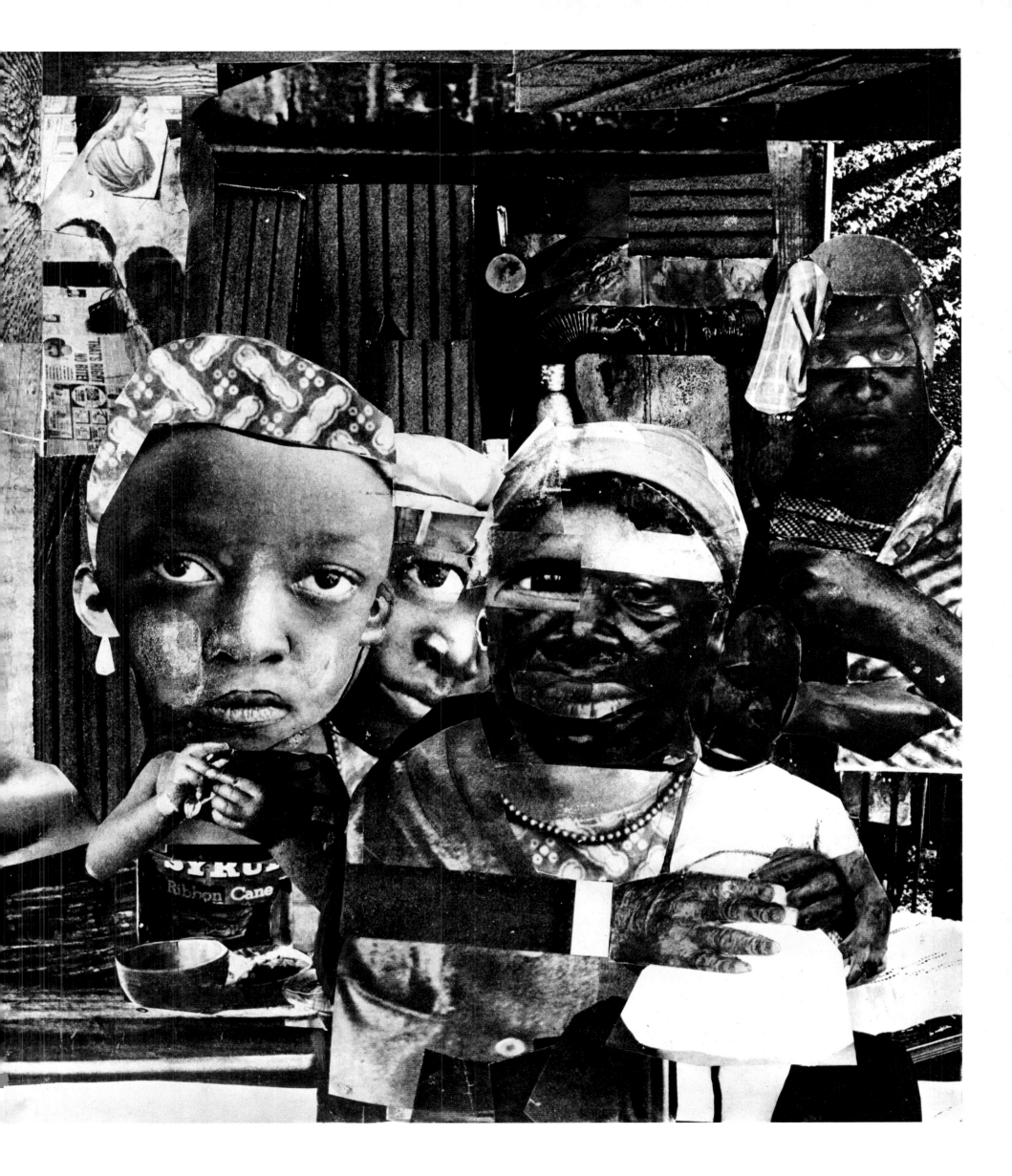

PLATE 27

EXPULSION FROM PARADISE. 1964. COLLAGE, 9 1/8 × 12″. COURTESY CORDIER & EKSTROM GALLERY, NEW YORK CITY

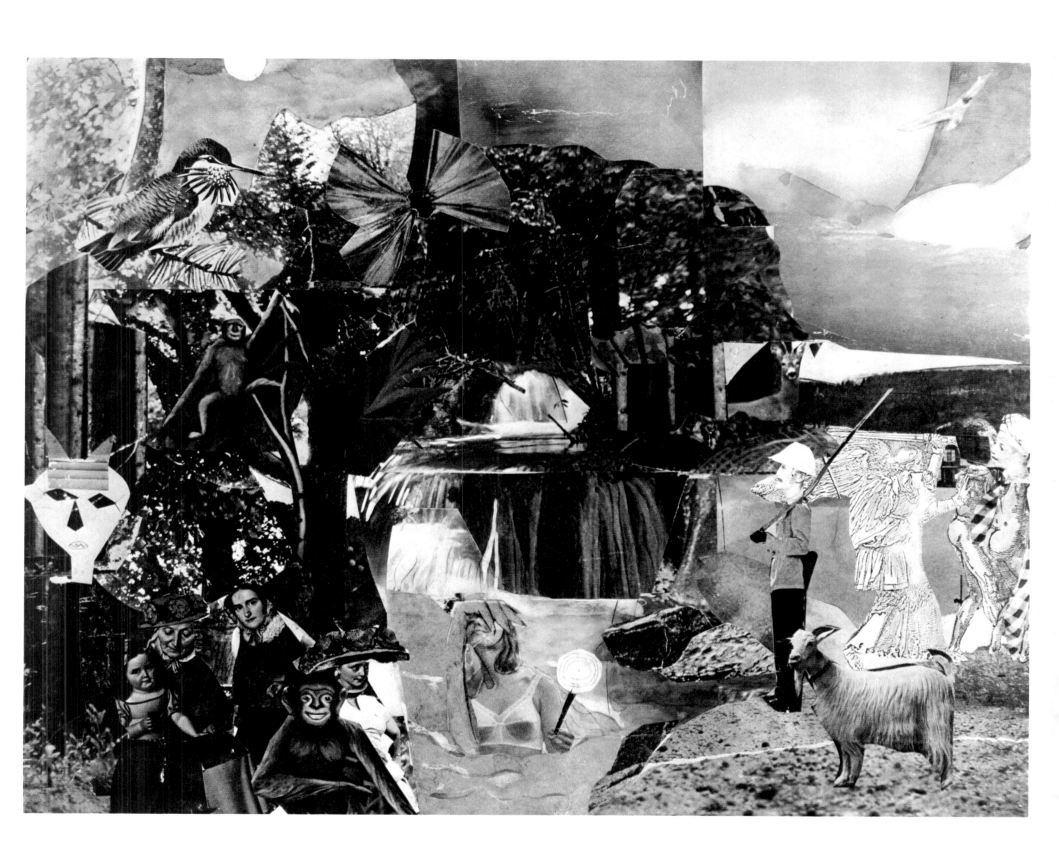

PLATE 28

COTTON. 1964. COLLAGE, 9 1/2 × 12″. COURTESY CORDIER & EKSTROM GALLERY, NEW YORK CITY

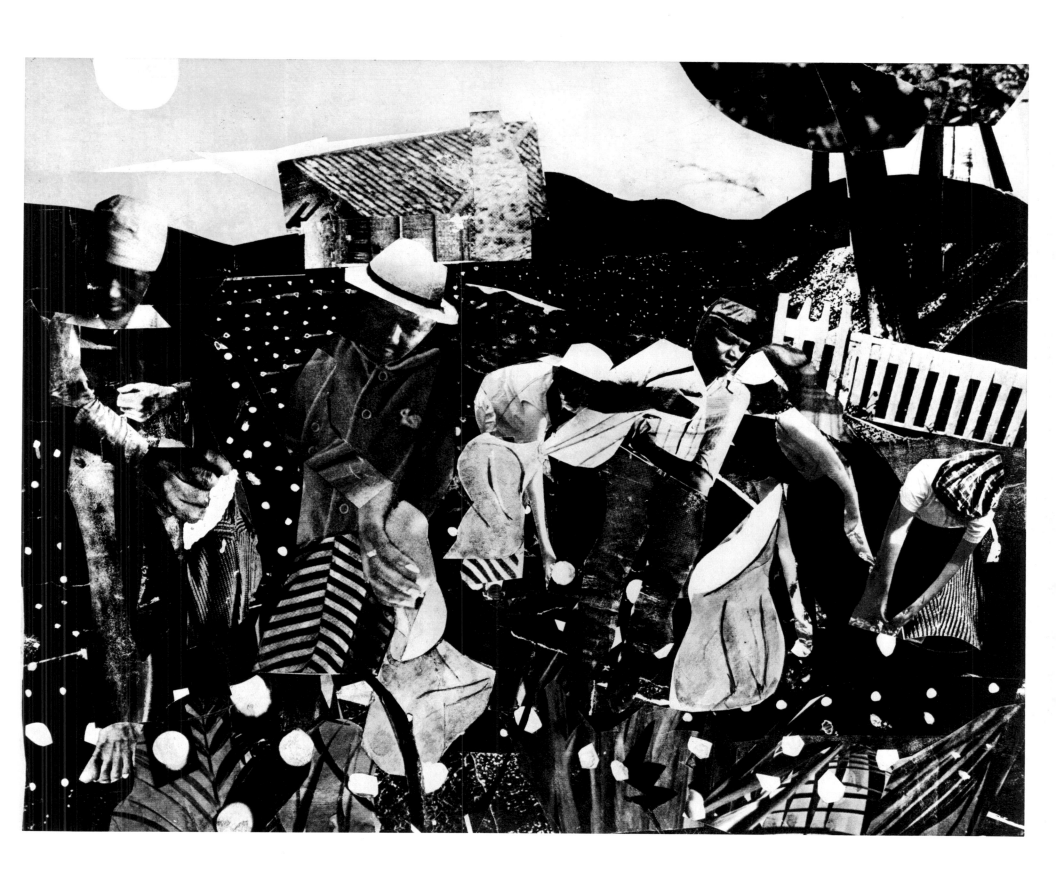

PLATE 29

THE DOVE. 1964. COLLAGE, 35 × 48″. COURTESY CORDIER & EKSTROM GALLERY, NEW YORK CITY

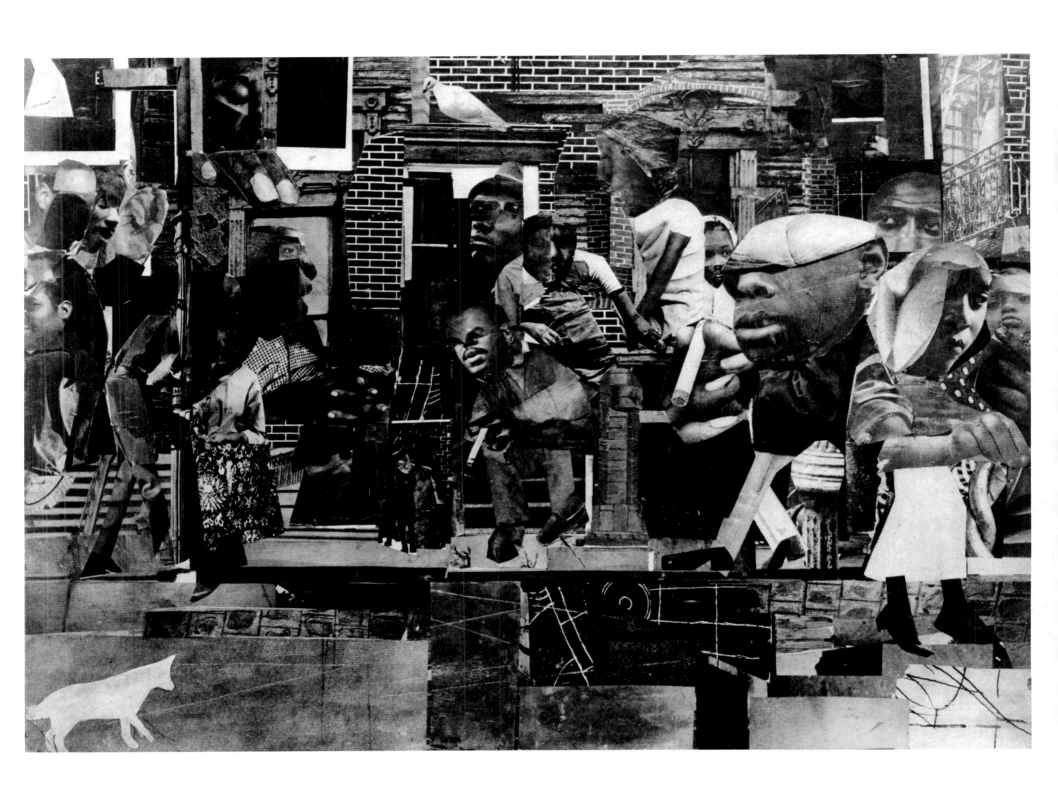

PLATE 30

SATURDAY EVENING. 1965. COLLAGE, 7 1/2 × 10 1/4″.
COURTESY CORDIER & EKSTROM GALLERY, NEW YORK CITY

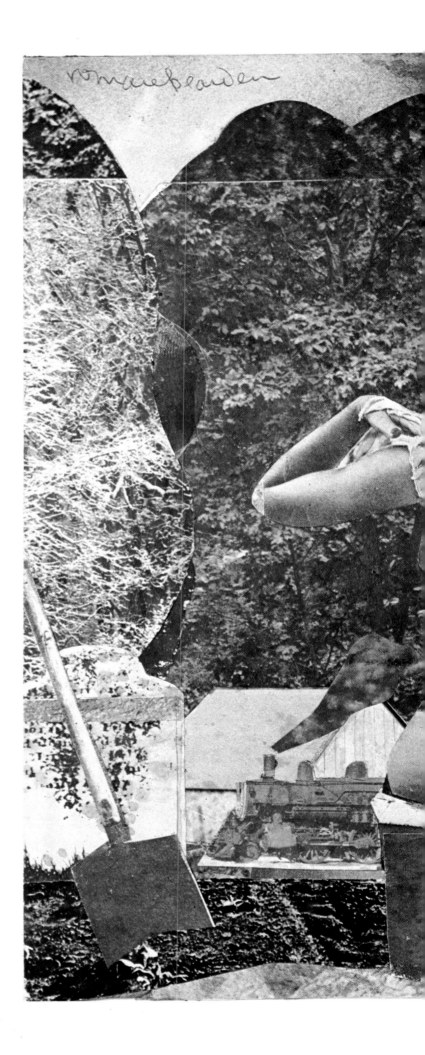

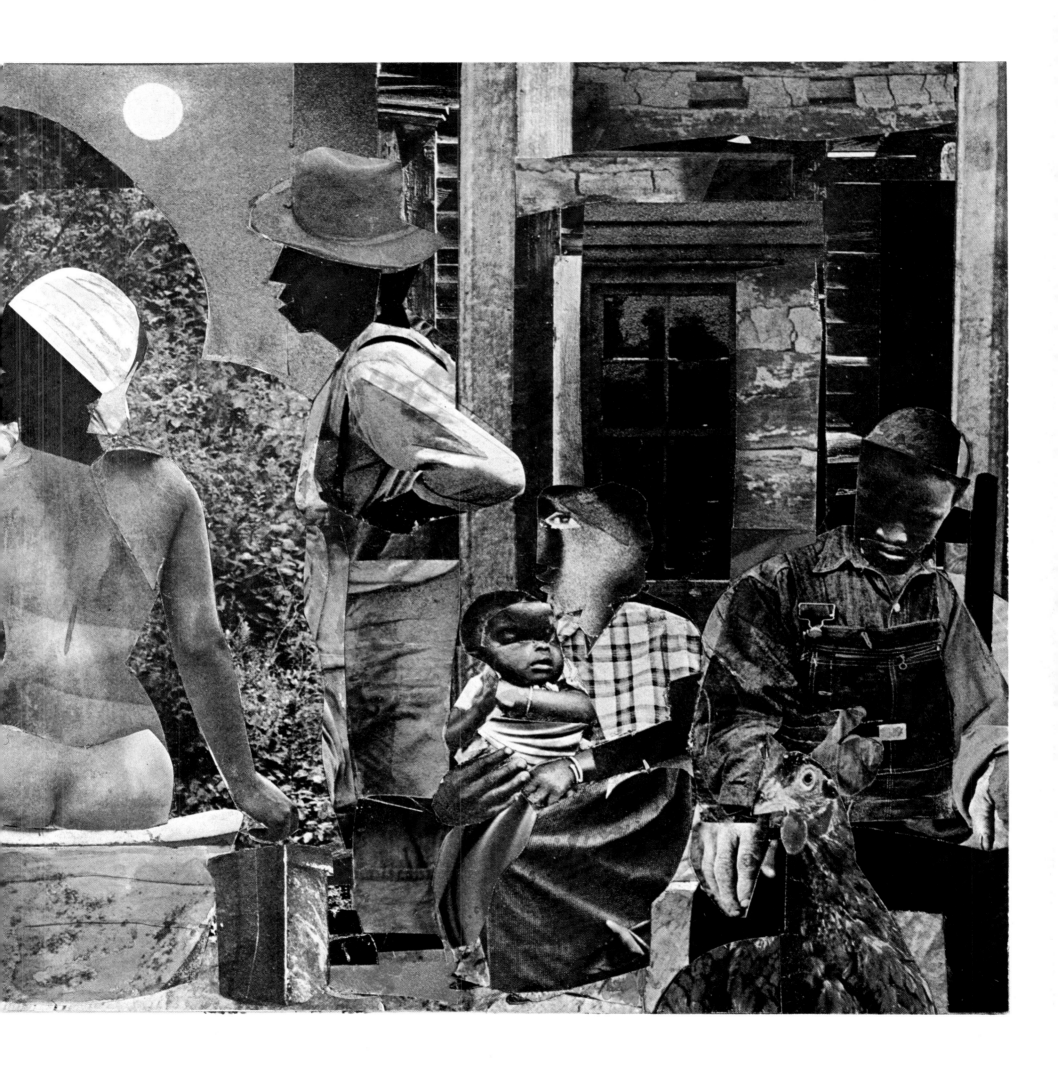

PLATE 31

GIRL BATHING. 1965. COLLAGE, 13 1/2 × 10". COURTESY J. L. HUDSON GALLERY, DETROIT

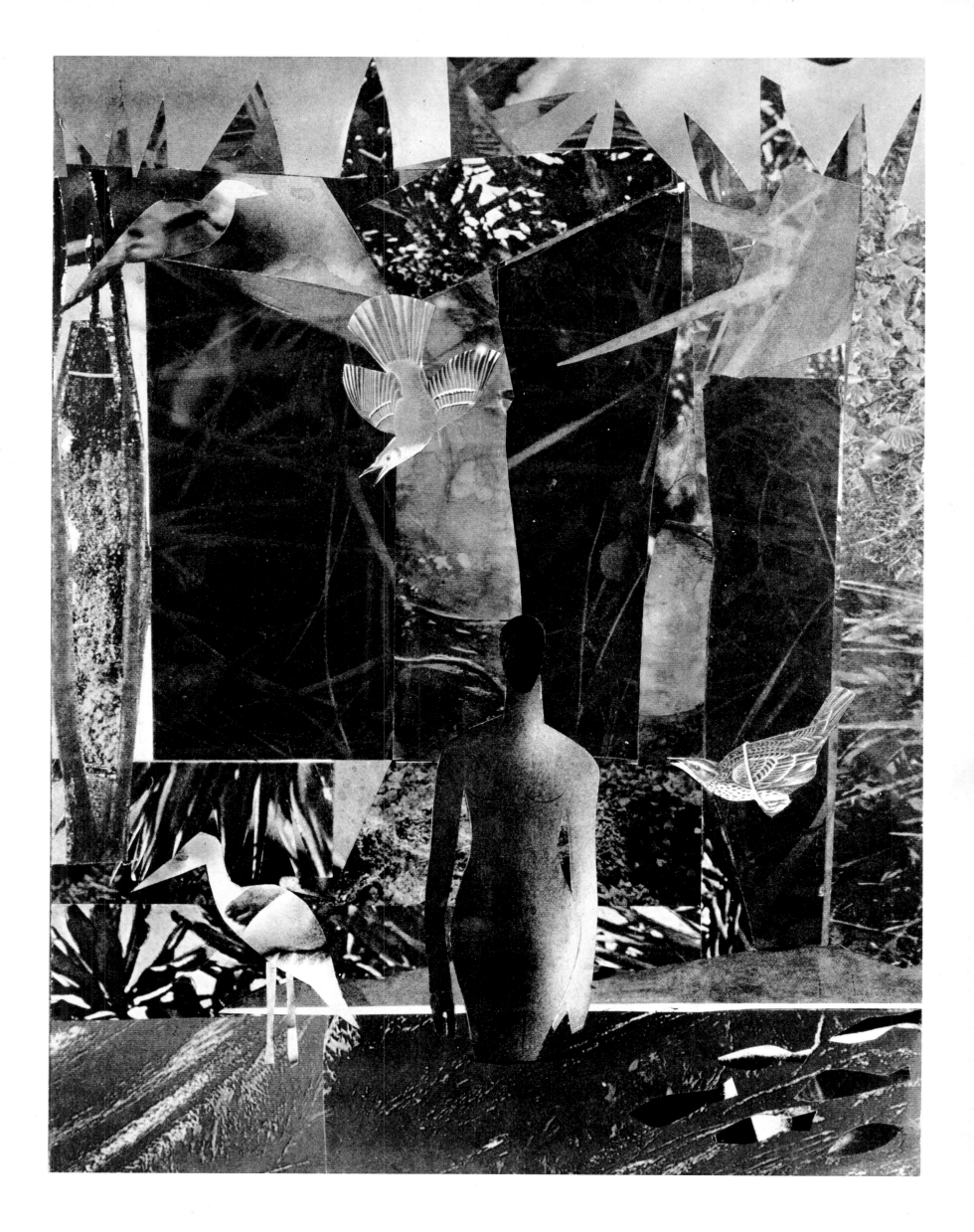

PLATE 32

DESTRUCTION OF SODOM AND GOMORRAH. 1965. COLLAGE, 12 3/4 × 8 3/4″. COURTESY CORDIER & EKSTROM GALLERY, NEW YORK CITY

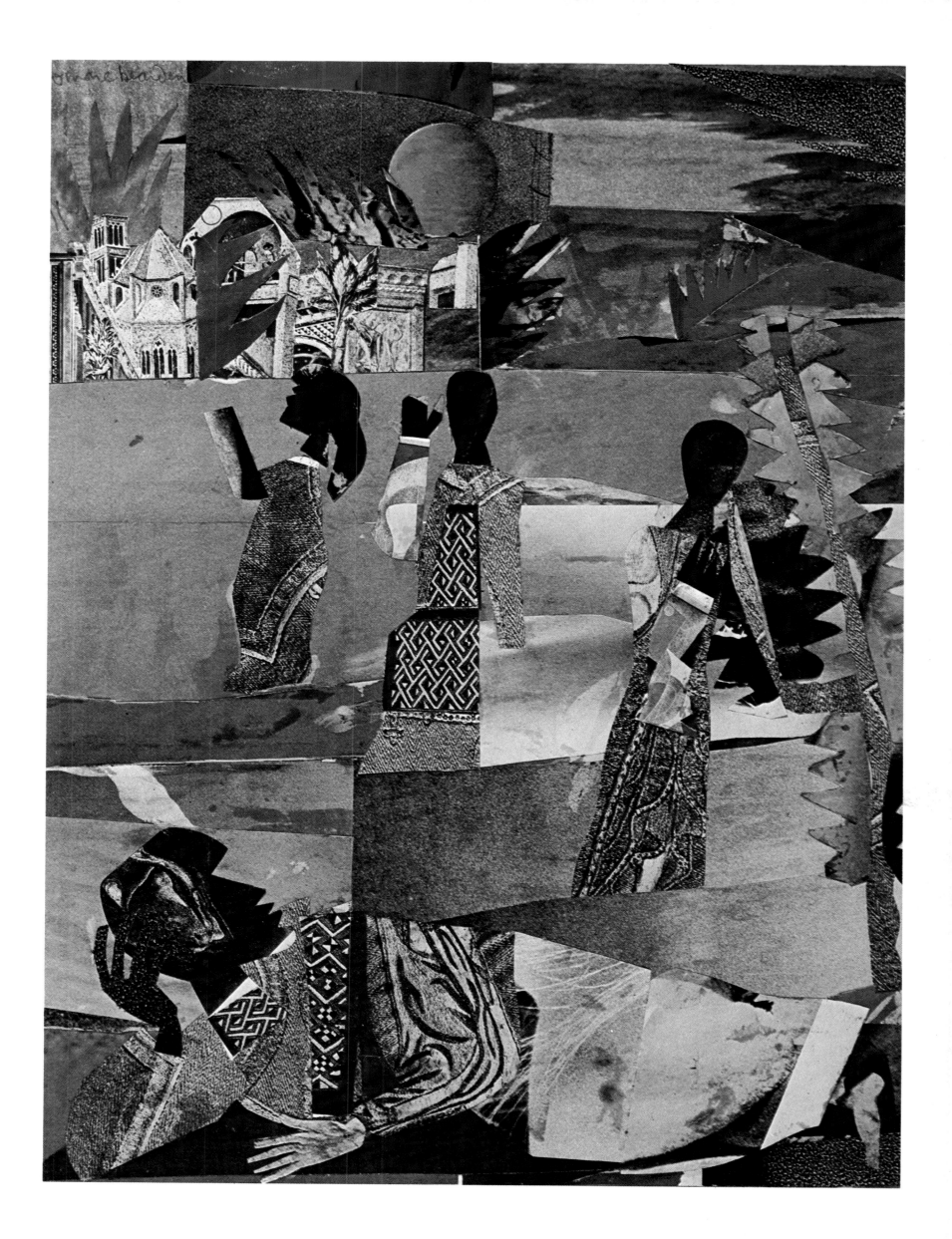

PLATE 33

PITTSBURGH. 1967. COLLAGE, 7 3/4 × 10 1/2″. COURTESY CORDIER & EKSTROM GALLERY, NEW YORK CITY

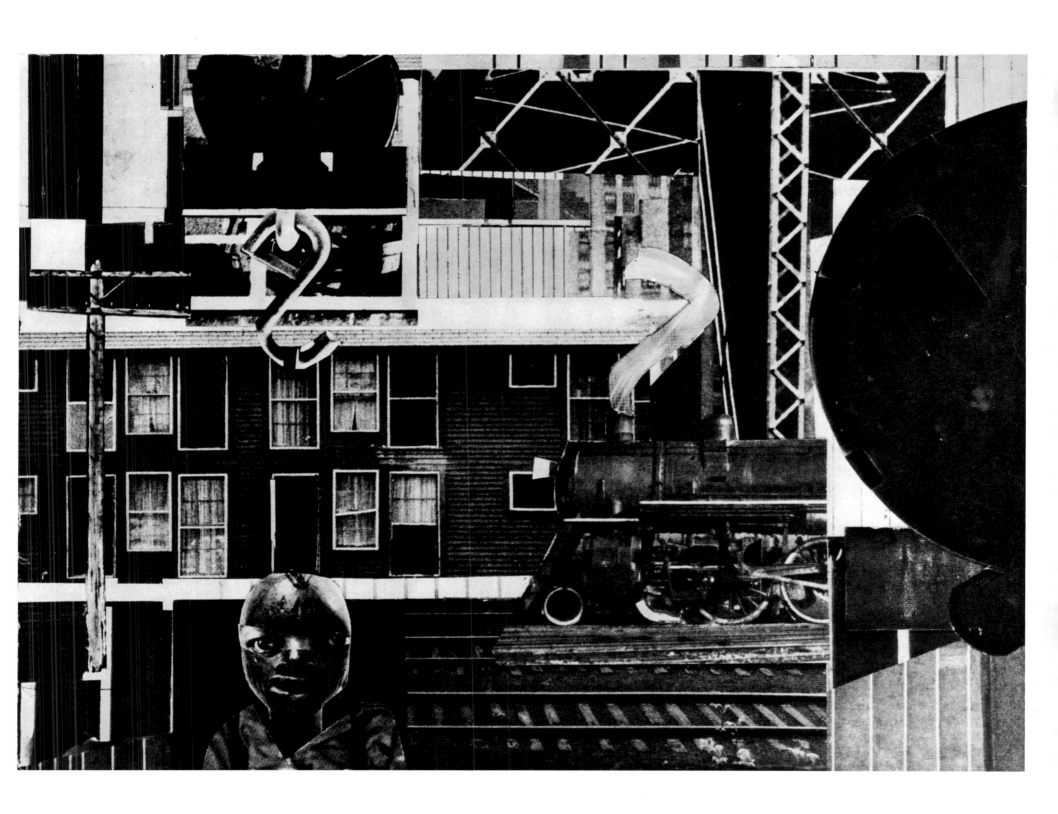

PLATE 34

BAPTISM. 1964. COLLAGE, 10 × 6 1/2″. COURTESY CORDIER & EKSTROM GALLERY, NEW YORK CITY

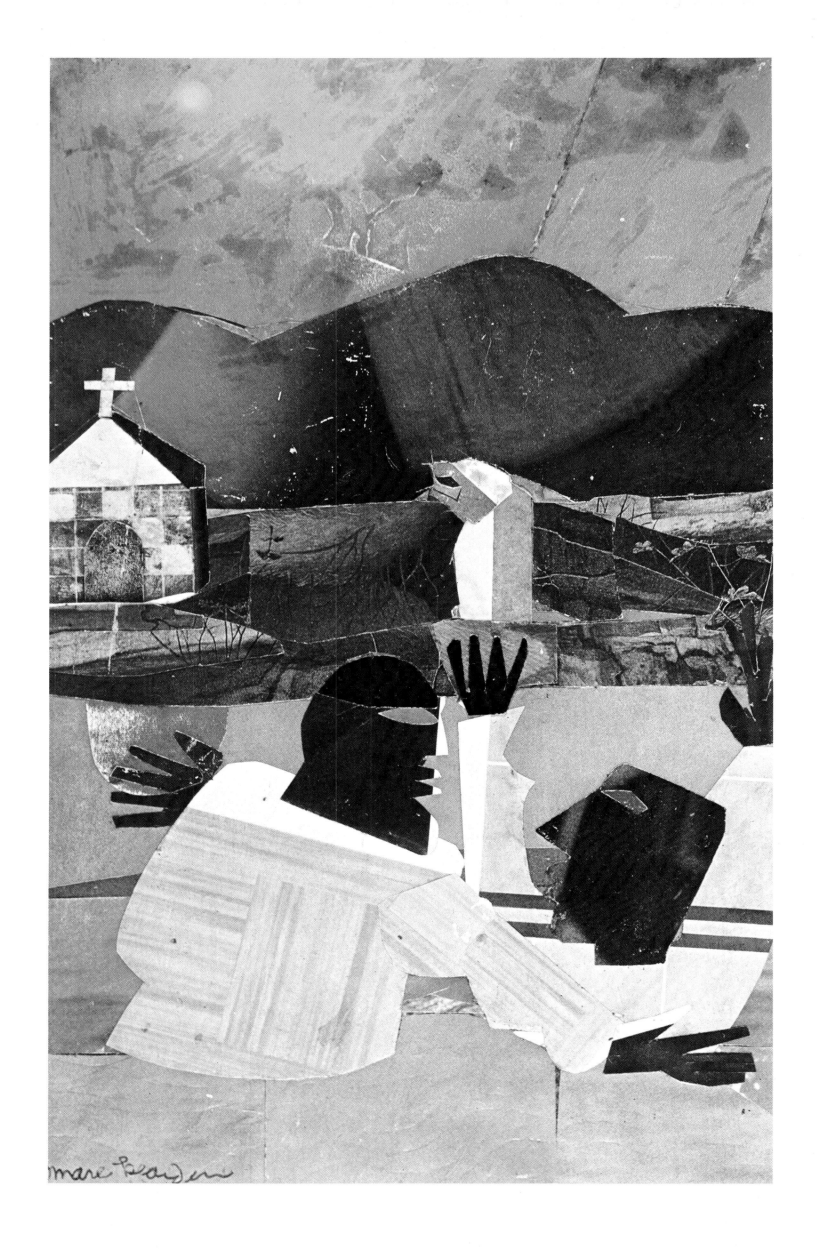

mare Bearden

PLATE 35

MELON EATER. 1966. COLLAGE, 12 × 3 1/2". COURTESY J. L. HUDSON GALLERY, DETROIT

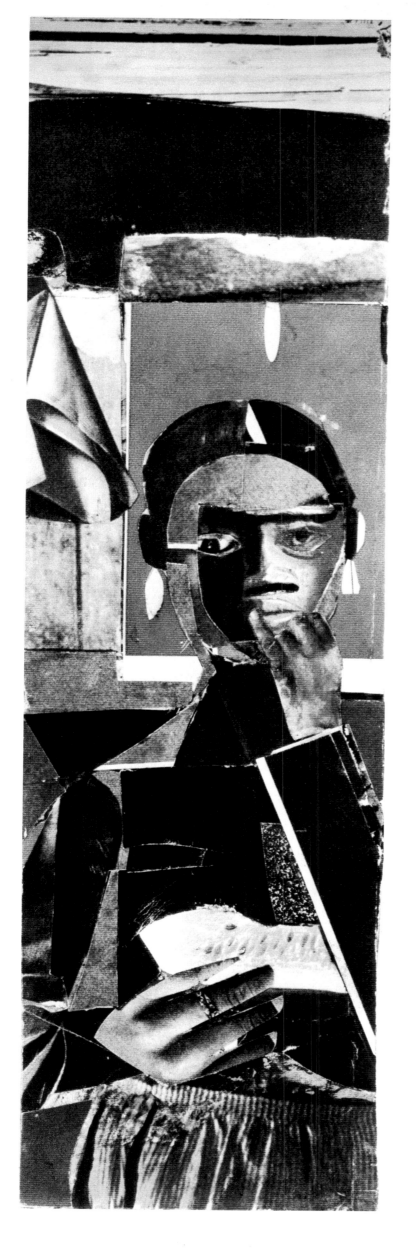

PLATE 36

THE BLUE BIRD. 1966. COLLAGE, 9 1/2 × 6 3/4″. COURTESY J. L. HUDSON GALLERY, DETROIT

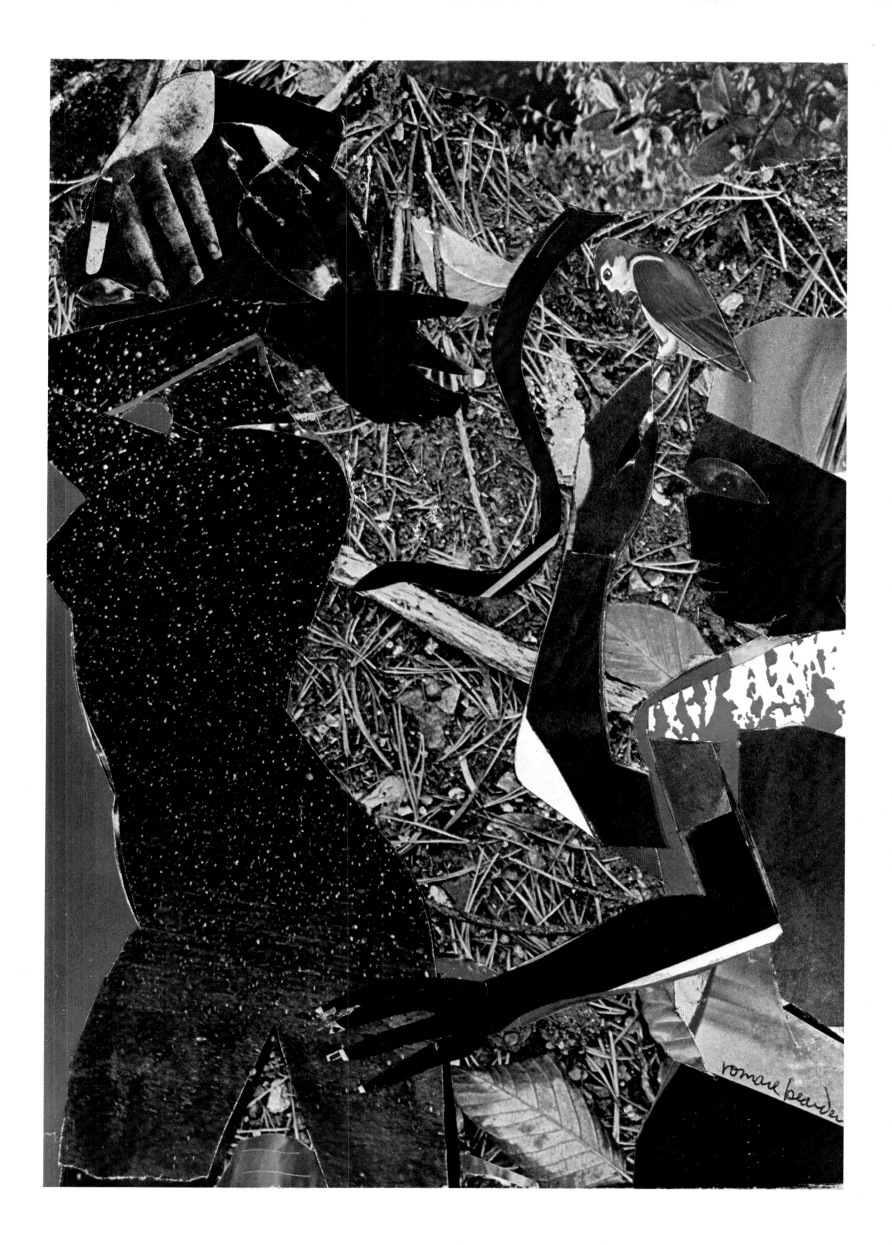

PLATE 37

FARMHOUSE INTERIOR. 1966. COLLAGE, 9 5/8 × 12 1/2″. COLLECTION SHELDON ROSS, DETROIT

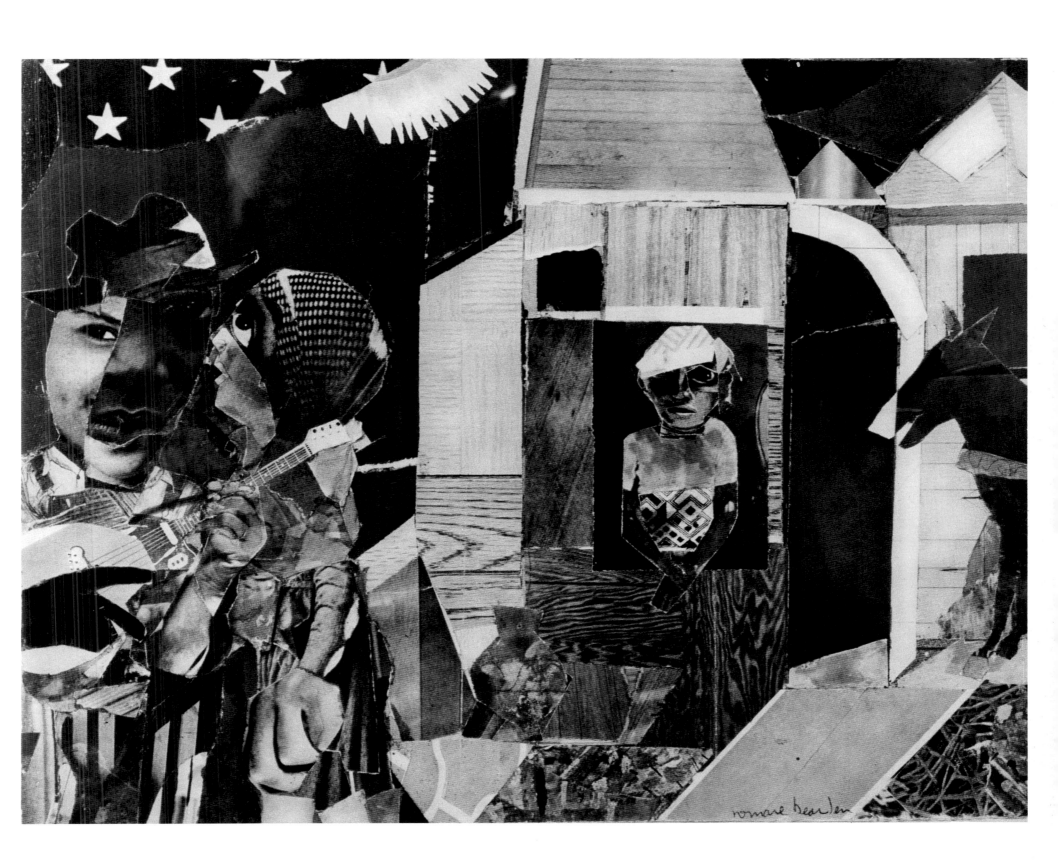

PLATE 38

WORK TRAIN. 1966. COLLAGE, 9 3/4 × 12 1/2″.
COLLECTION SHELDON ROSS, DETROIT

108

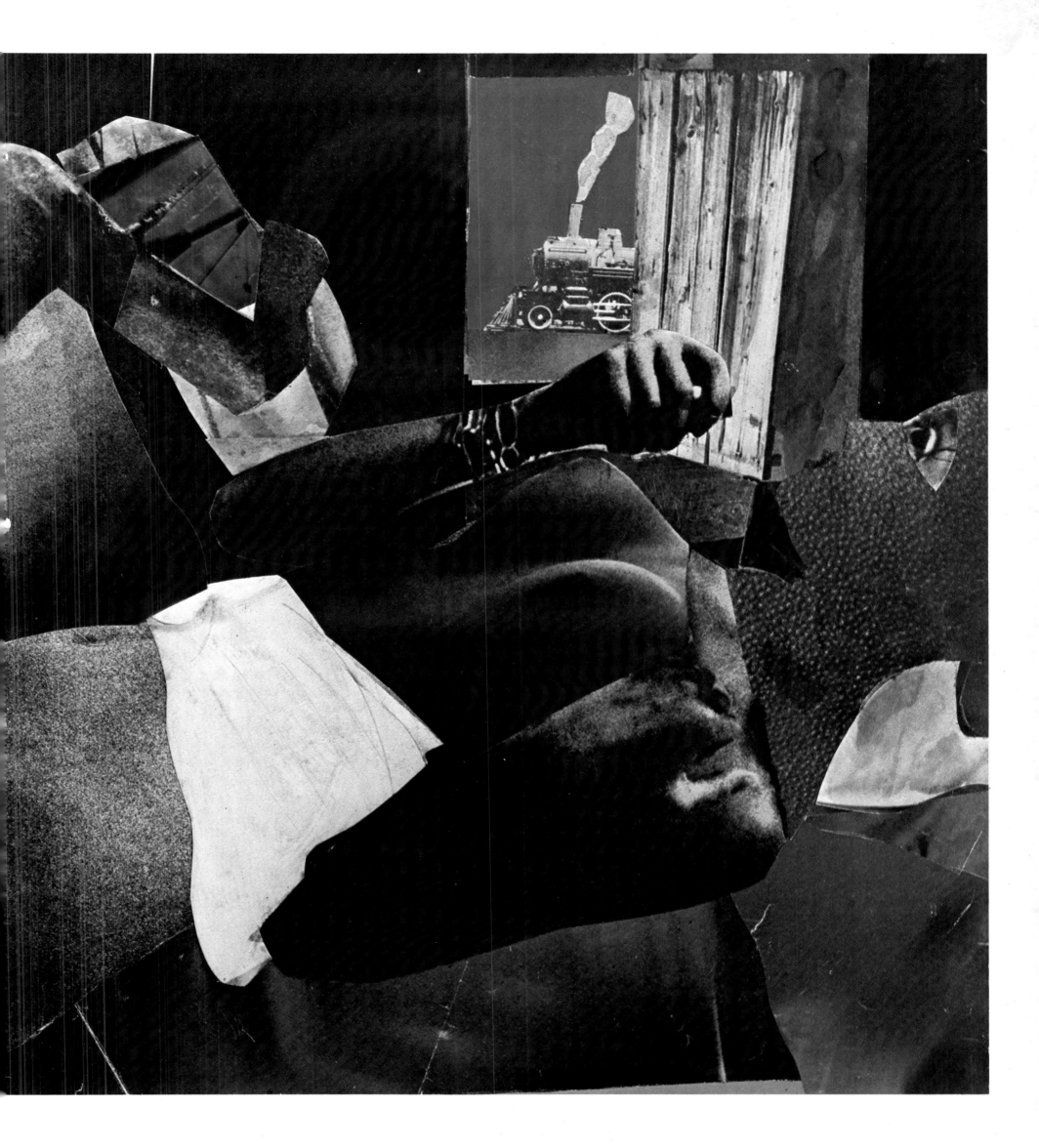

PLATE 39

SUMMERTIME. 1967. COLLAGE, 56 × 44″. COLLECTION JESSE P. SHANOK, NEW YORK CITY

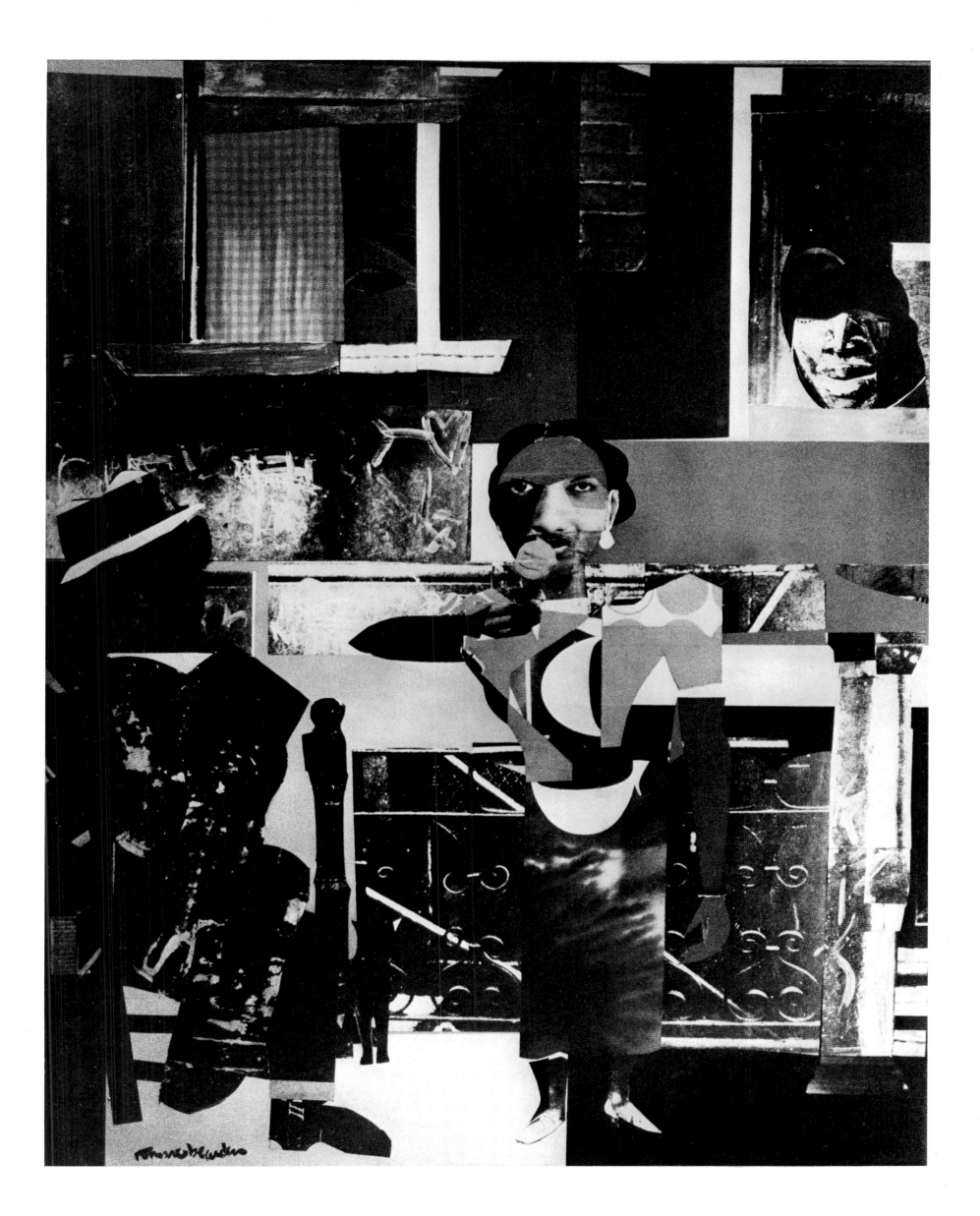

PLATE 40

FISH FRY. 1967. COLLAGE, 30 × 40″. COLLECTION MR. AND MRS. JOSHUA LEE, NEW YORK CITY

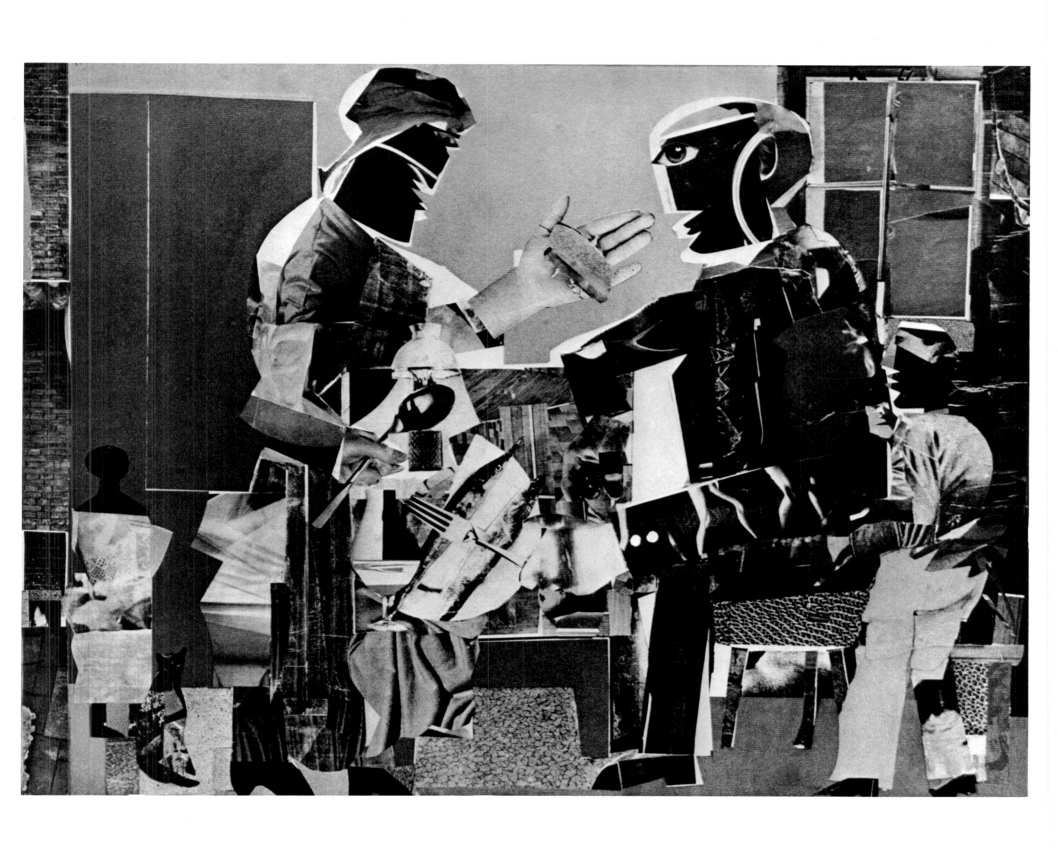

PLATE 41

BACKYARD. 1967. COLLAGE, 40 × 30″. COLLECTION SENATOR AND MRS. JACOB K. JAVITS, NEW YORK CITY

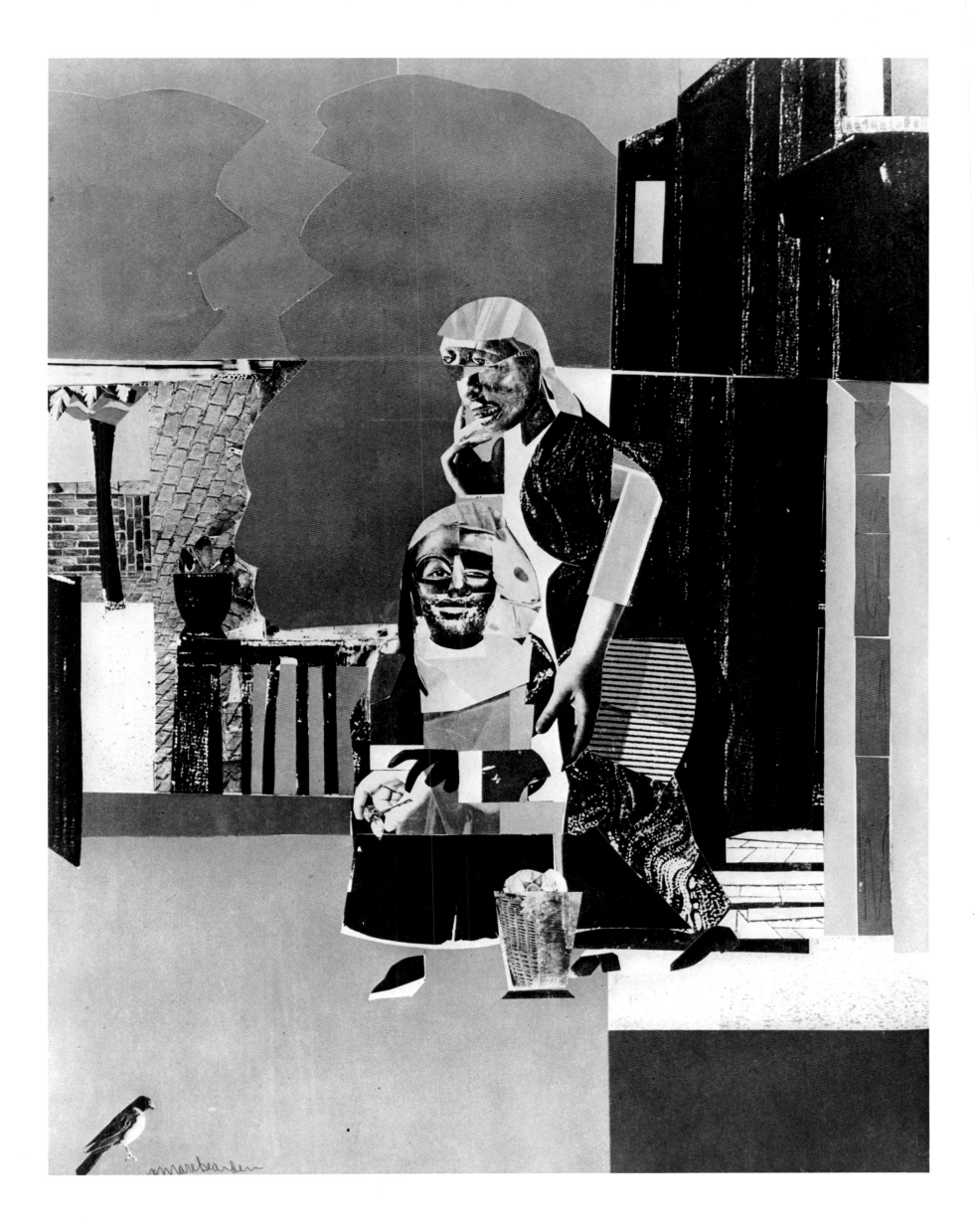

PLATE 42

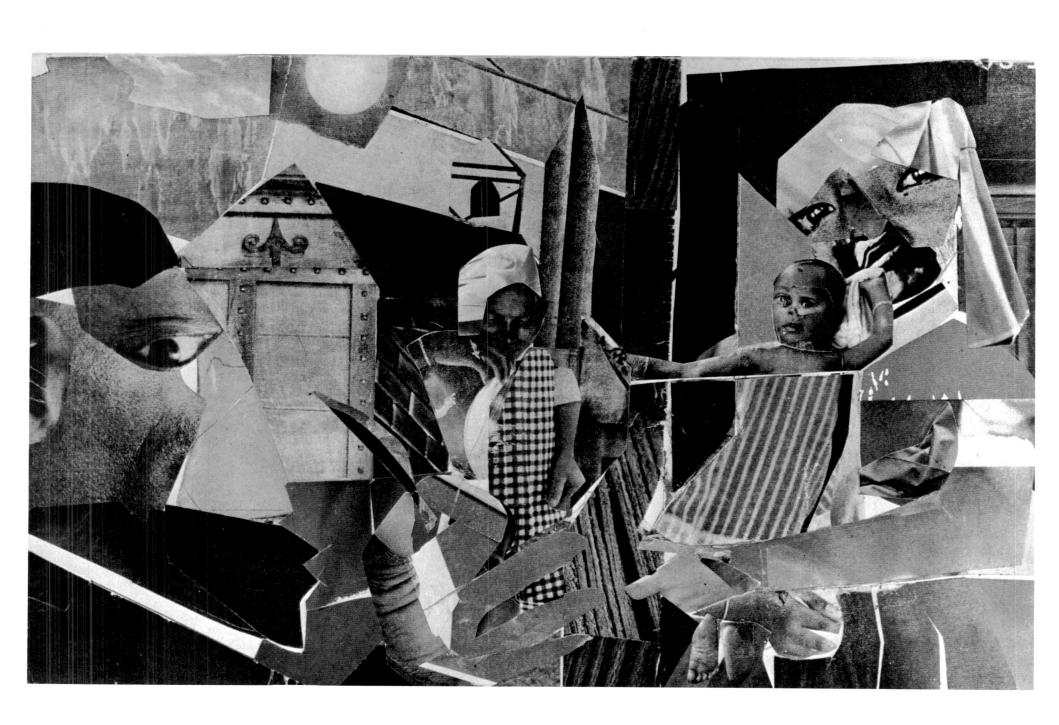

PLATE 43

THE RETURN OF THE PRODIGAL SON. 1967. COLLAGE, $44 \times 56''$. COLLECTION ADRIAN ART, NEW YORK CITY

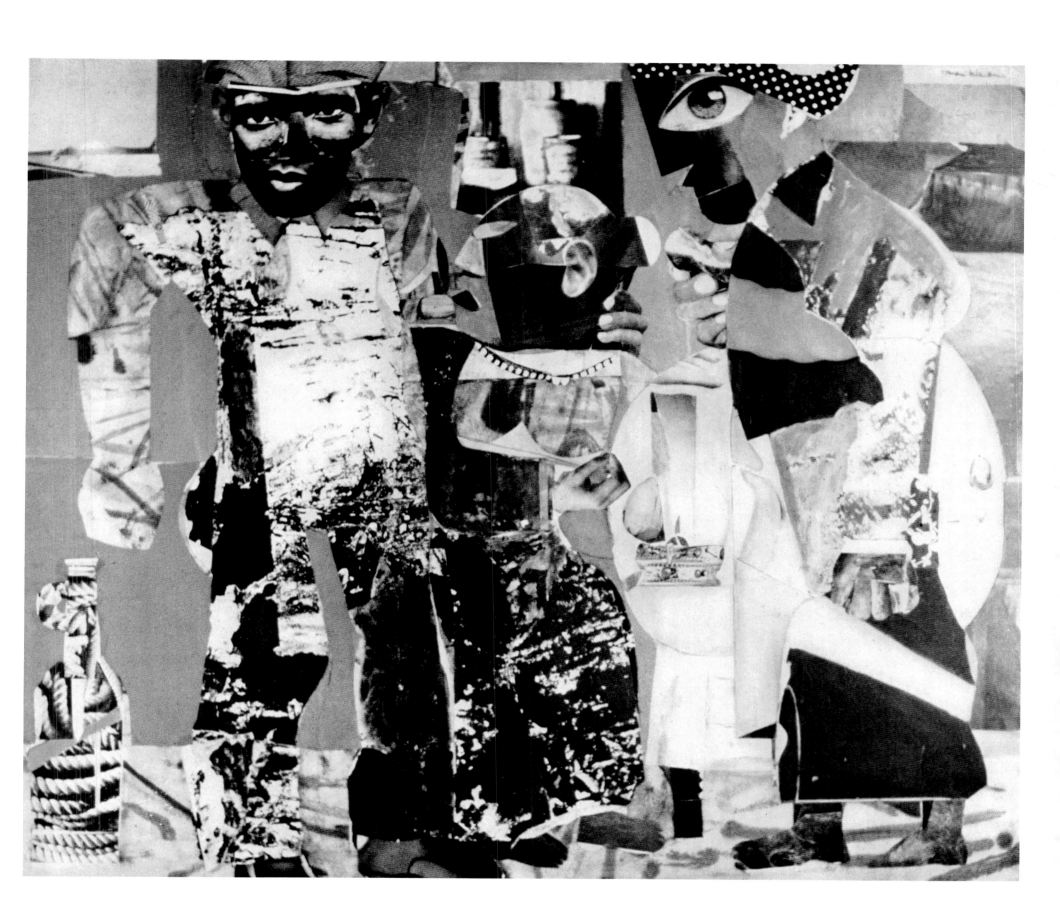

PLATE 44

ROCKET TO THE MOON. 1967. COLLAGE, 12 1/2 × 9″. COLLECTION NANETTE ROHAN BEARDEN, NEW YORK CITY

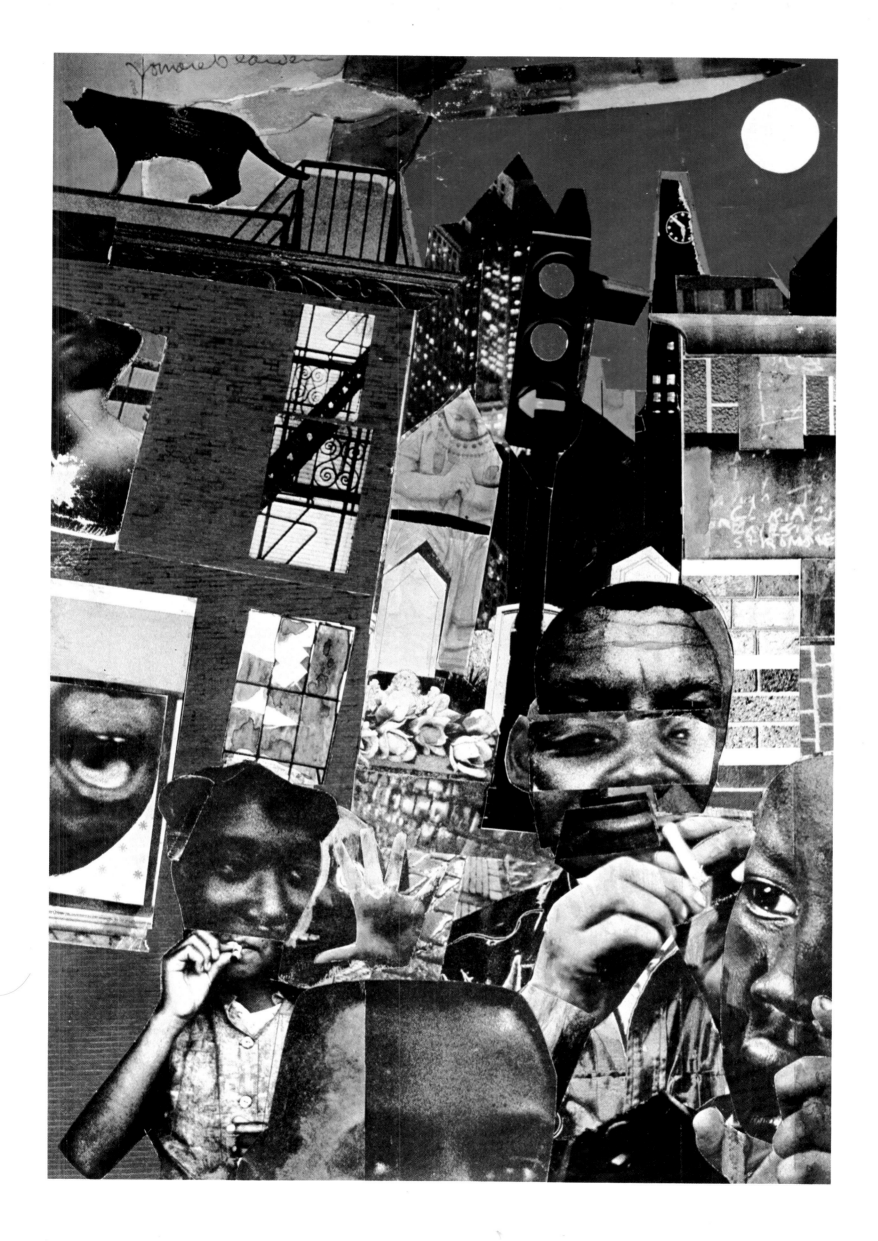

PLATE 45

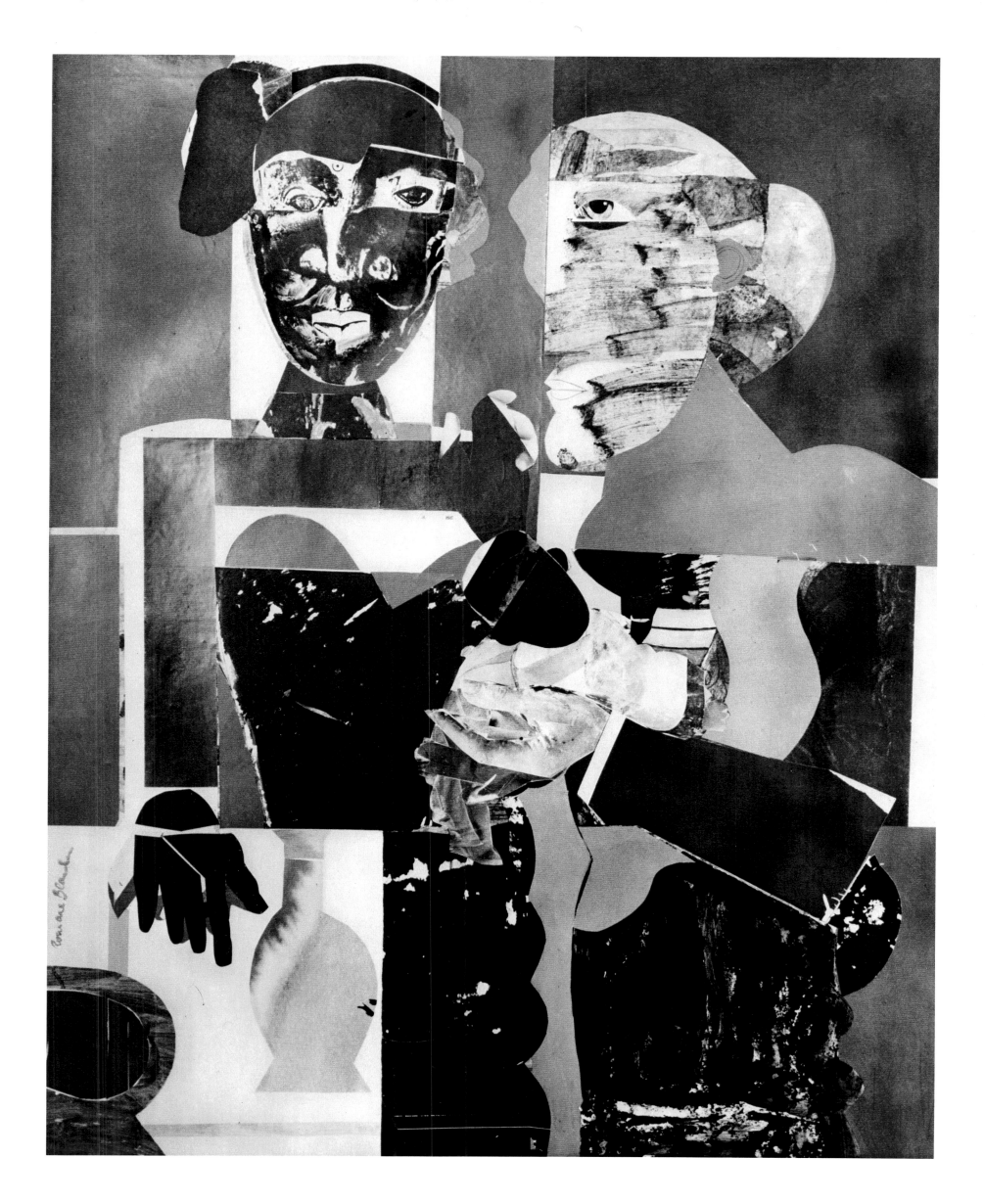

PLATE 46

THREE FOLK MUSICIANS. 1967. COLLAGE AND MIXED MEDIUMS, 50 1/8 × 60". COURTESY J. L. HUDSON GALLERY, DETROIT

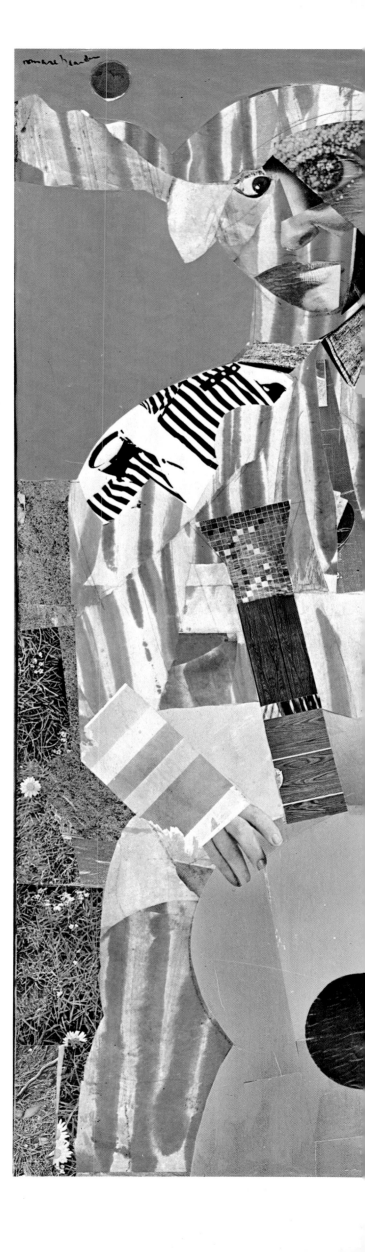

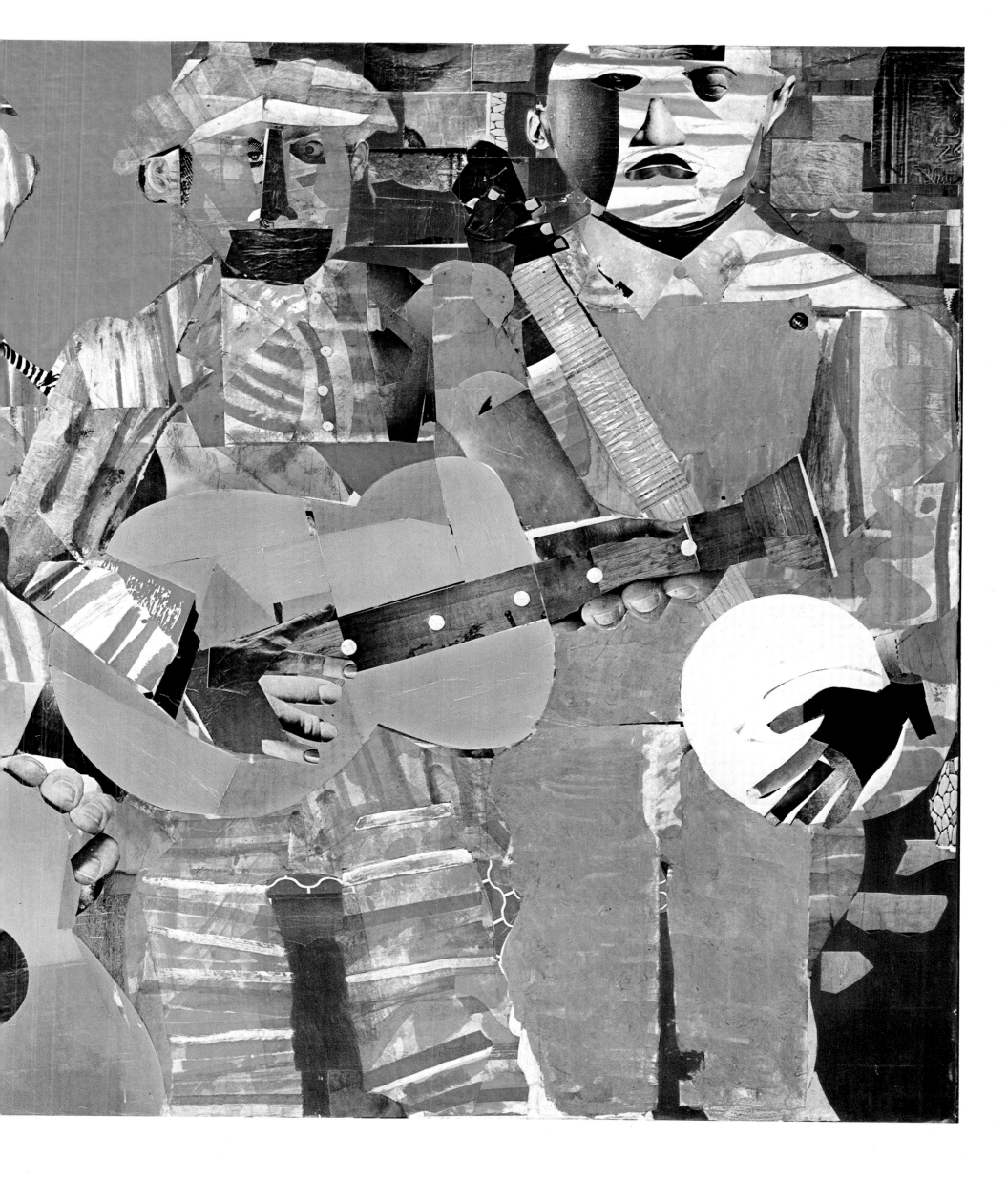

PLATE 47

THE RITES OF SPRING. 1967. COLLAGE AND MIXED MEDIUMS, 55 3/4 × 44″. COLLECTION MR. AND MRS. CARTER BURDEN, NEW YORK CITY

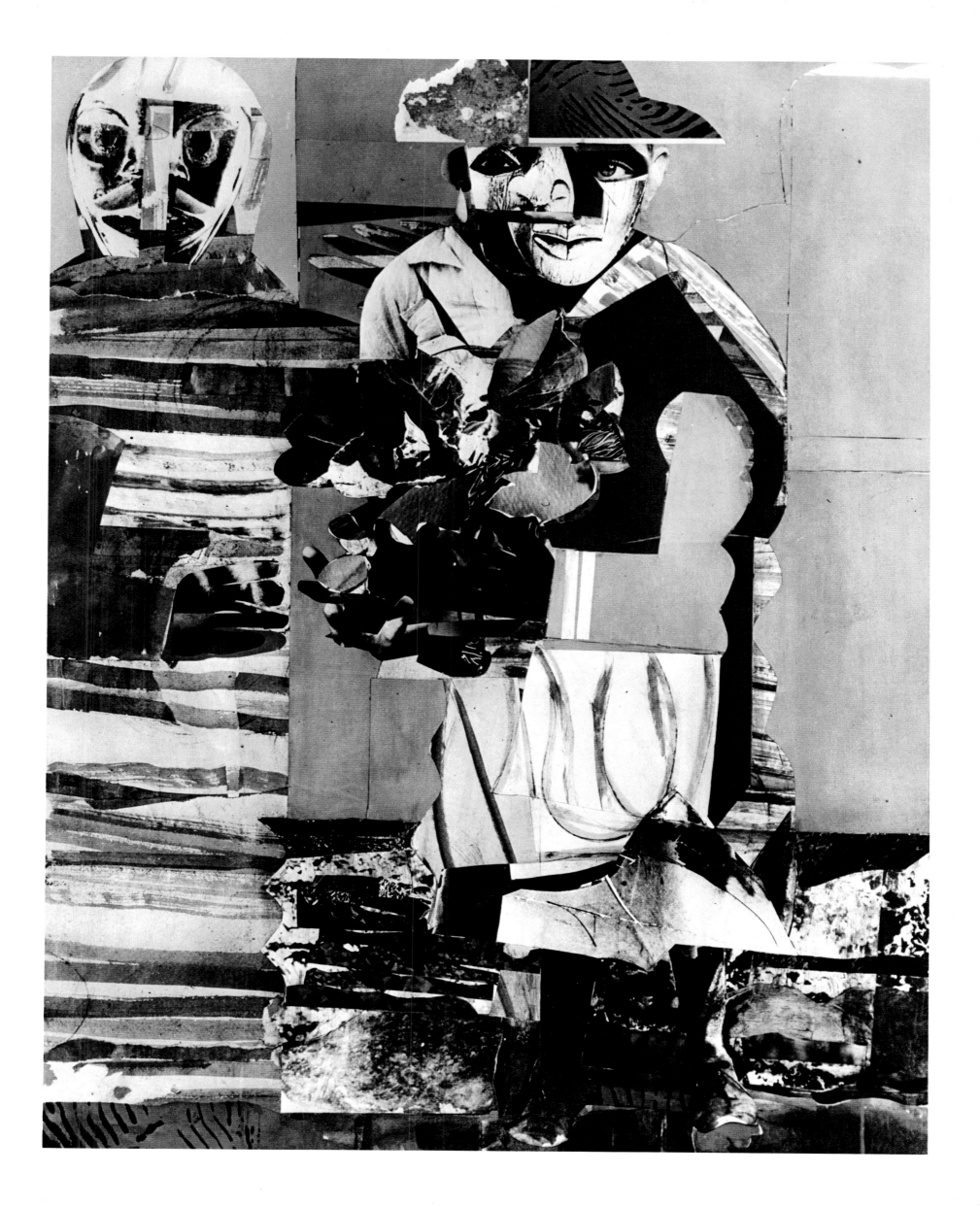

PLATE 48

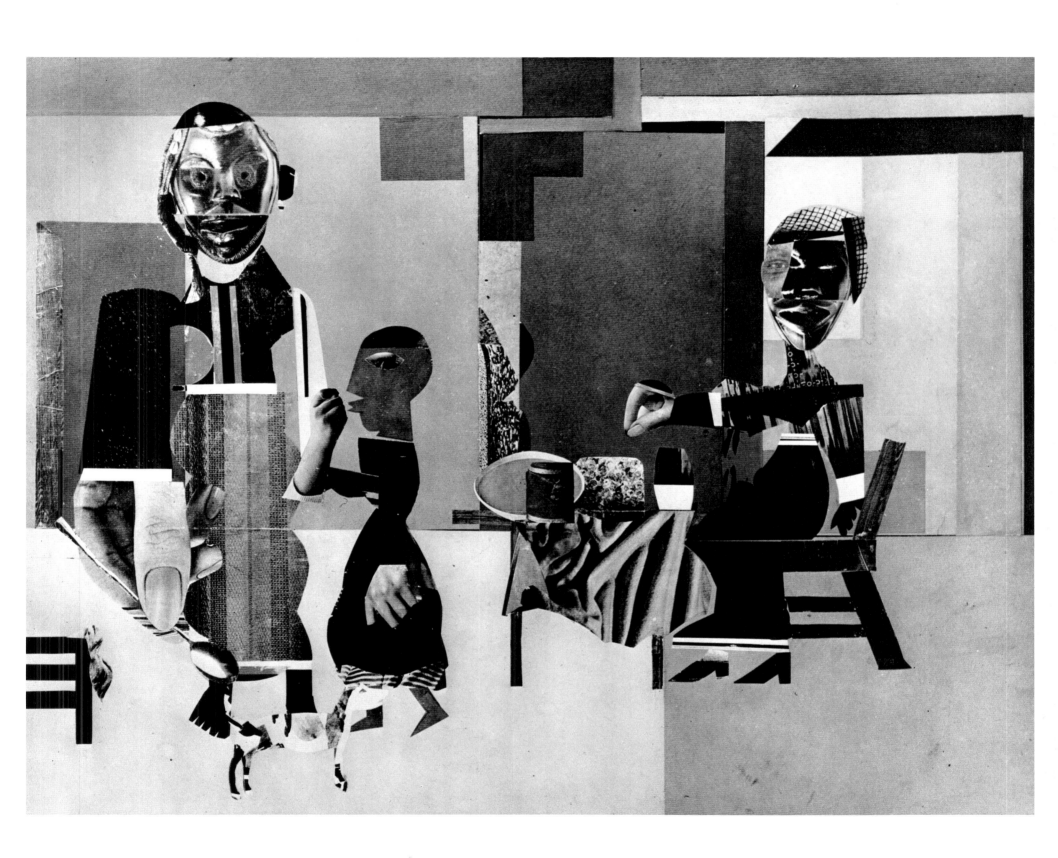

PLATE 49

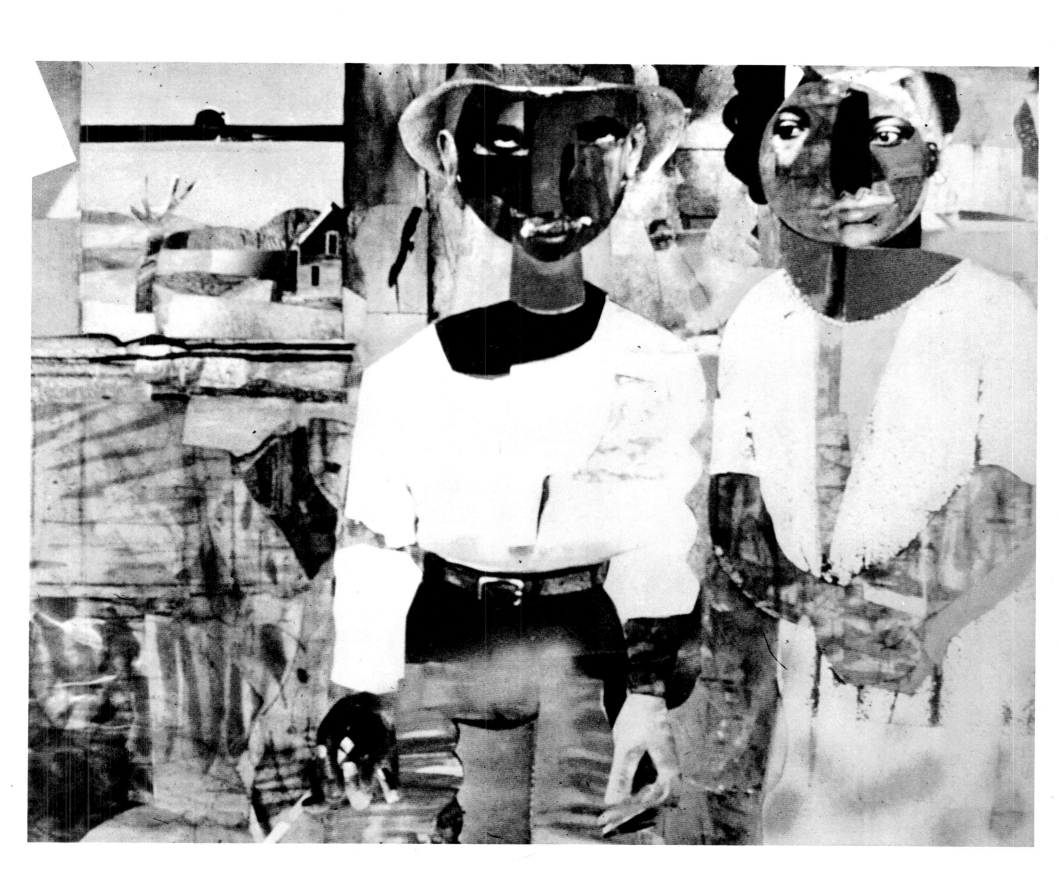

PLATE 50

PALM SUNDAY PROCESSIONAL. 1967–68. COLLAGE, 56 1/8 × 44 1/8″. COURTESY CORDIER & EKSTROM GALLERY, NEW YORK CITY

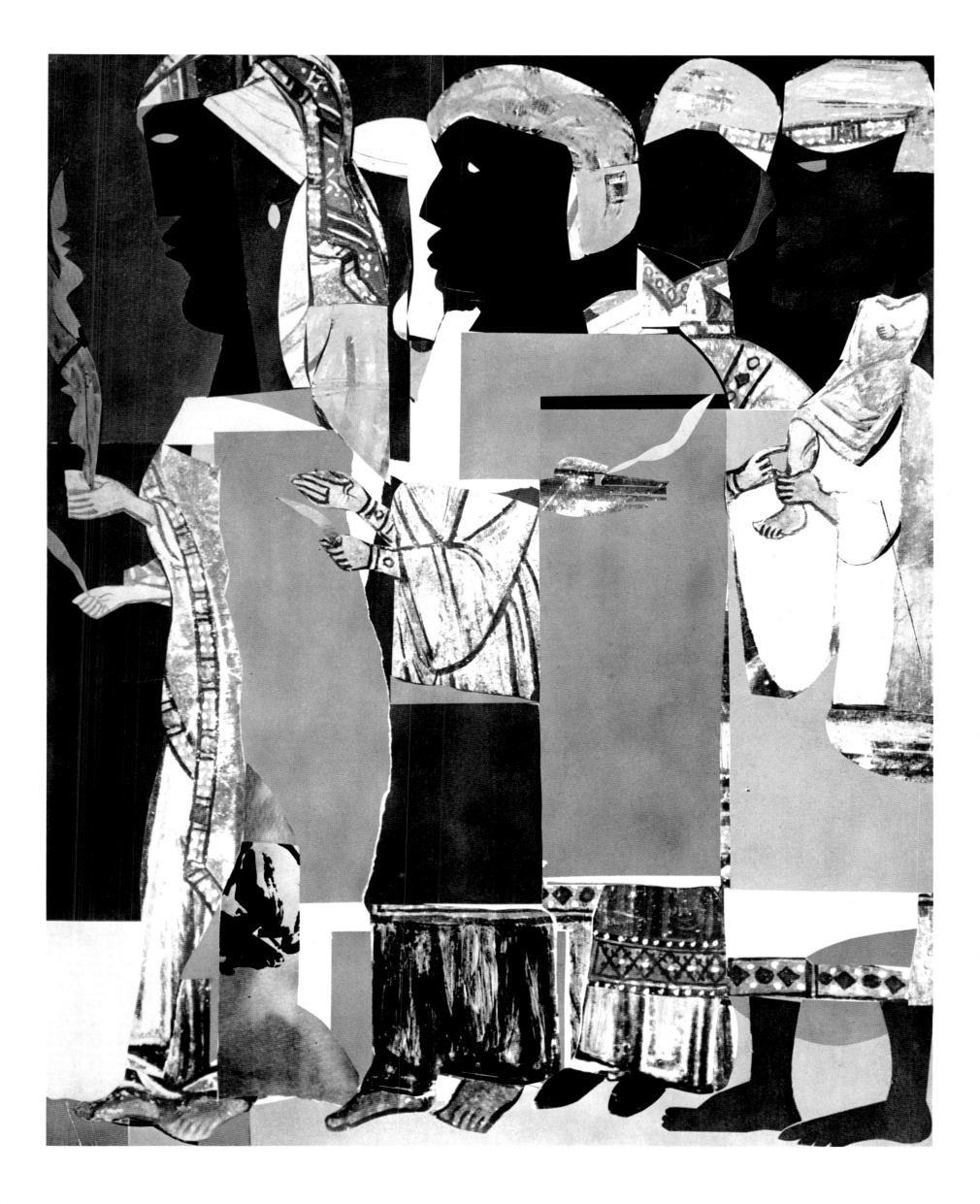

PLATE 51

CIRCE PREPARING A BANQUET FOR ULYSSES. 1968. COLLAGE, $44 \times 56''$. COLLECTION REV. AND MRS. NATHAN SCOTT, JR., CHICAGO

134

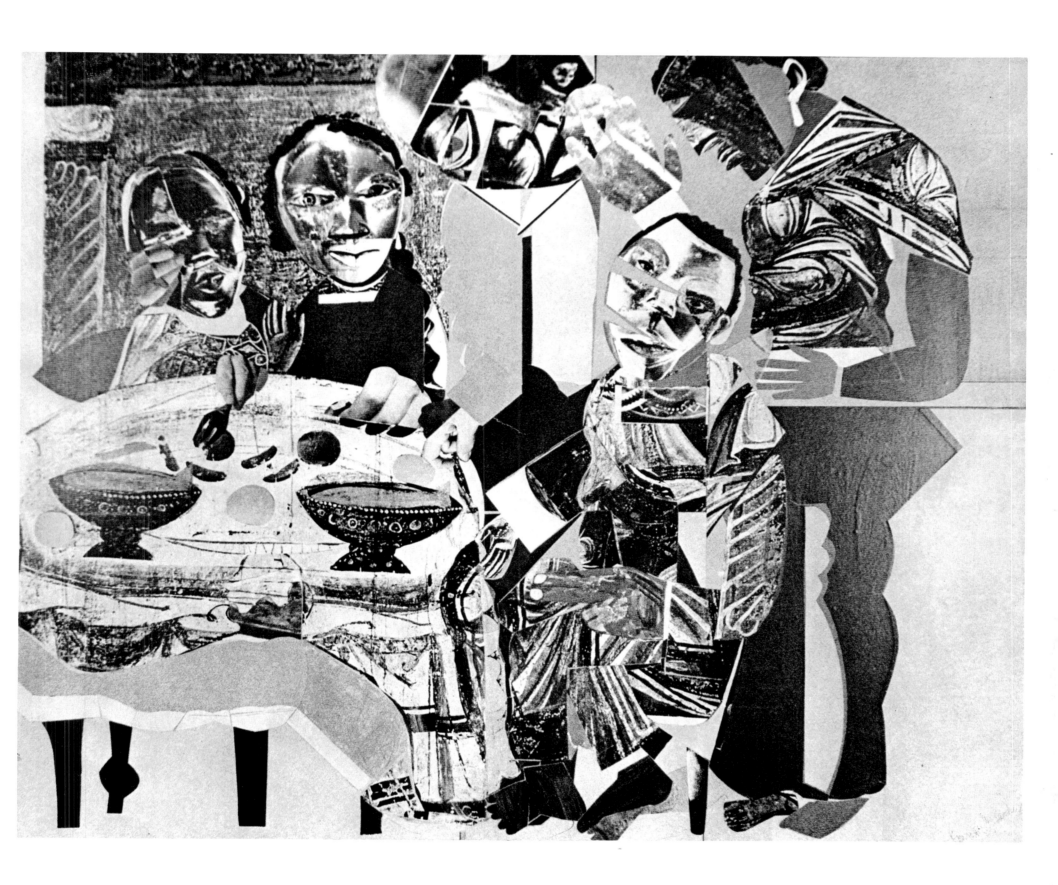

PLATE 52

STRANGE MORNING. 1968. COLLAGE, 44×56". COLLECTION MR. AND MRS. RALPH ELLISON, NEW YORK CITY

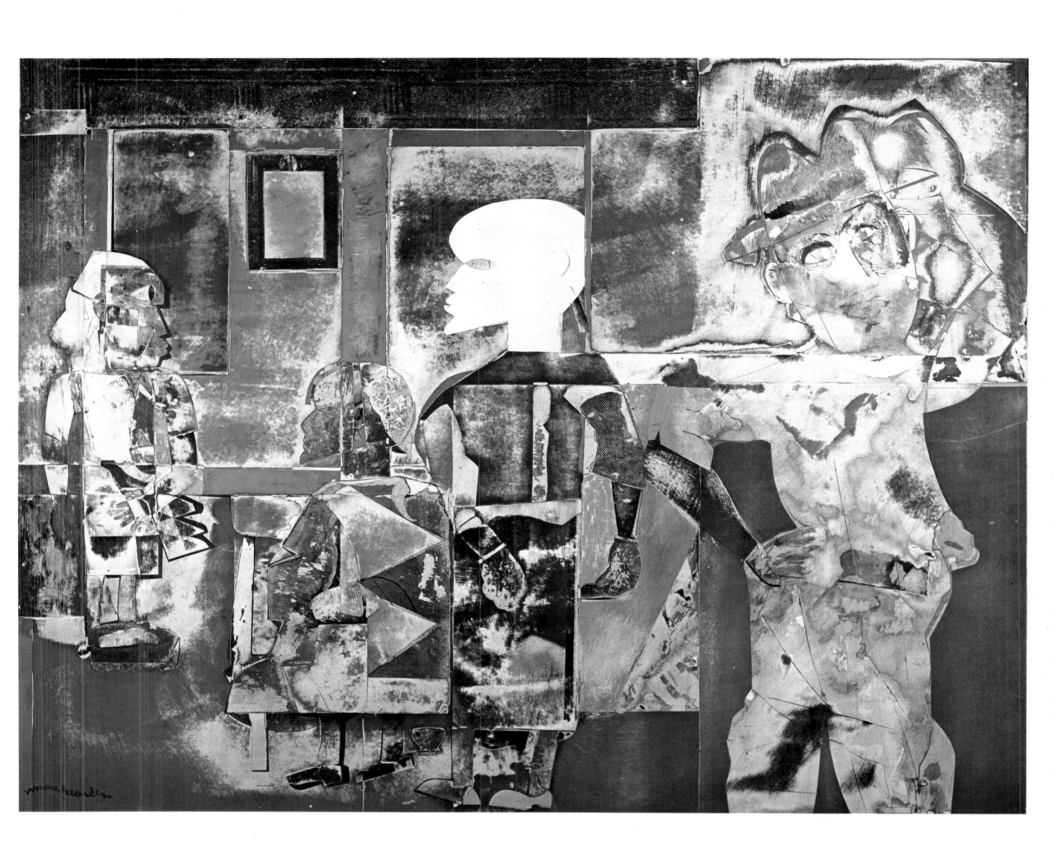

PLATE 53

SERENADE. 1968. COLLAGE, $46 \times 32 \ 1/4''$. COLLECTION JACQUES KAPLAN, NEW YORK CITY

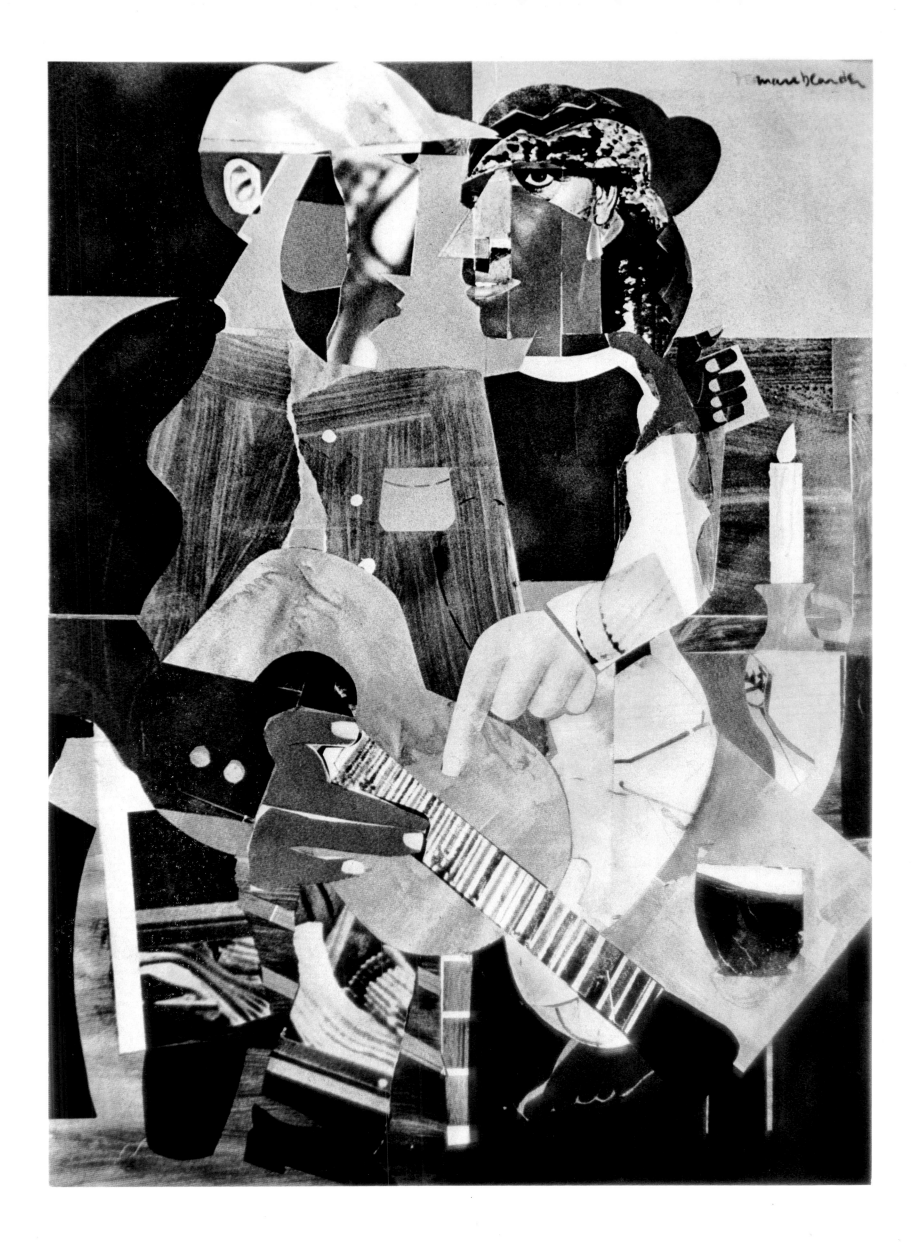

PLATE 54

INTERIOR. 1968. COLLAGE, 18 1/2 × 27 1/2".

COLLECTION MR. AND MRS. RALPH ELLISON, NEW YORK CITY

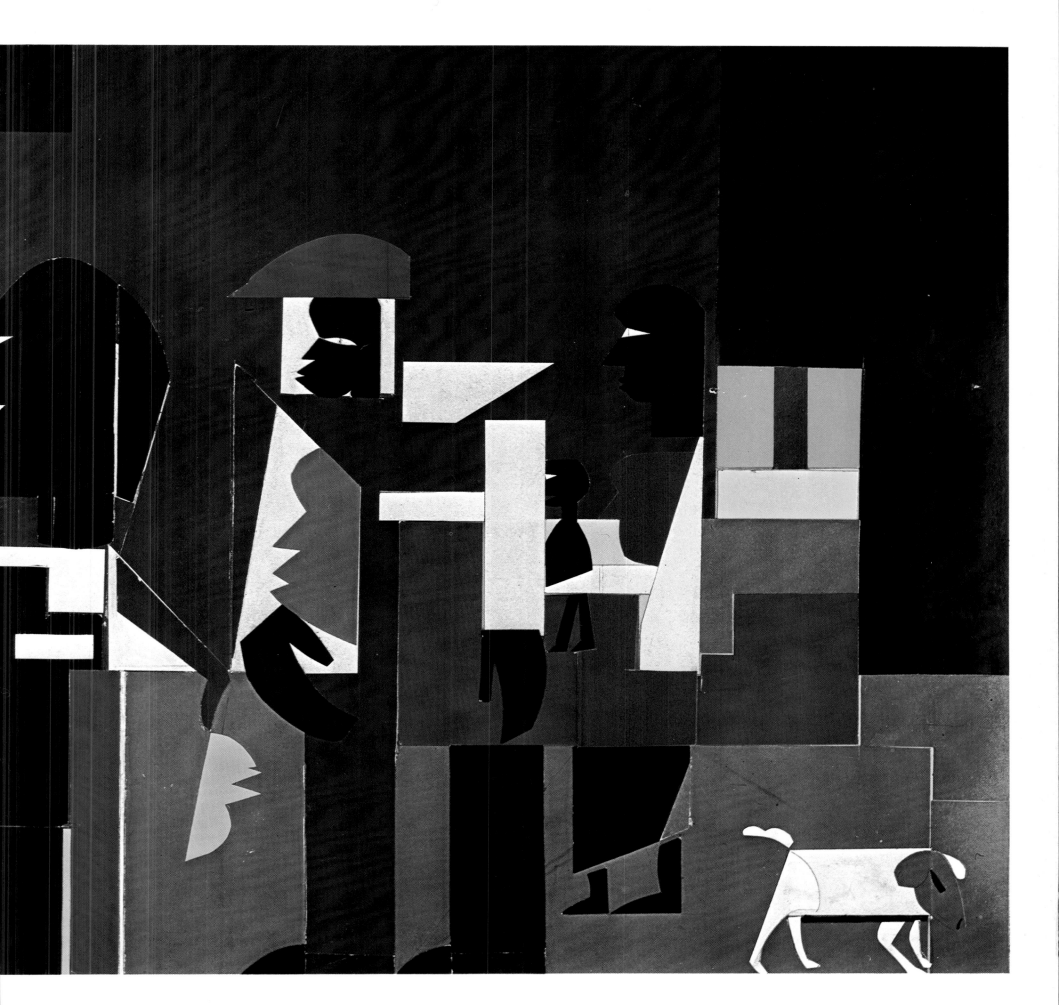

PLATE 55

MOTHER AND CHILD. 1968. COLLAGE, $40 \times 30''$. COLLECTION NANETTE ROHAN BEARDEN, NEW YORK CITY

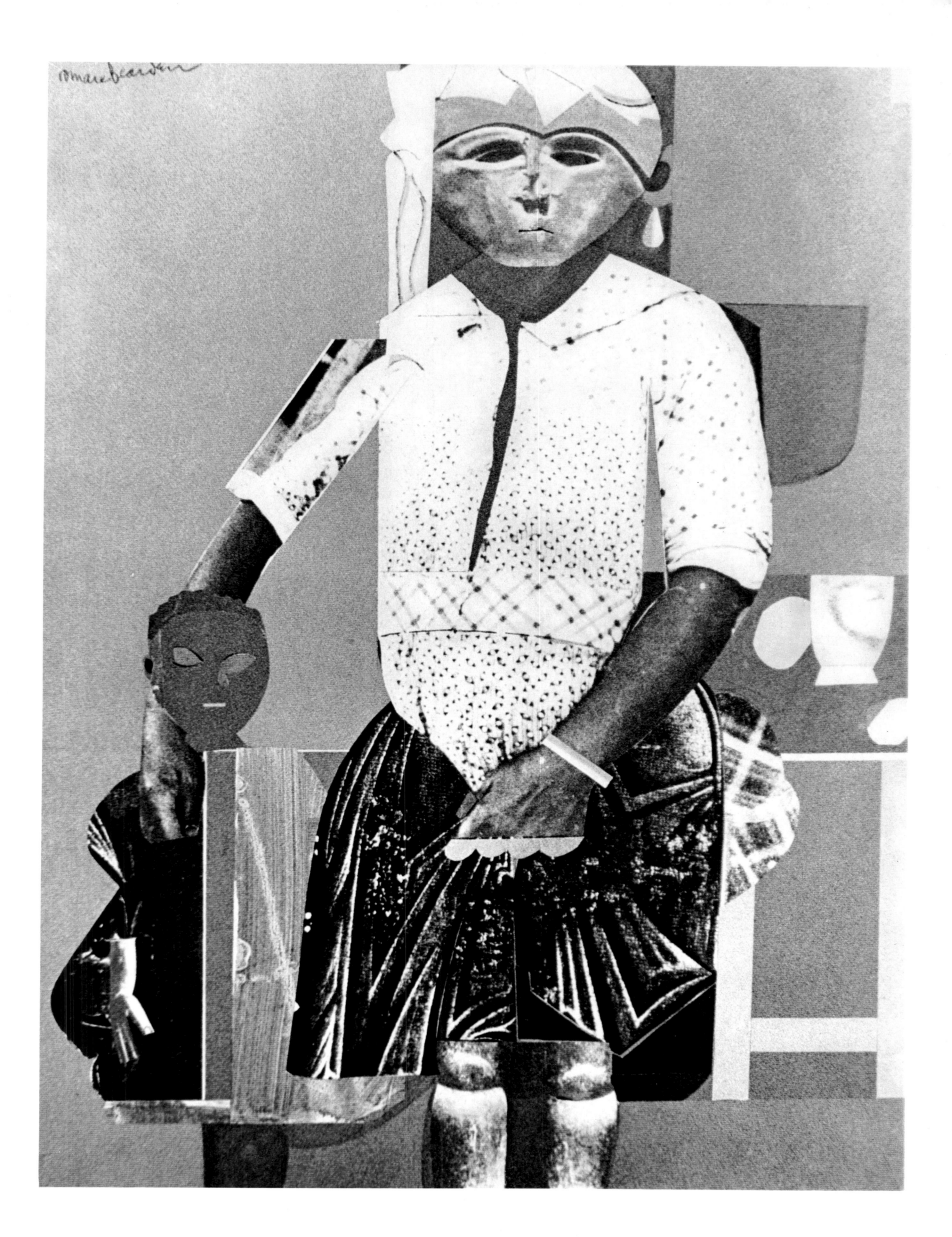

PLATE 56

FARMER. 1968. COLLAGE, 40 × 30″. COLLECTION NANETTE ROHAN BEARDEN, NEW YORK CITY

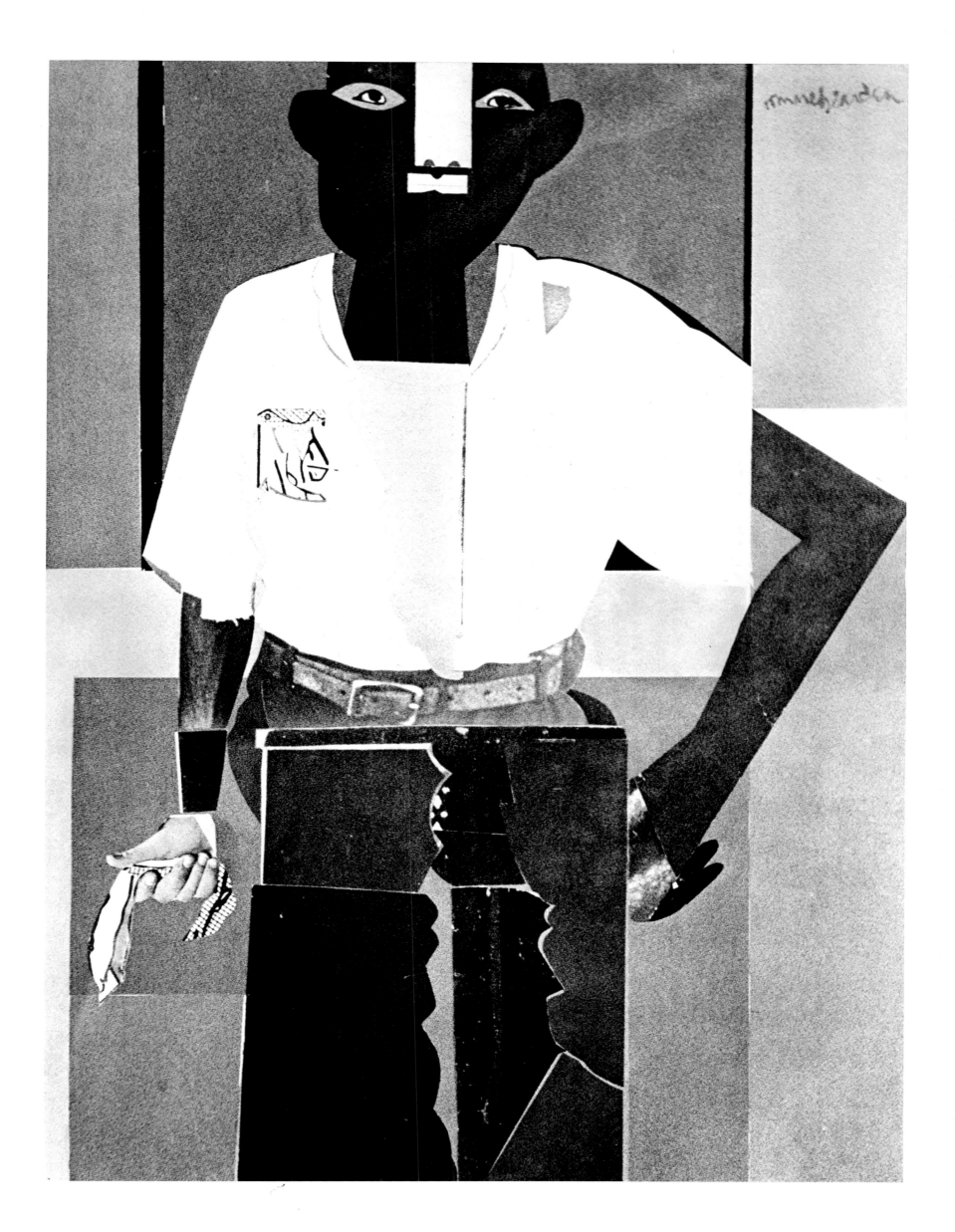

PLATE 57

BLUE INTERIOR, MORNING. 1968. COLLAGE, 44 × 56″. CHASE MANHATTAN BANK, NEW YORK CITY

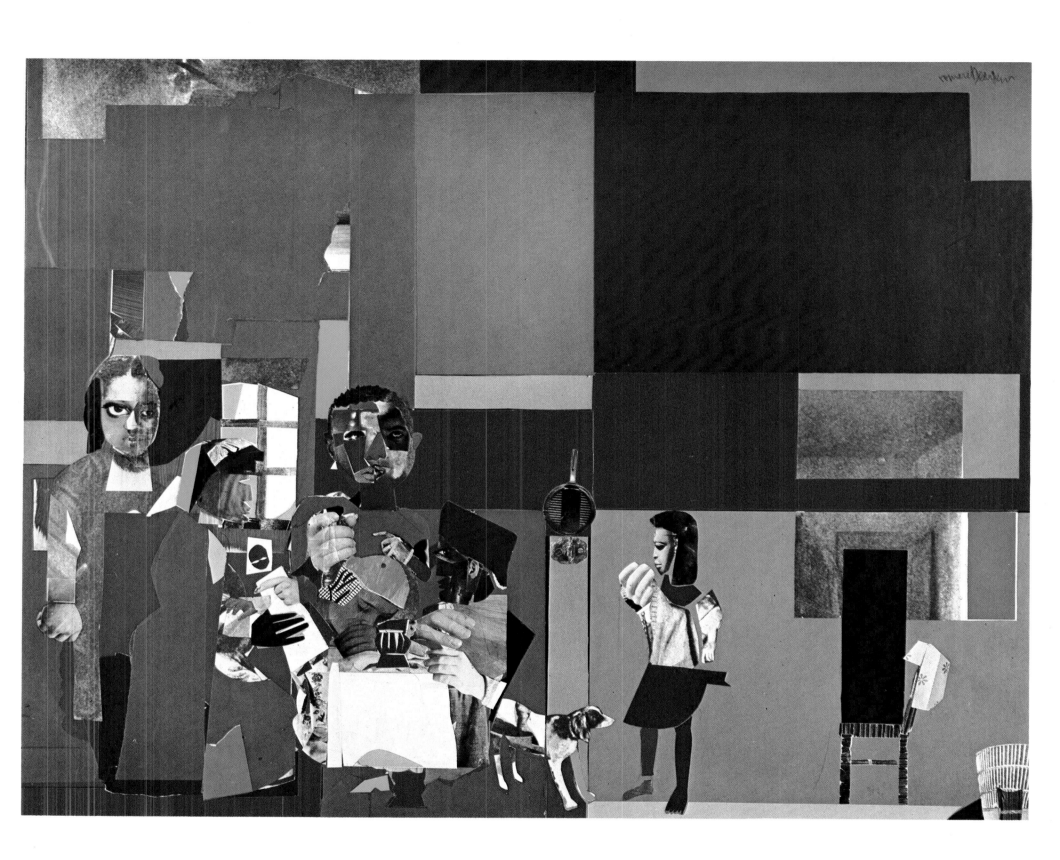

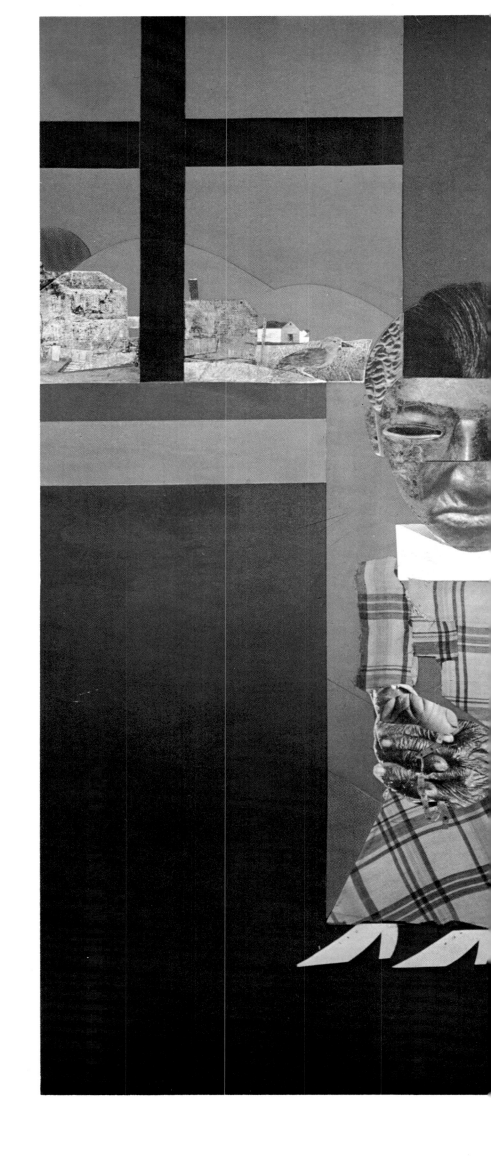

PLATE 58

SATURDAY MORNING. 1969. COLLAGE, $44 \times 56''$.
COURTESY CORDIER & EKSTROM GALLERY, NEW YORK CITY

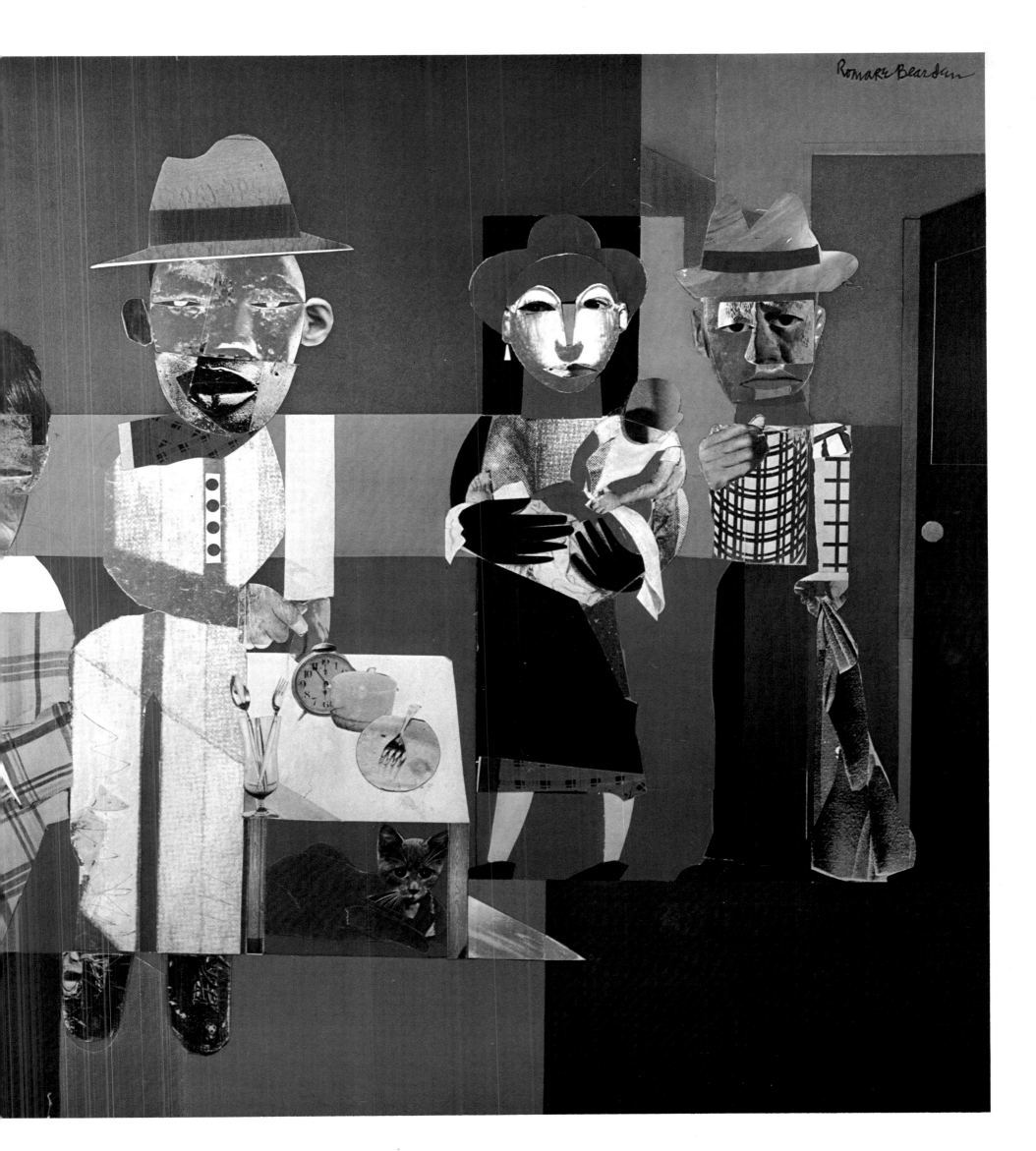

Romare Bearden

PLATE 59

MOTHER AND CHILD. 1969. COLLAGE, 8 1/2 × 4 1/4″. COURTESY CORDIER & EKSTROM GALLERY, NEW YORK CITY

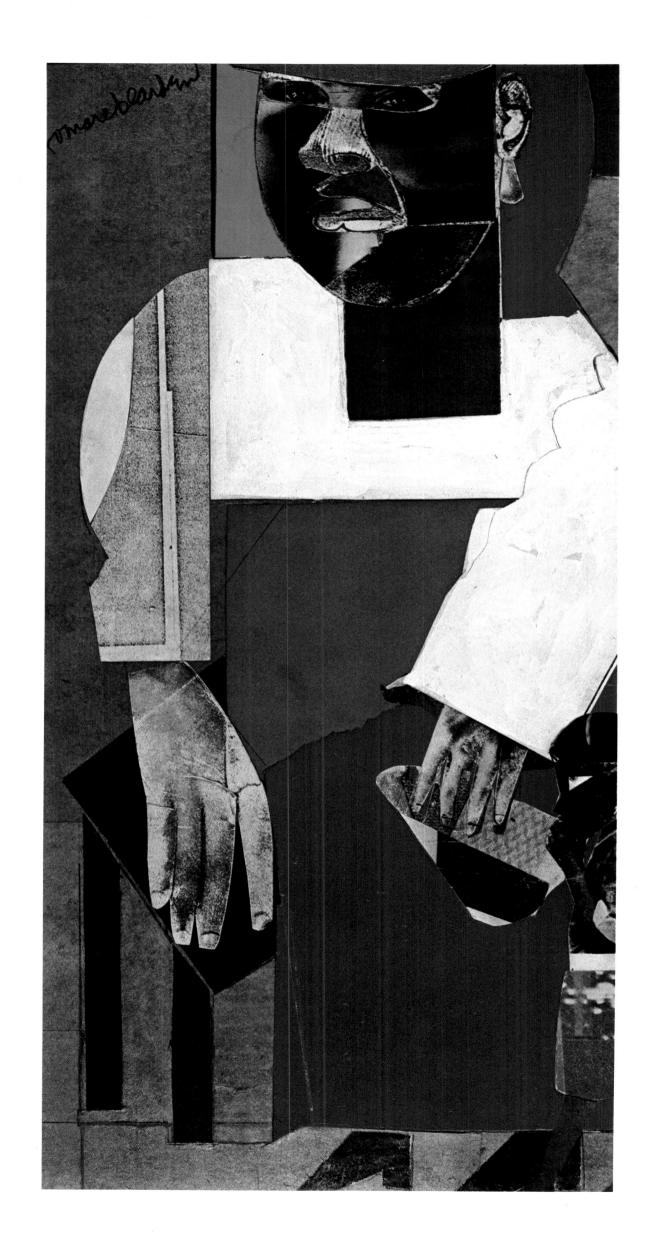

PLATE 60

TWO WOMEN. 1969. COLLAGE, 12 1/4 × 20″. COLLECTION MR. AND MRS. RALPH ELLISON, NEW YORK CITY

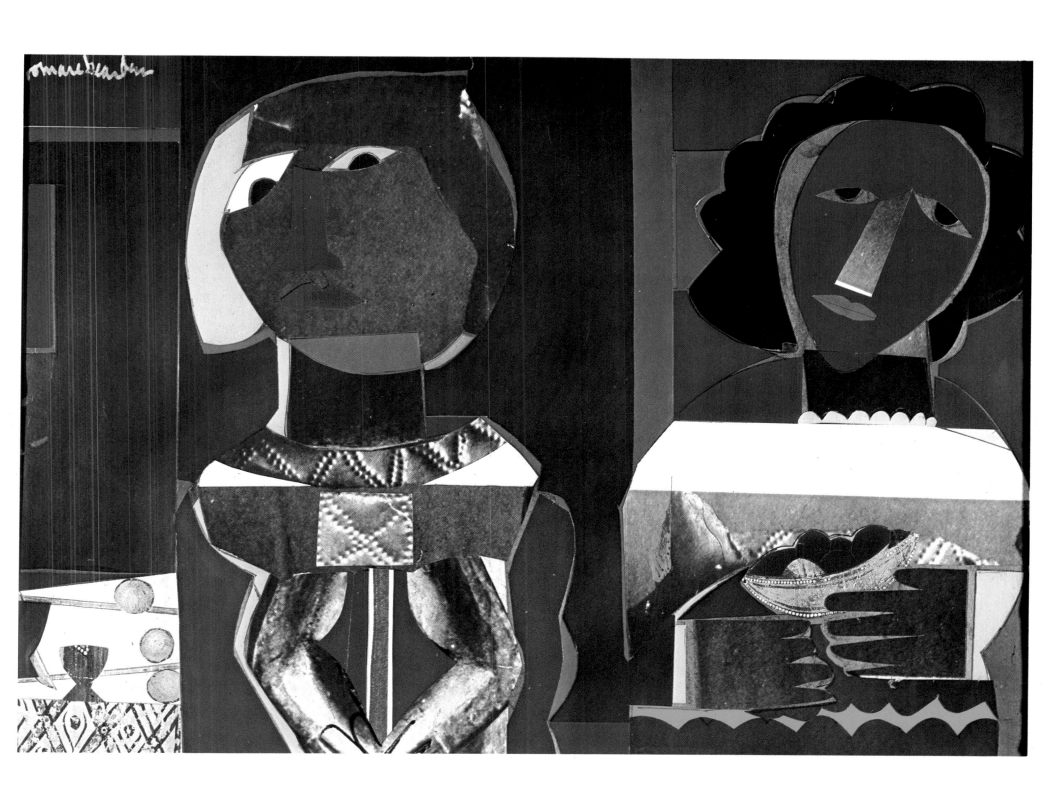

PLATE 61

SUSANNAH AT THE BATH. 1969. COLLAGE, 24 1/2 × 17 3/4″. COLLECTION ROBERT BRECKENRIDGE, NEW YORK CITY

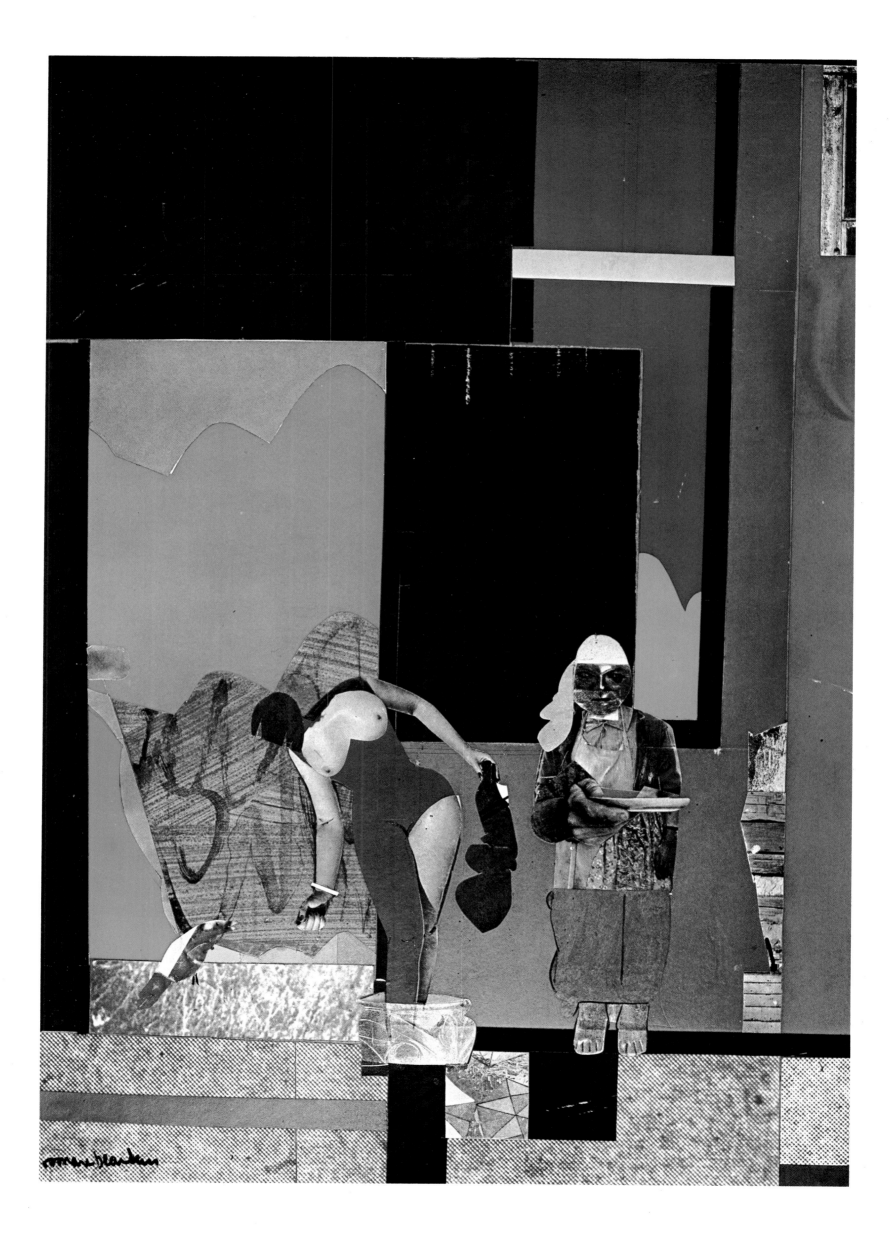

PLATE 62

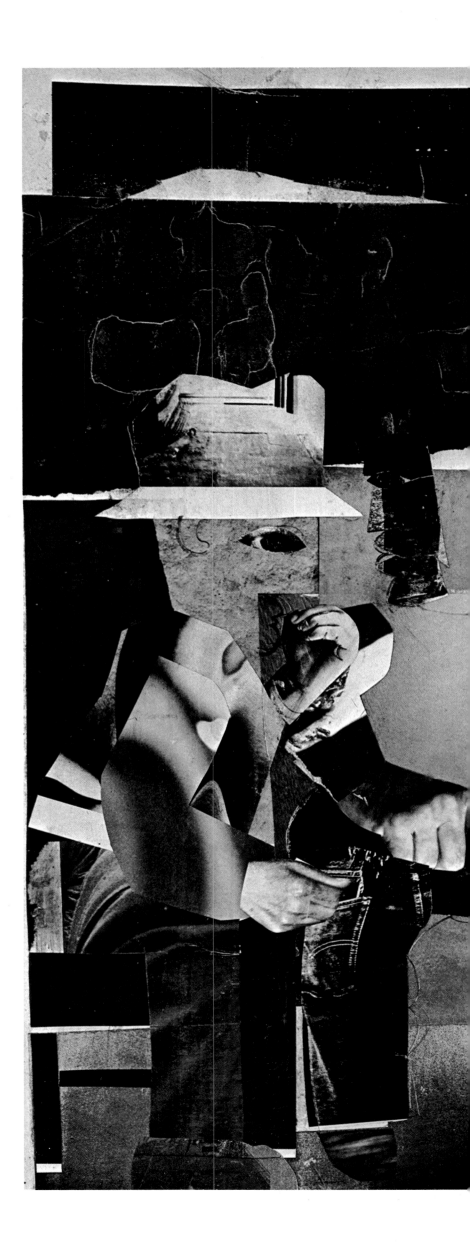

GRAY INTERIOR. 1969. COLLAGE, 25 1/2 × 32″.
COLLECTION MR. AND MRS. RALPH E. YES, NEW YORK CITY

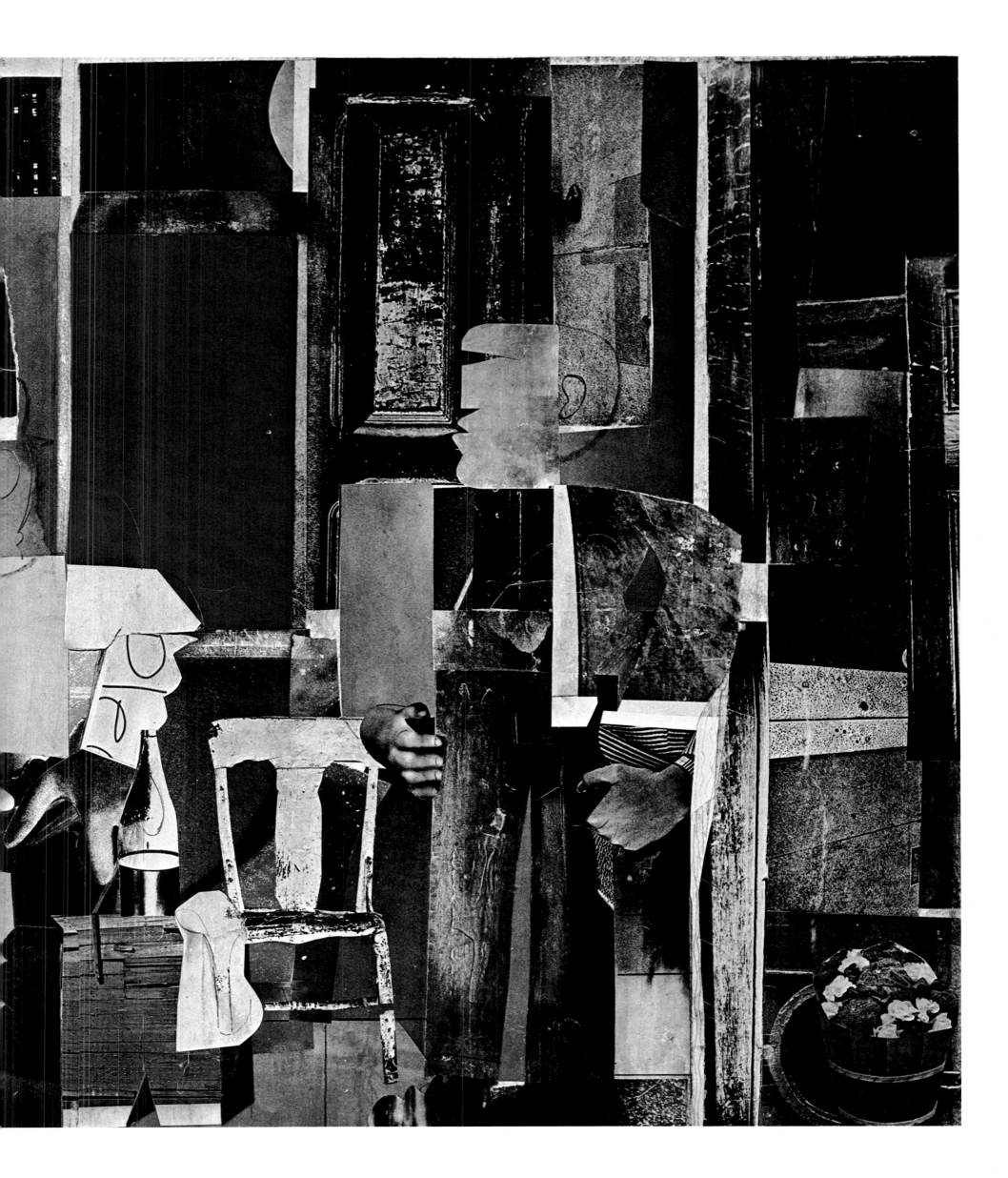

PLATE 63

BACKYARD. 1969. COLLAGE, 21 1/2 × 17 1/2″. COURTESY CORDIER & EKSTROM GALLERY, NEW YORK CITY

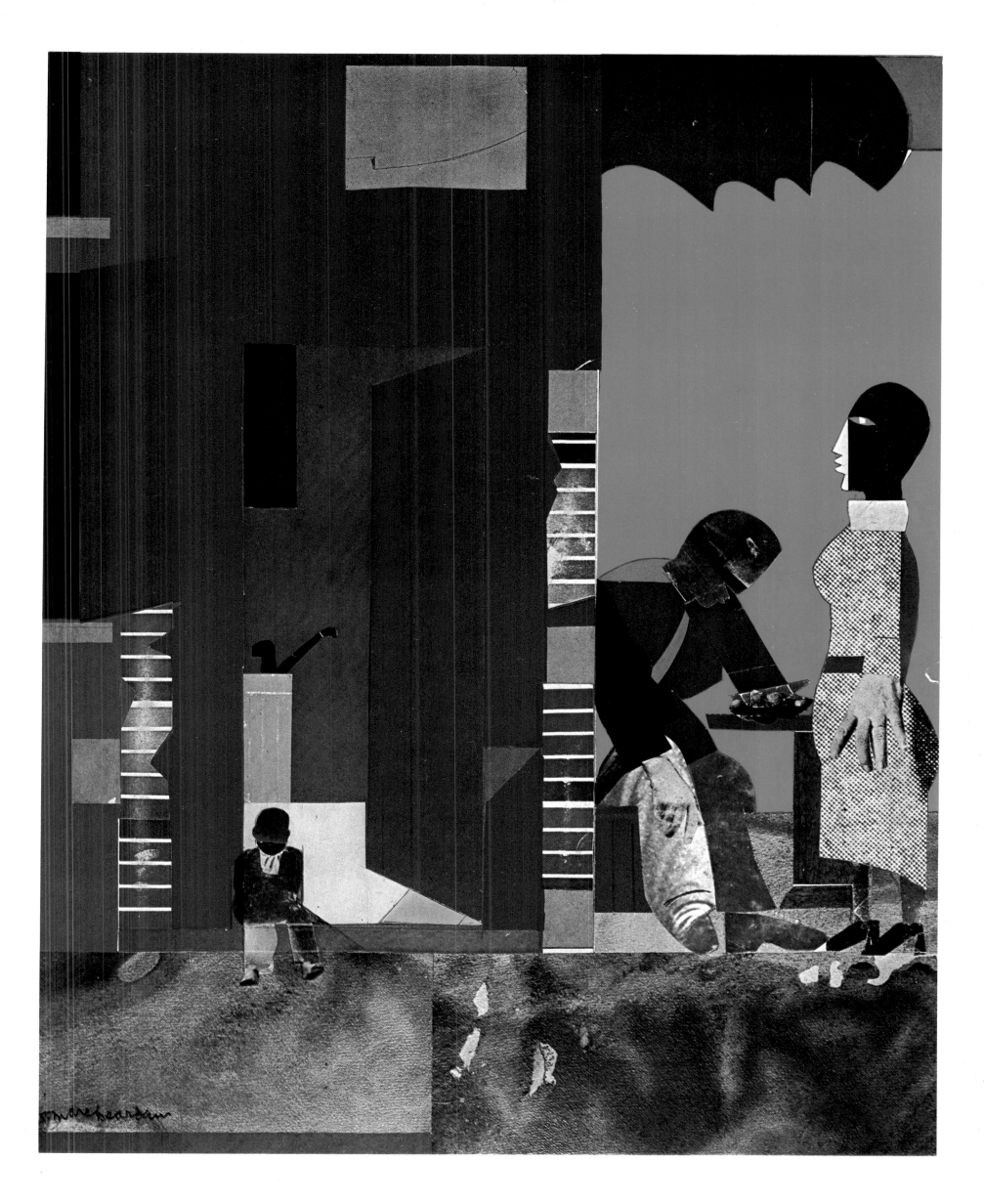

PLATE 64

BACK HOME FROM UP THE COUNTRY. 1969. COLLAGE, 50 × 39 3/4″. COURTESY CORDIER & EKSTROM GALLERY, NEW YORK CITY

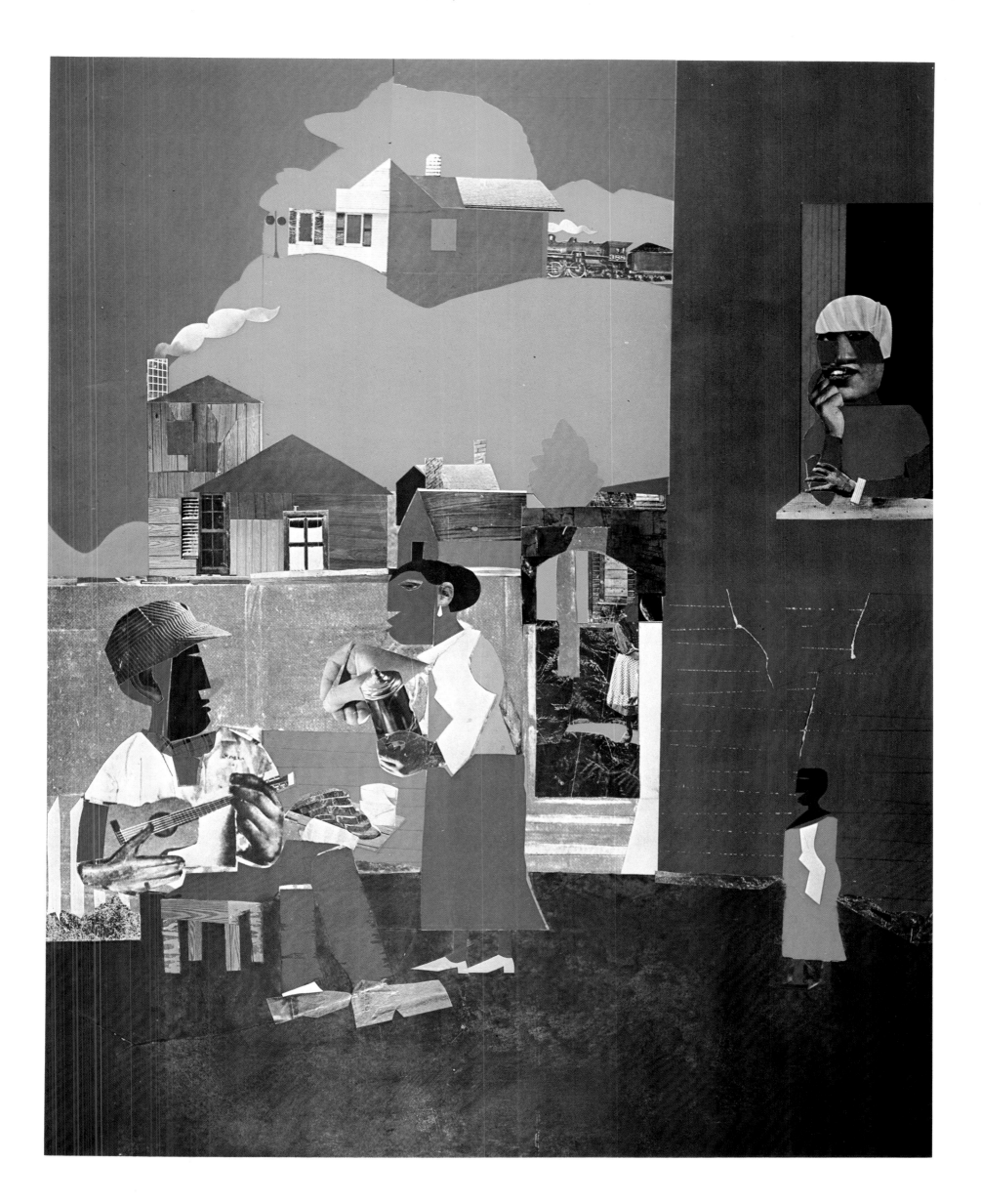

PLATE 65

SUNDAY AFTER SERMON. 1969. COLLAGE, 40 × 50″. COURTESY CORDIER & EKSTROM GALLERY, NEW YORK CITY

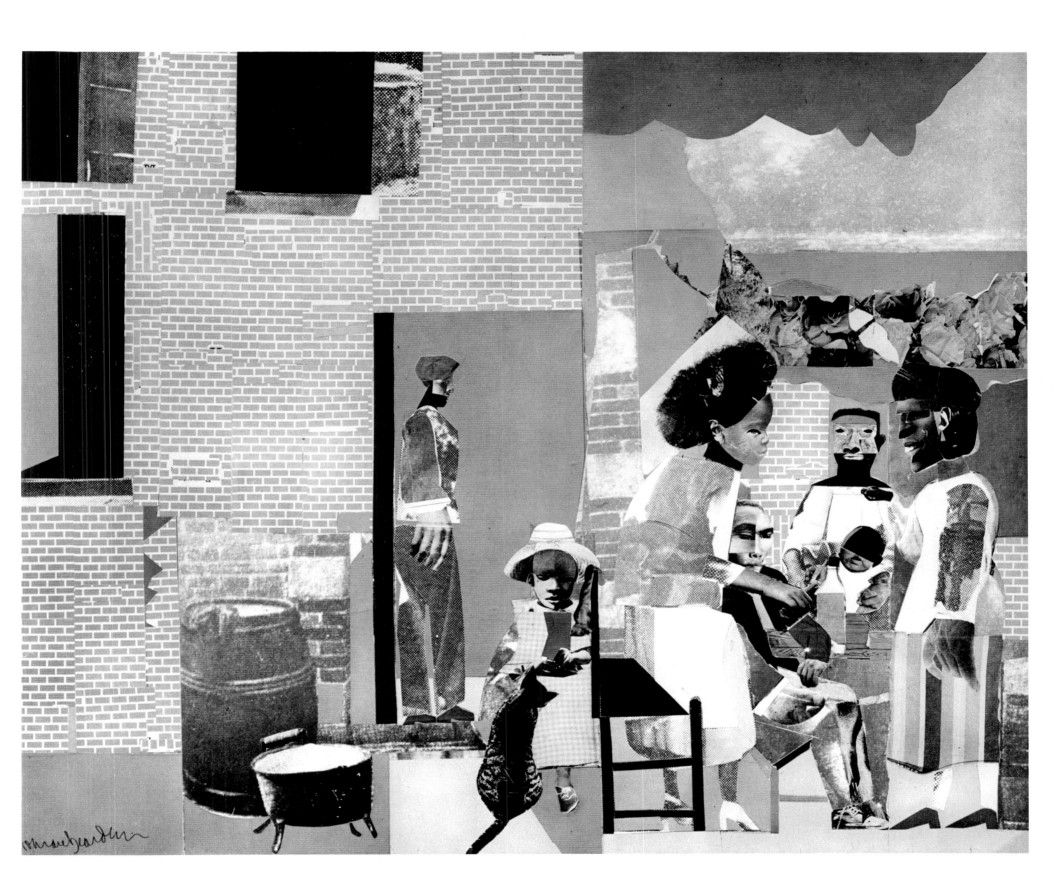

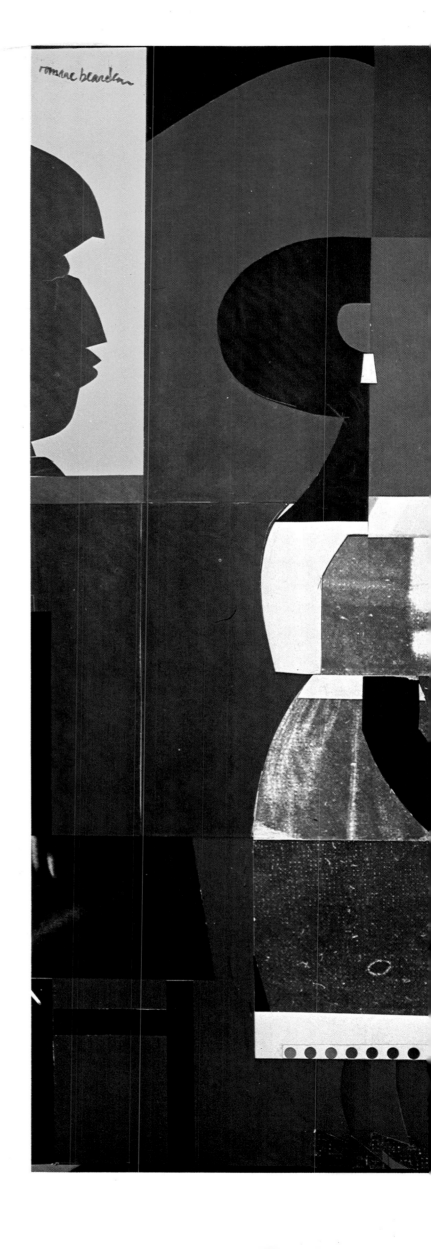

PLATE 66

INTERIOR WITH PROFILES. 1969. COLLAGE, 39 3/4 × 49 7/8″.
FIRST NATIONAL BANK OF CHICAGO

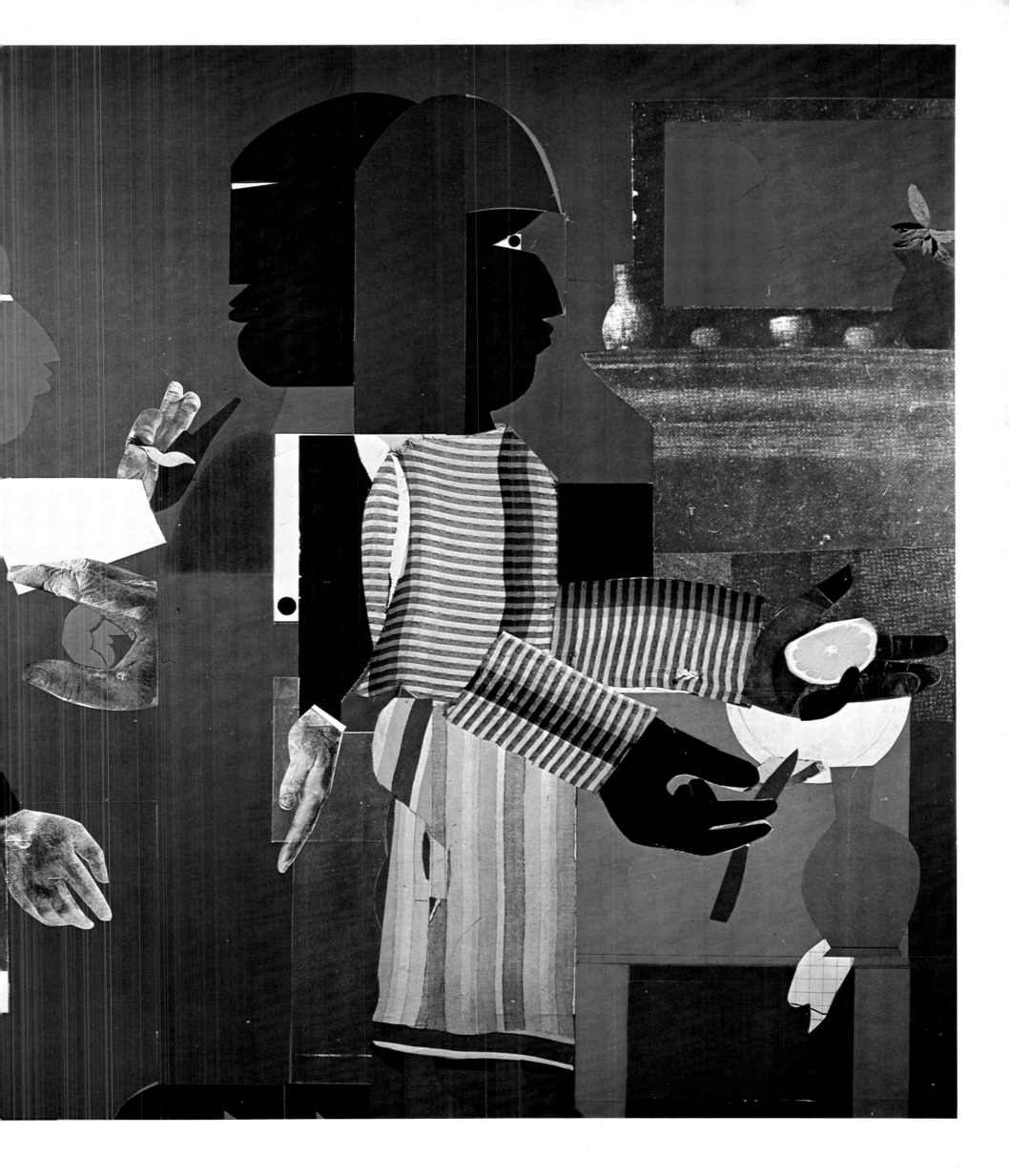

PLATE 67

Sodom e Gomorrah

PLATE 68

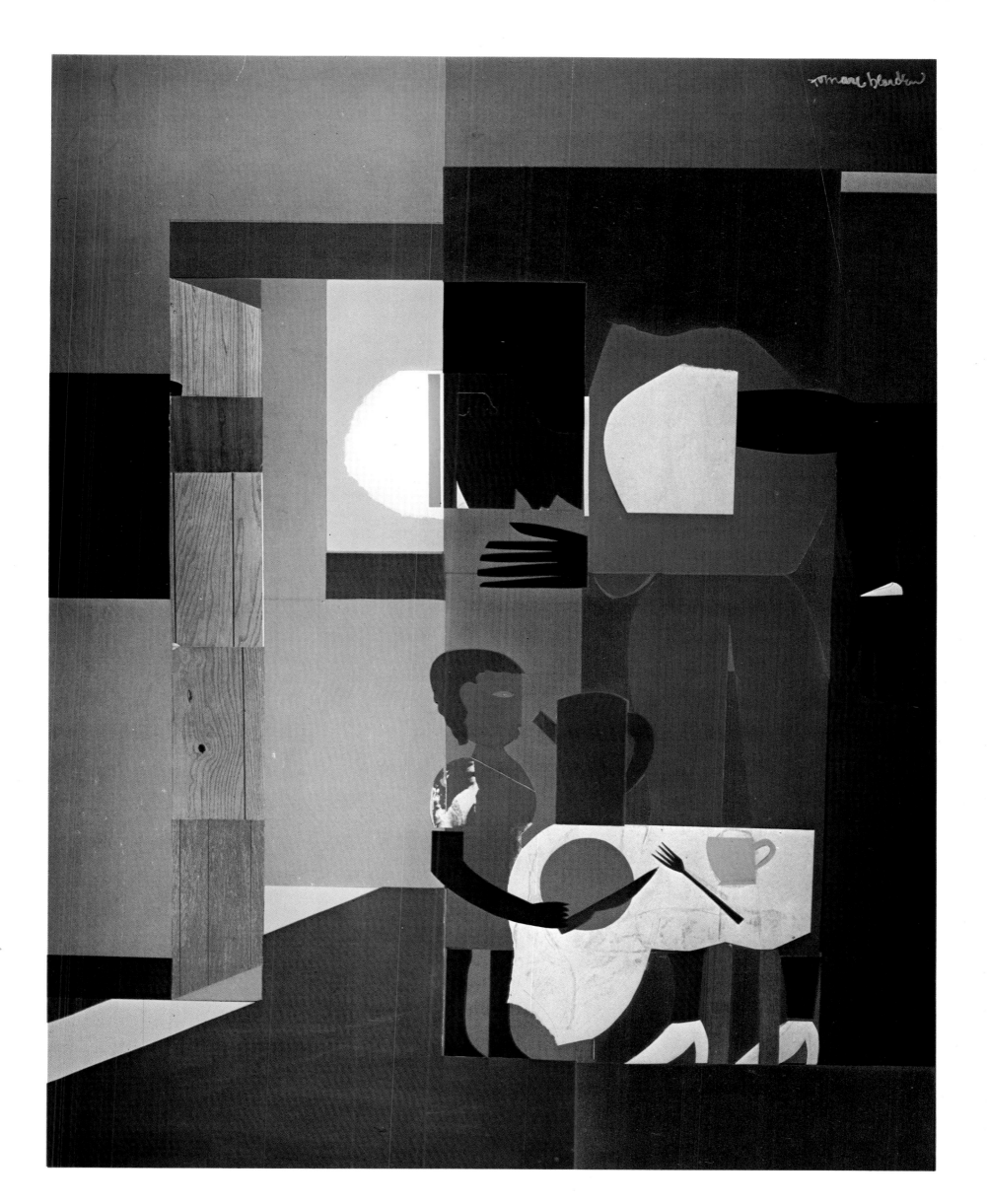

PLATE 69

SUSANNAH. 1969. COLLAGE, 12 × 9″. COLLECTION MISS HELEN MARY HARDING, NEW YORK CITY

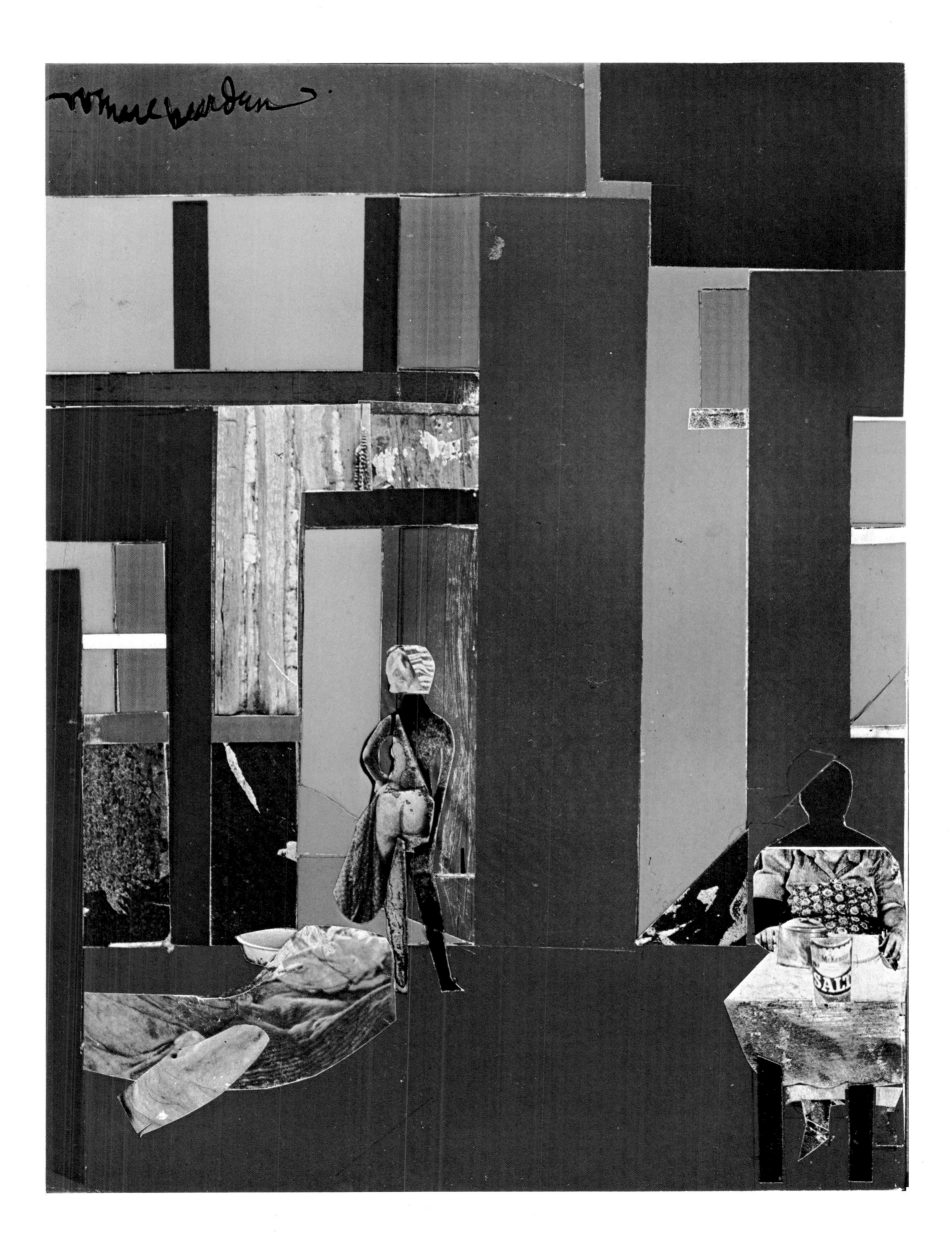

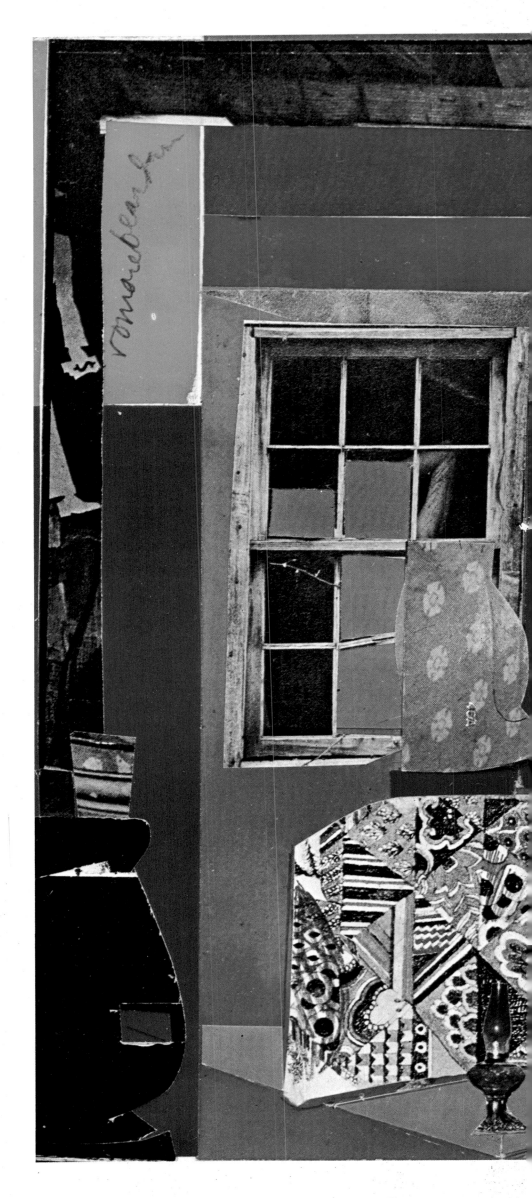

PLATE 70

PATCHWORK QUILT. 1969. COLLAGE, $9 \times 11\ 7/8''$.
COLLECTION MISS HELEN MARY HARDING, NEW YORK CITY

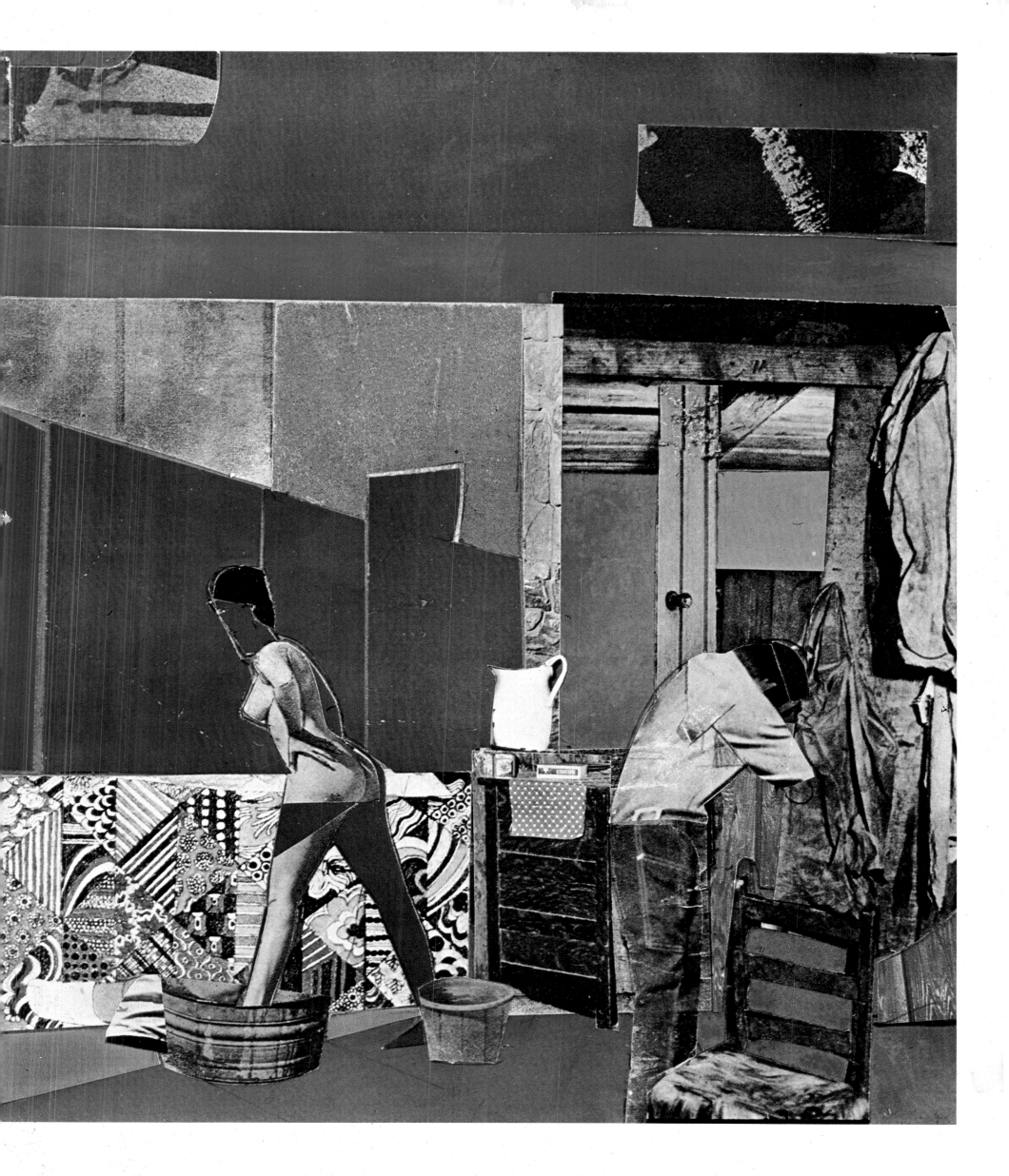

PLATE 71

BLACK MANHATTAN. 1969. COLLAGE, 25 3/8 × 21 ″. COLLECTION MR. AND MRS. THEODORE KHEEL, NEW YORK CITY

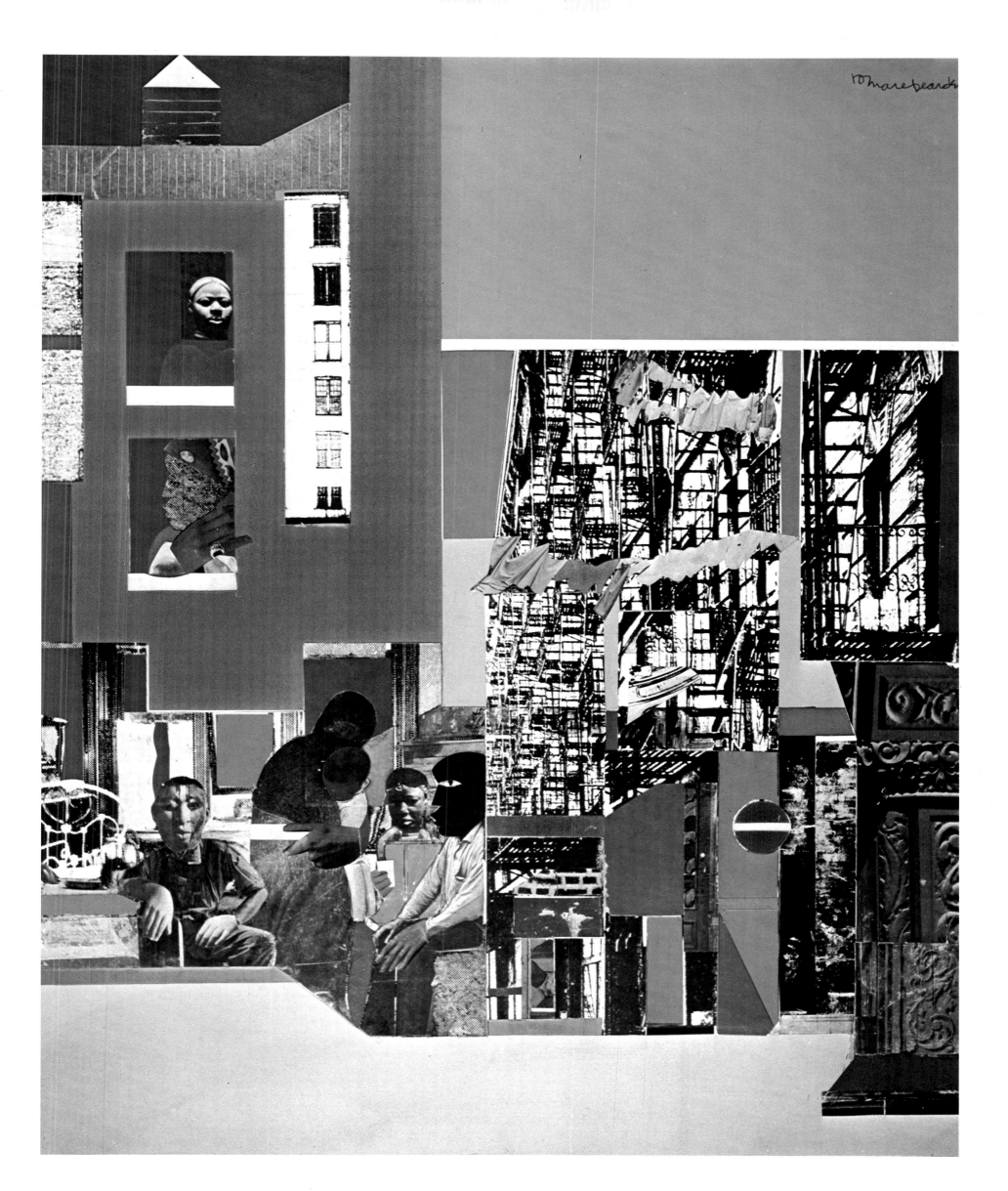

PLATE 72

INTERIOR 1969. 1969. COLLAGE, 9 × 11 1/2″. COURTESY CORDIER & EKSTROM GALLERY, NEW YORK CITY

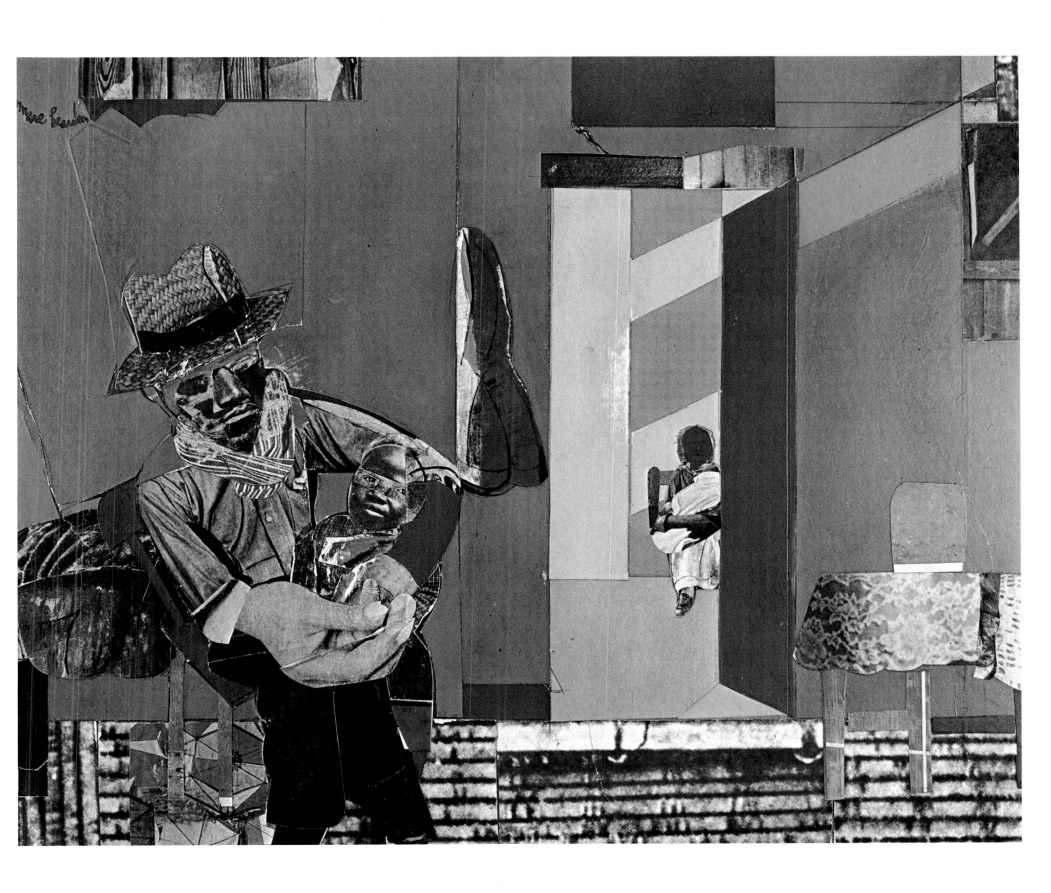

PLATE 73

SUNDAY NEW YORK TIMES MAGAZINE COVER. 1969

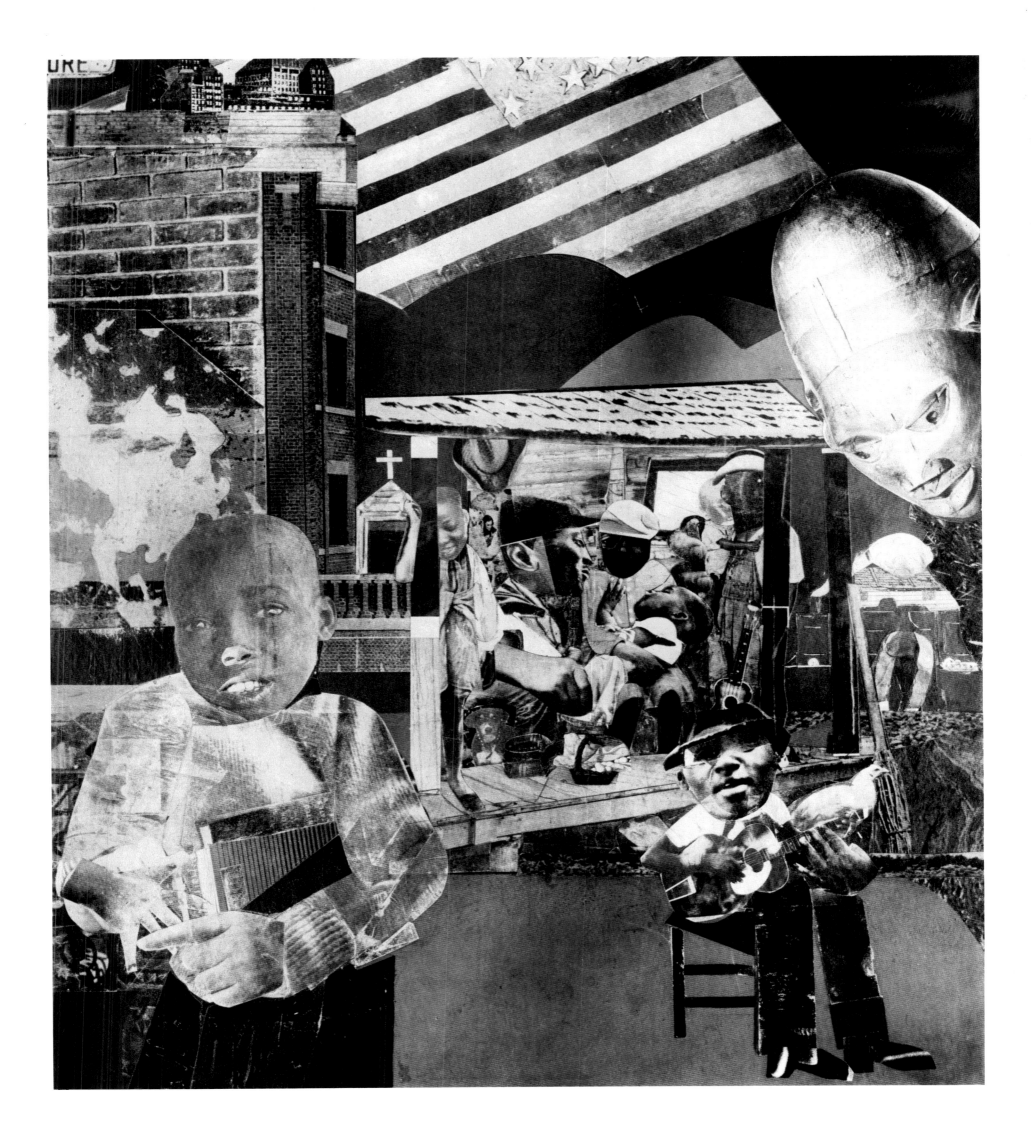

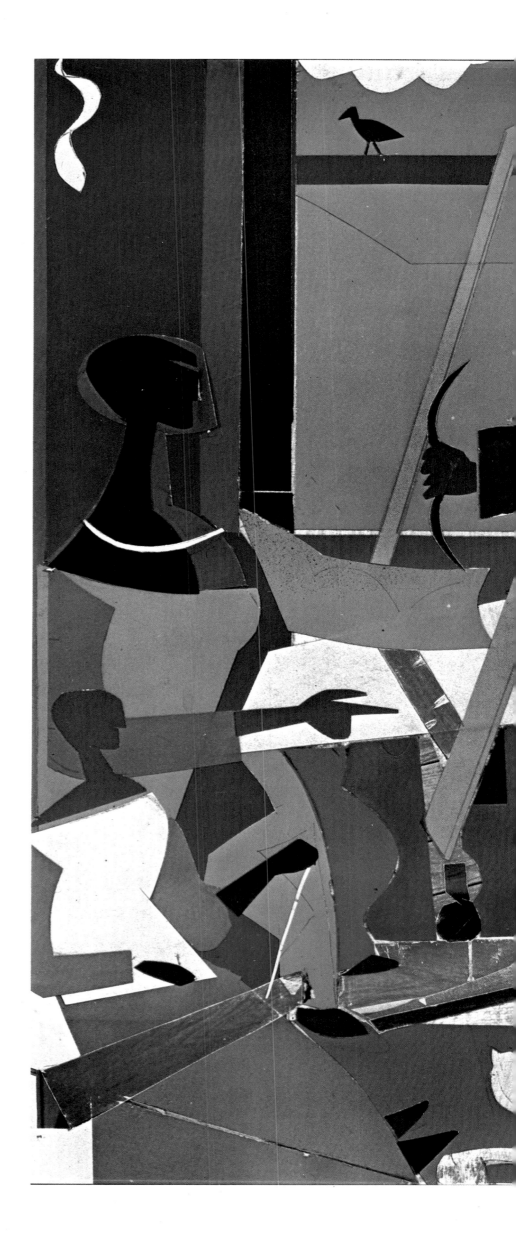

PLATE 74

HOMMAGE À PINTURICCHIO. 1969. COLLAGE, 8 1/2 × 11".
COURTESY CORDIER & EKSTROM GALLERY, NEW YORK CITY

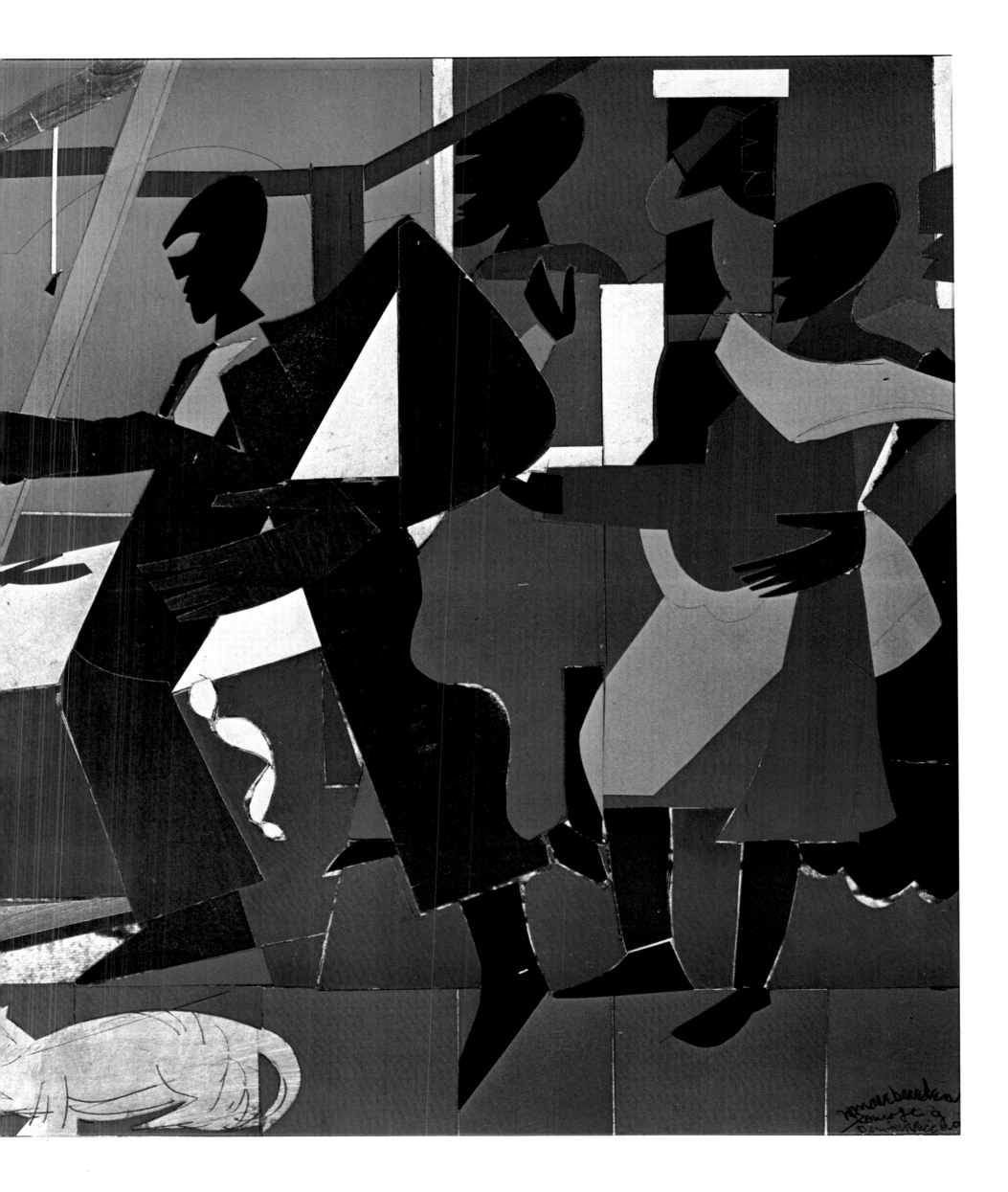

PLATE 75

BLUE MONDAY. 1969. COLLAGE, $9 \times 12''$. COLLECTION MISS HELEN MARY HARDING, NEW YORK CITY

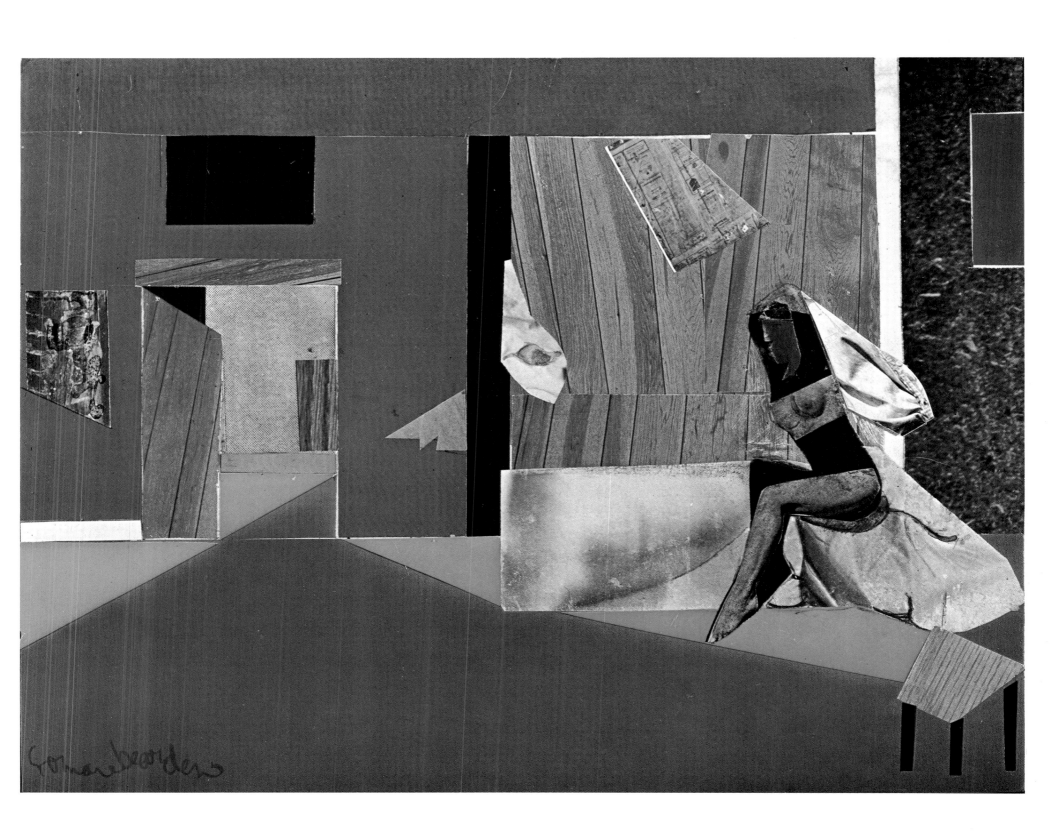

PLATE 76

FLIGHTS AND FANTASY. 1970. COLLAGE AND MIXED MEDIUMS, 8 3/4 × 11 5/8″. SHOREWOOD PUBLISHERS, NEW YORK CITY

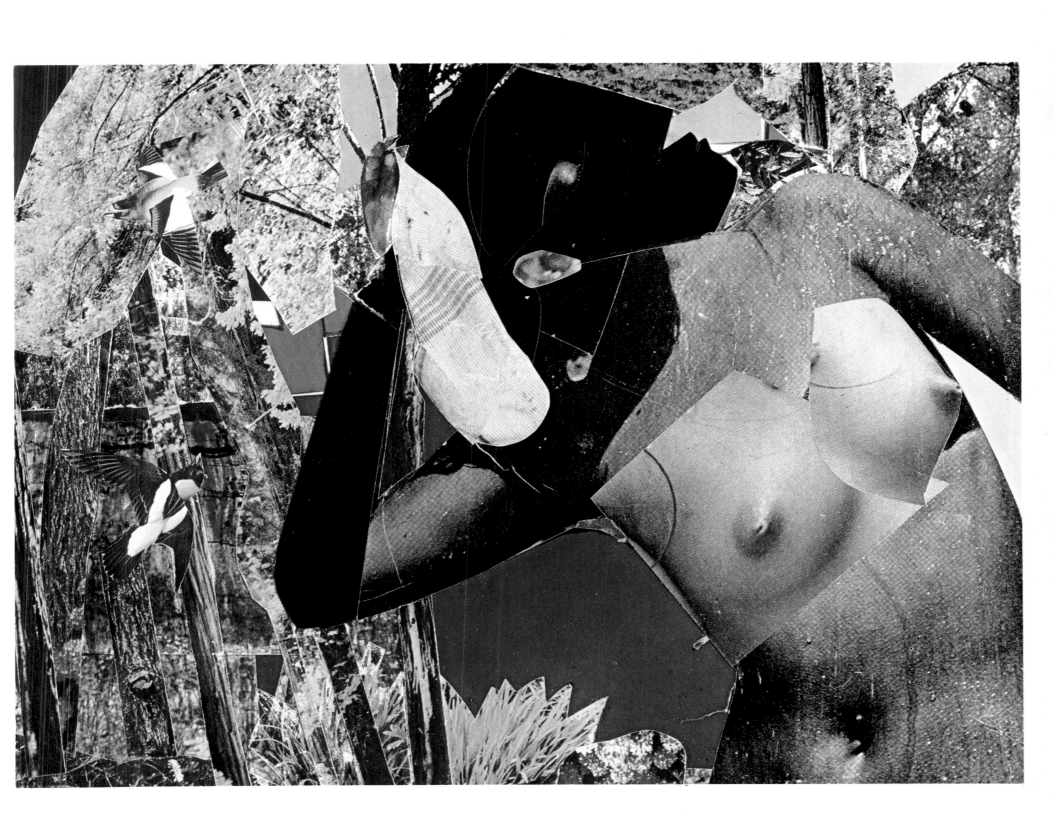

PLATE 77

MEMORIES. 1970. COLLAGE, 14 × 19 3/4″. SHOREWOOD PUBLISHERS, NEW YORK CITY

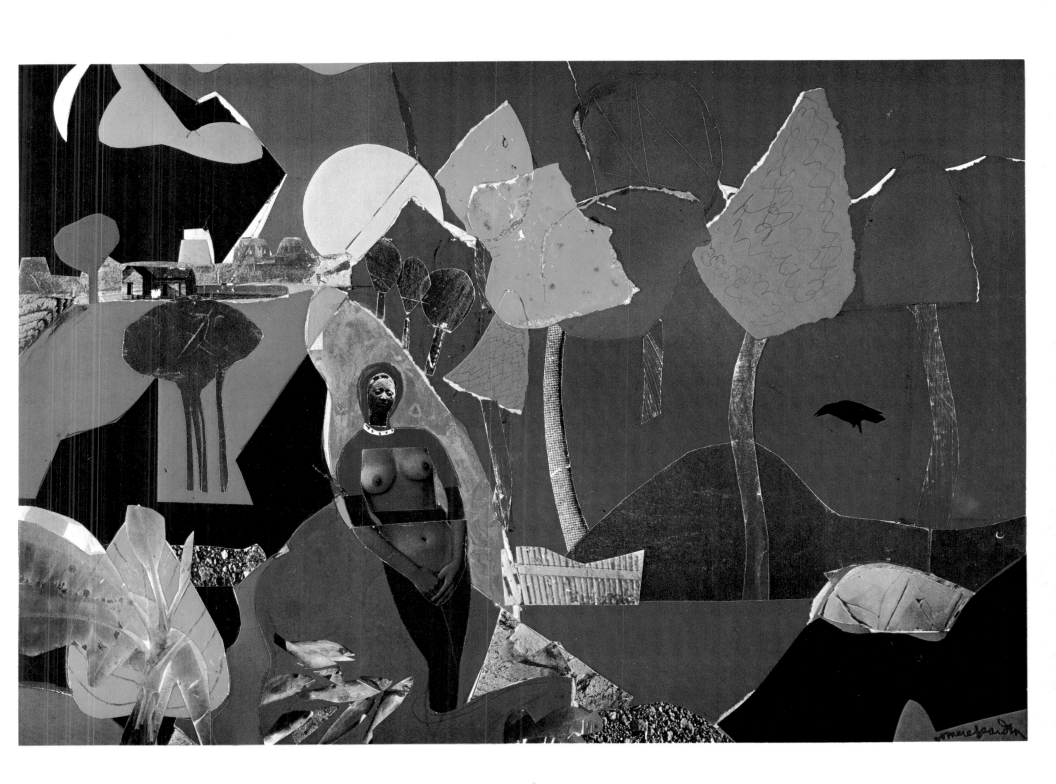

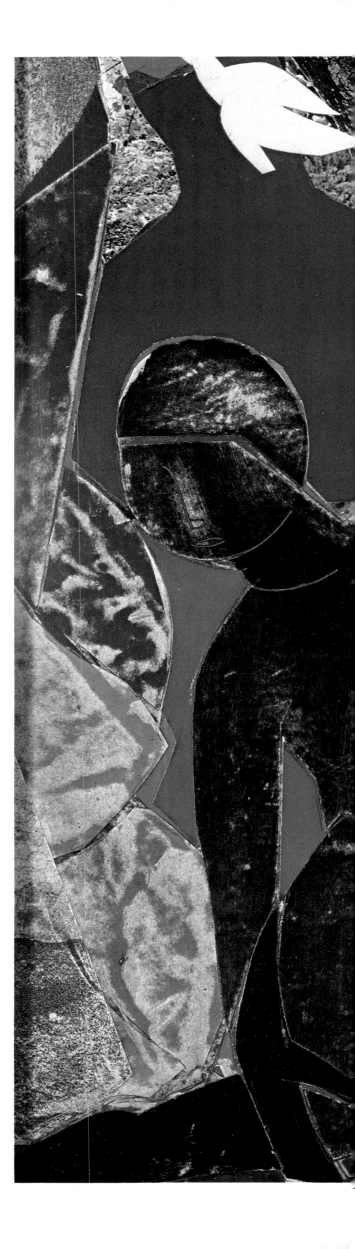

PLATE 78

RITUAL BAYOU. 1970. COLLAGE AND MIXED MEDIUMS, 13 1/2 × 15 3/4".
SHOREWOOD PUBLISHERS, NEW YORK CITY

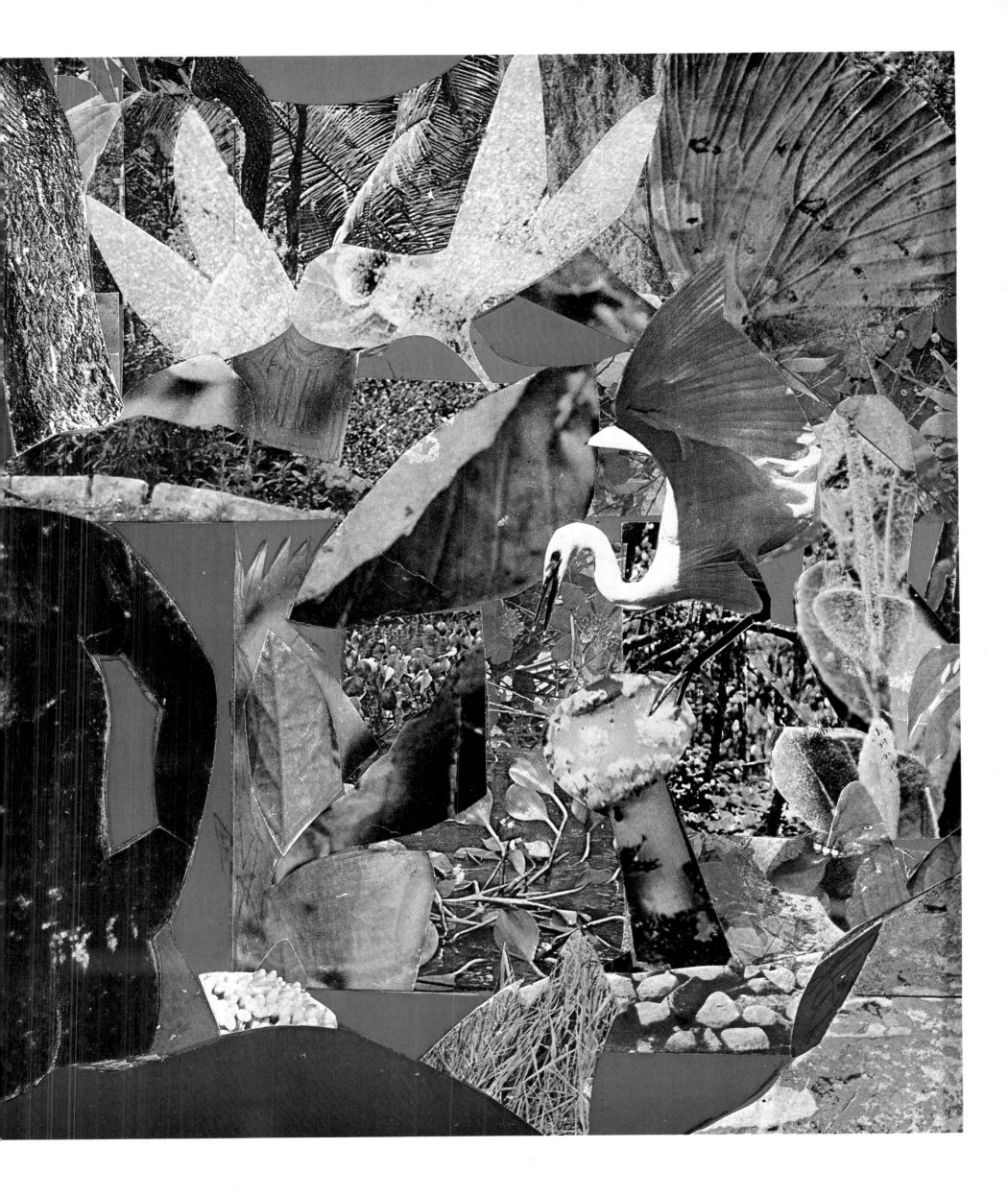

PLATE 79

FAMILY. 1970. COLLAGE, 9 × 12″. COLLECTION HARRY HENDERSON, CROTON-ON-HUDSON, N.Y.

PLATE 80

PATCHWORK QUILT. 1970. COLLAGE, 35 1/2 × 47 3/8″. THE MUSEUM OF MODERN ART, NEW YORK CITY

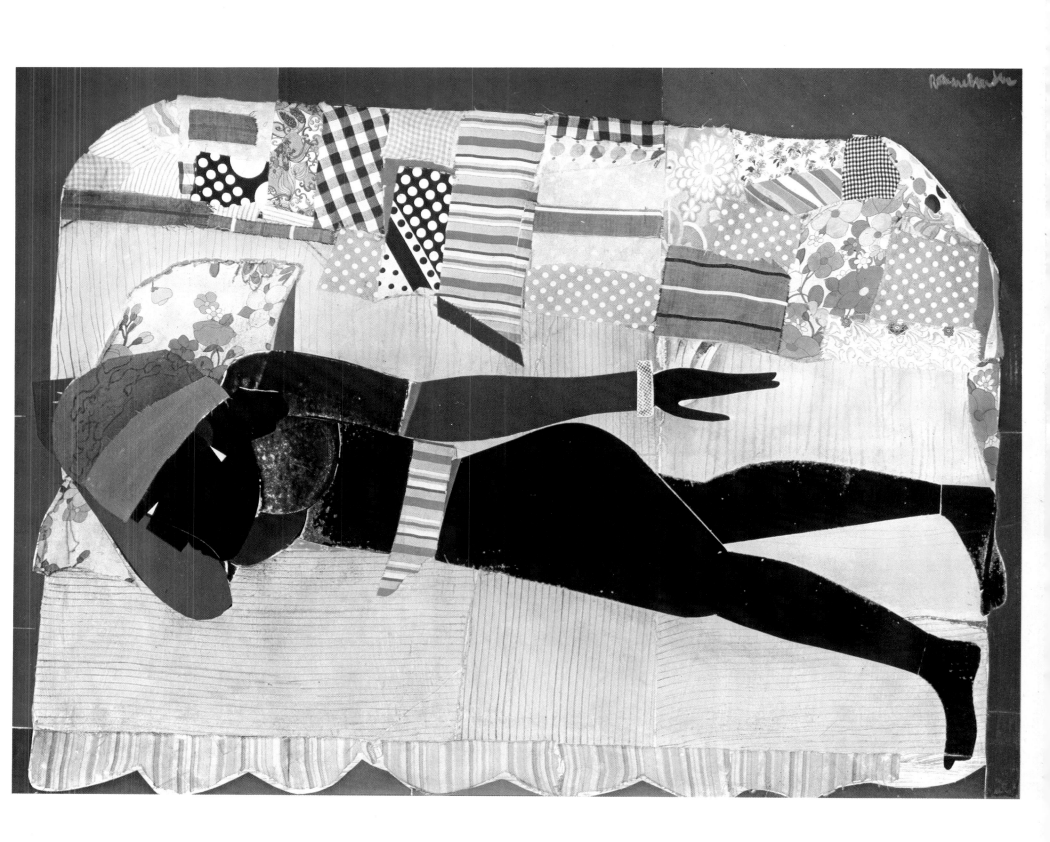

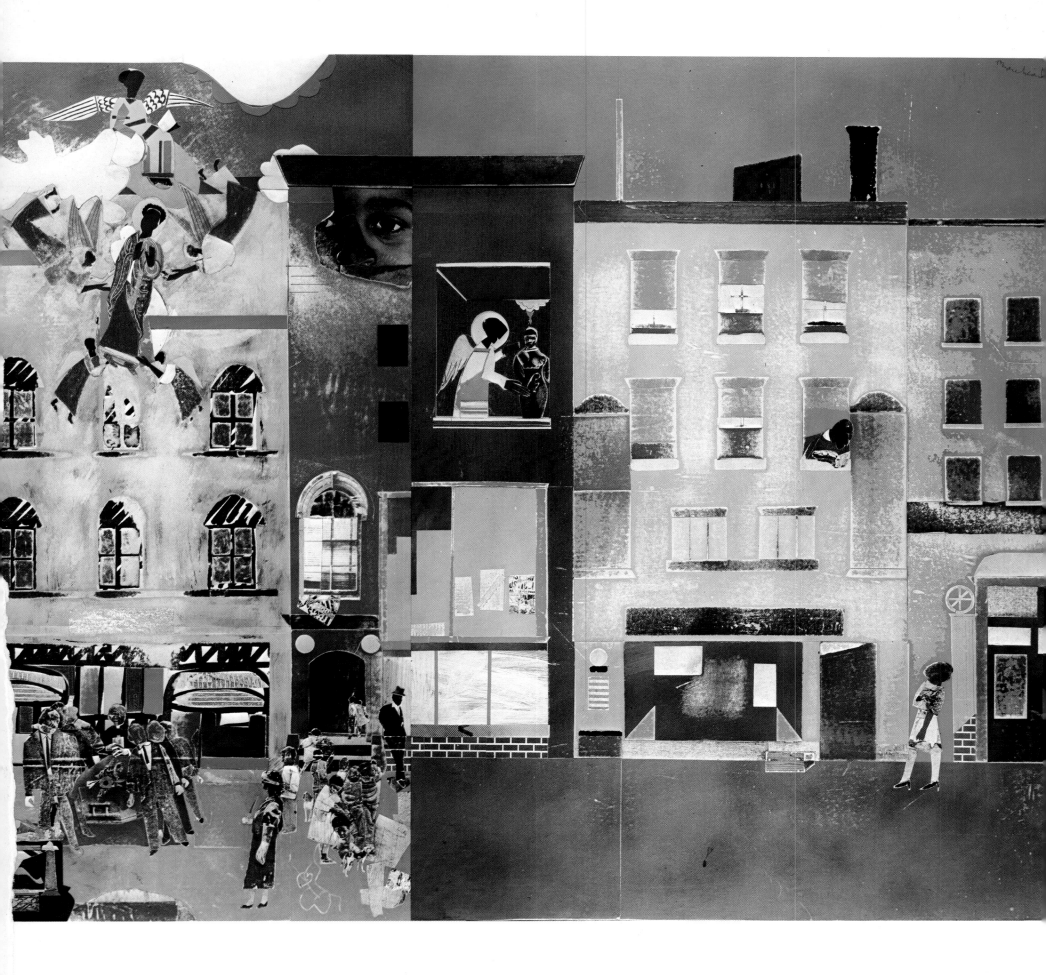

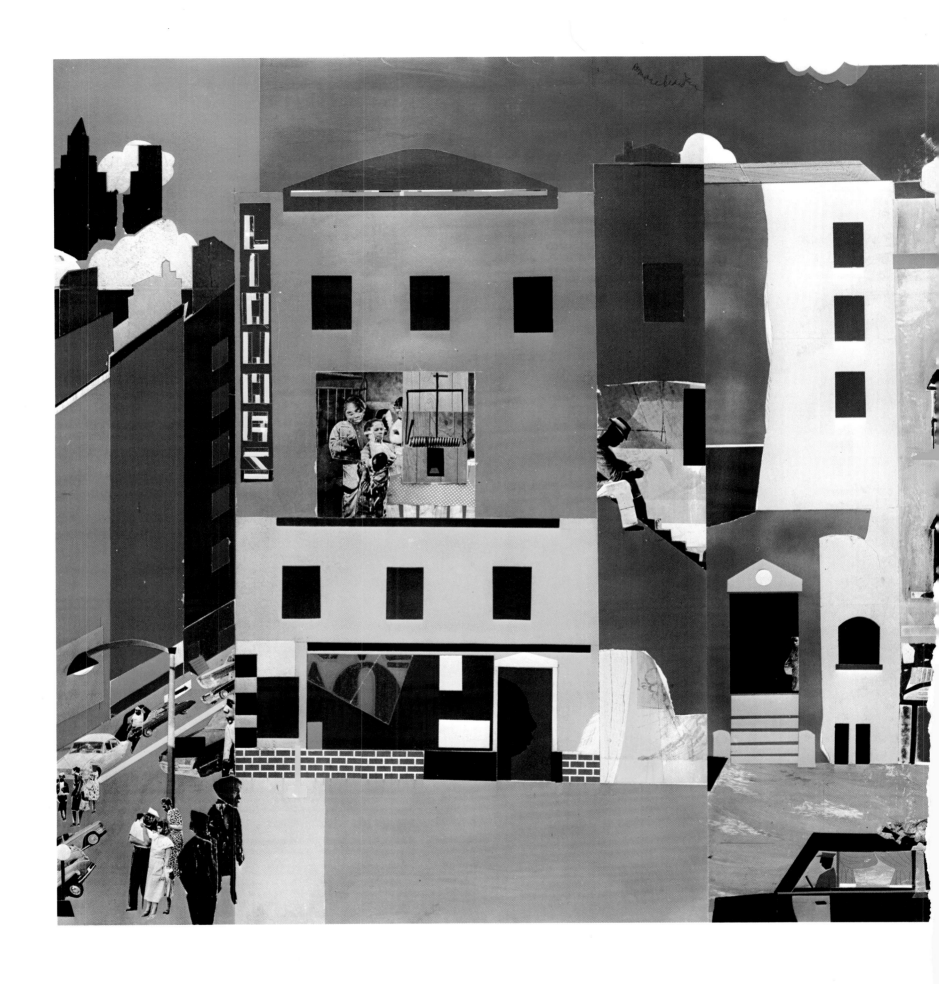

PLATE 81

THE BLOCK. 1971. COLLAGE WITH TAPE RECORDING OF STREET SOUNDS, CHURCH MUSIC, ETC. 6 PAINTINGS, OVERALL SIZE 4 × 18 FEET. SHOREWOOD PUBLISHERS, NEW YORK CITY

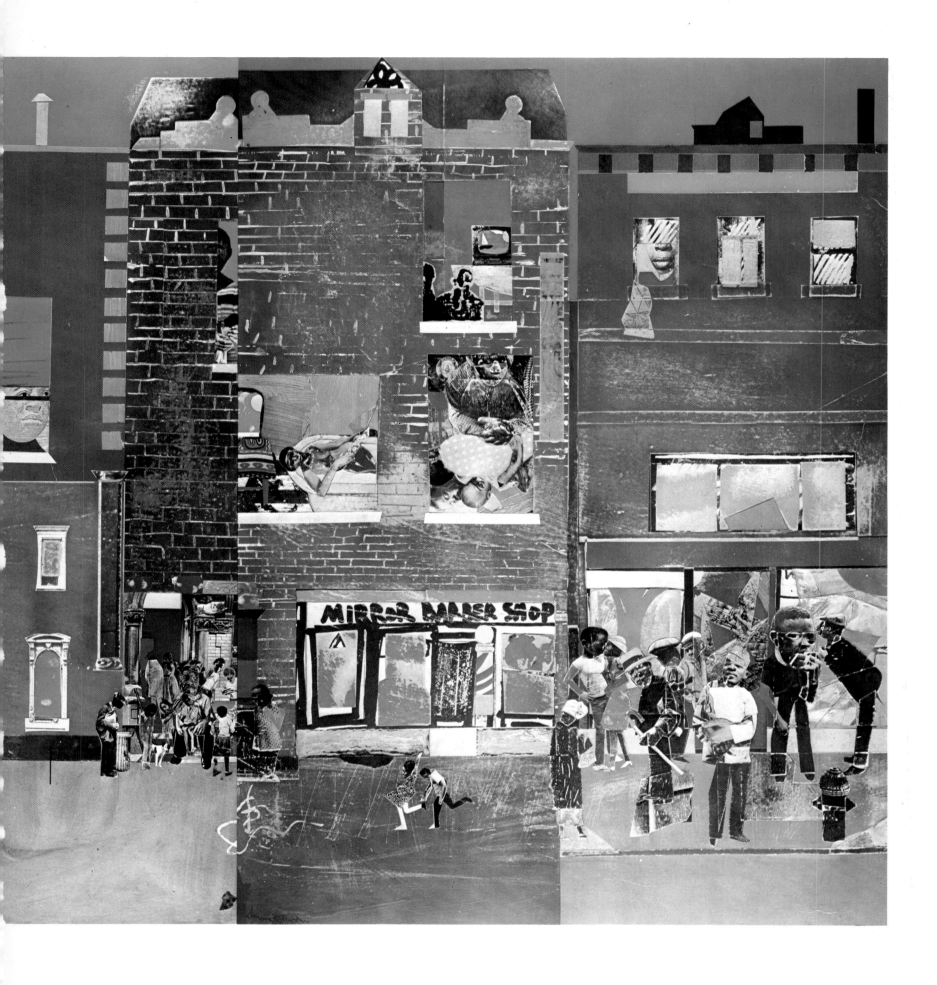

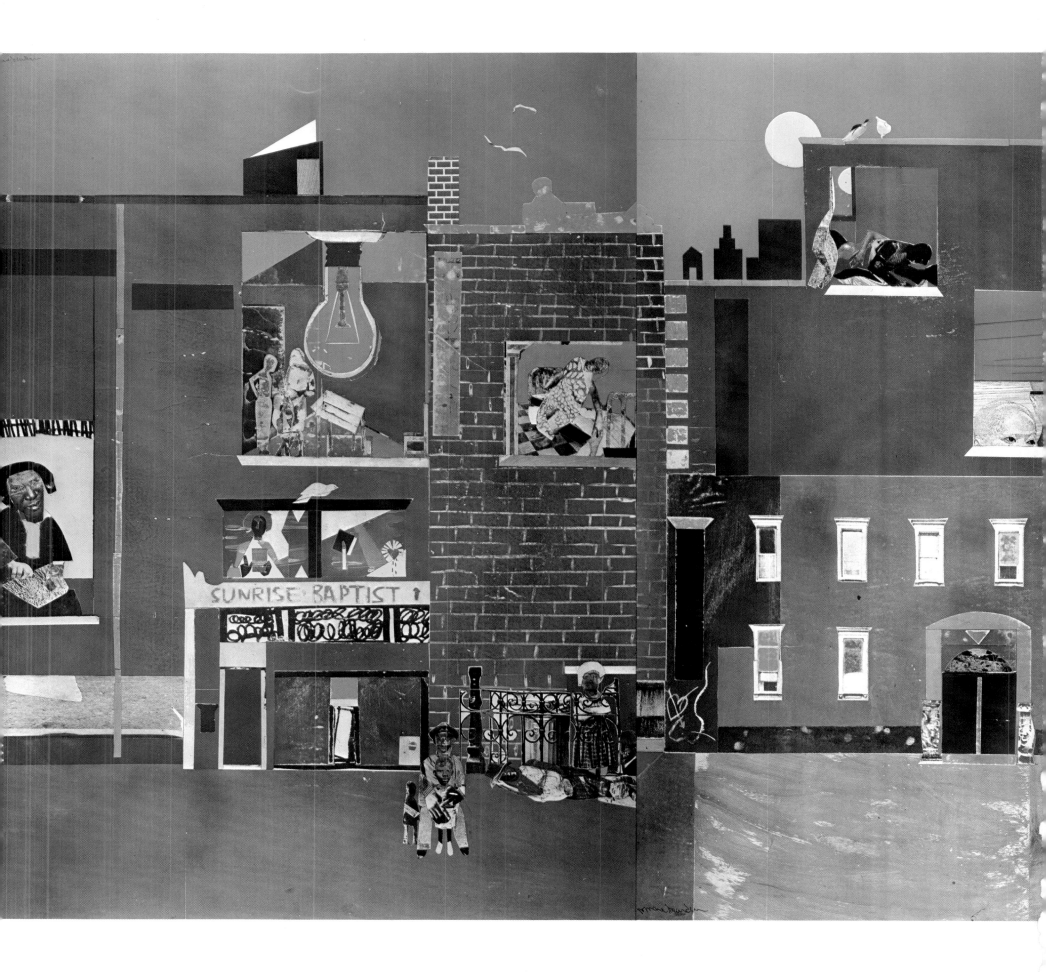

PLATE 82

TIME OF THE GINGHAM ROOSTER. 1970. COLLAGE, 12 × 16″.
SHOREWOOD PUBLISHERS, NEW YORK CITY

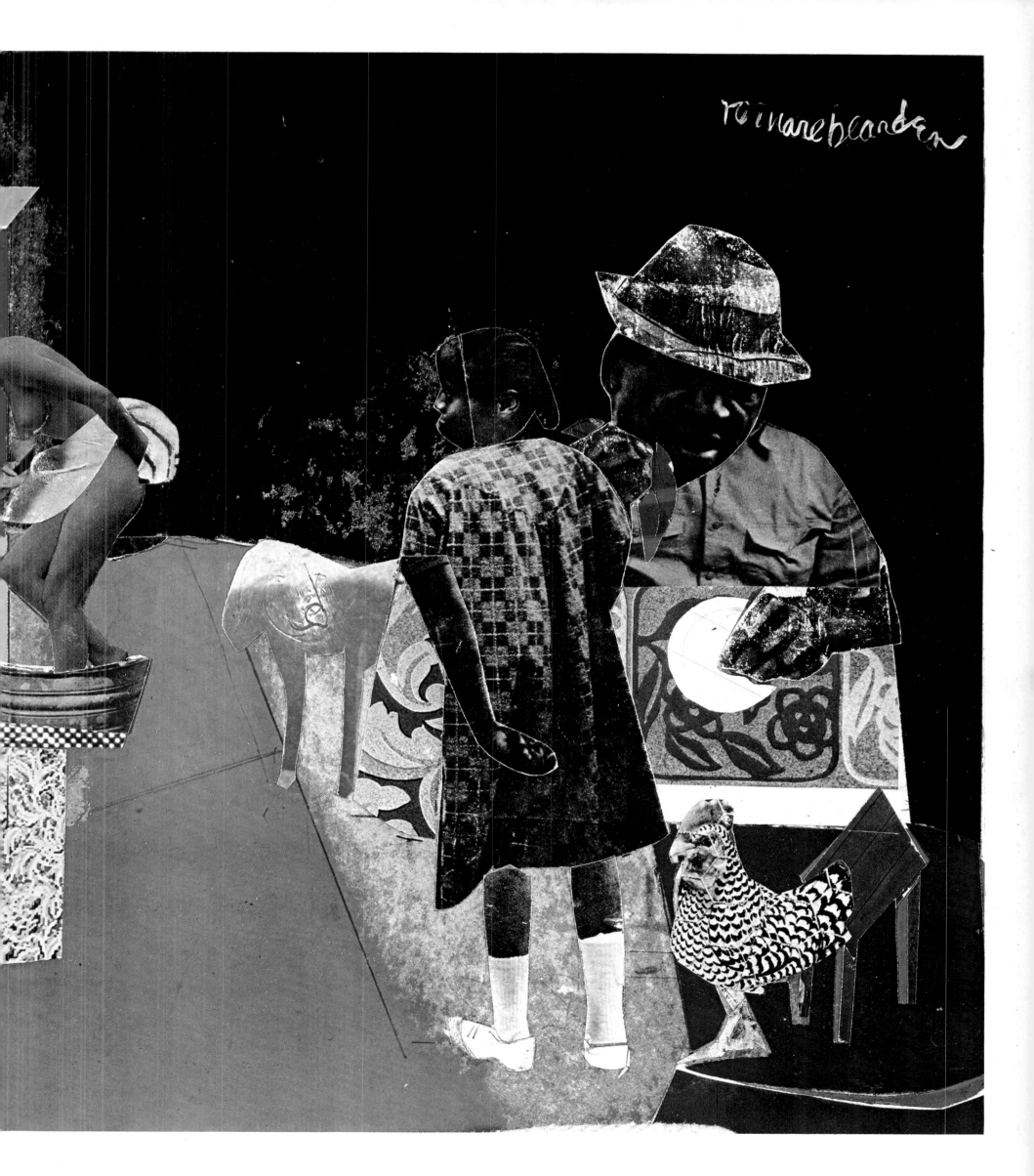

PLATE 83

BEFORE THE FIRST WHISTLE. 1970. COLLAGE, 19 3/4 × 15″. SHOREWOOD PUBLISHERS, NEW YORK CITY

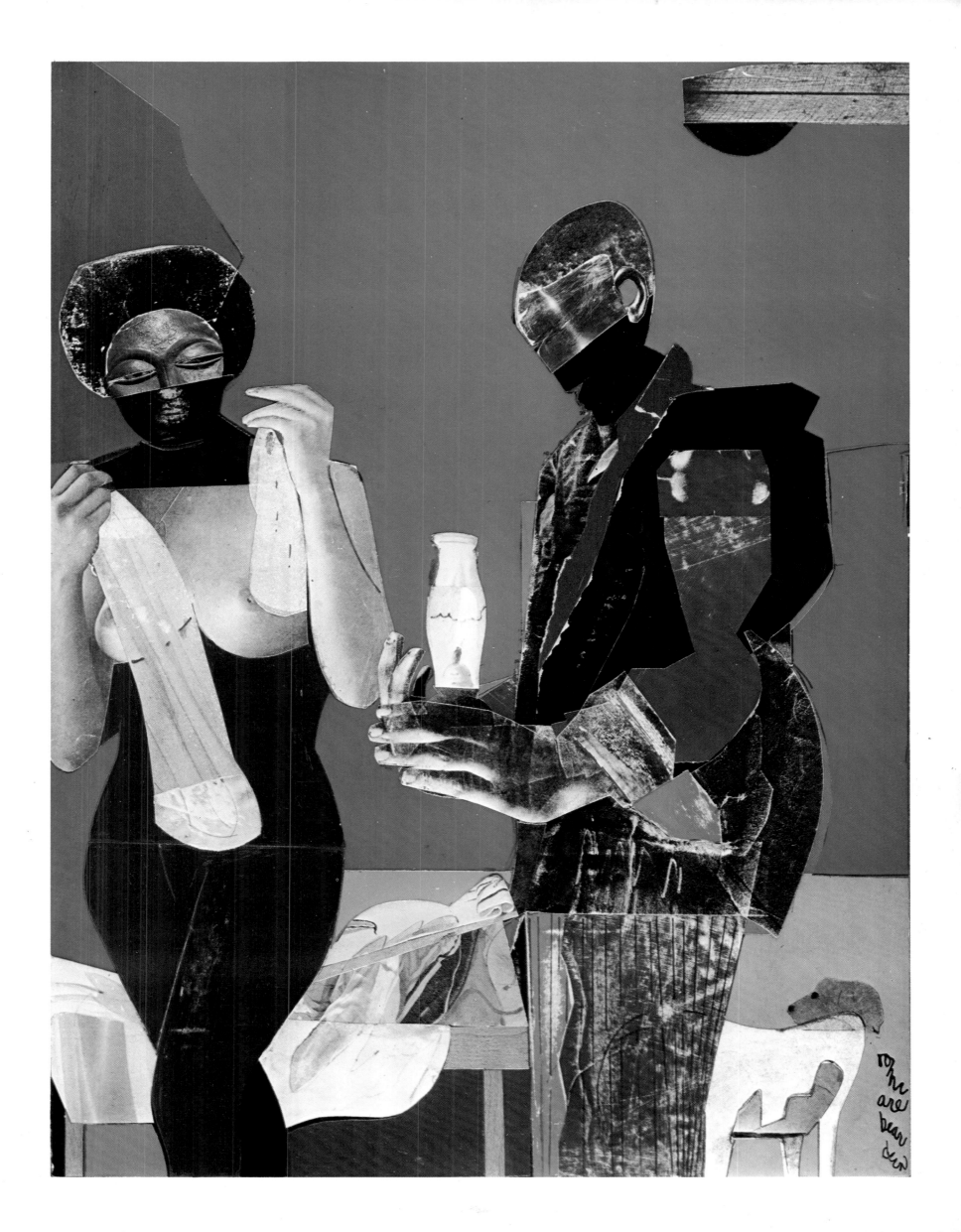

PLATE 84

THE FLIGHT OF THE PINK BIRD. 1970. COLLAGE, 11 3/4 × 25 1/8″. SHOREWOOD PUBLISHERS, NEW YORK CITY

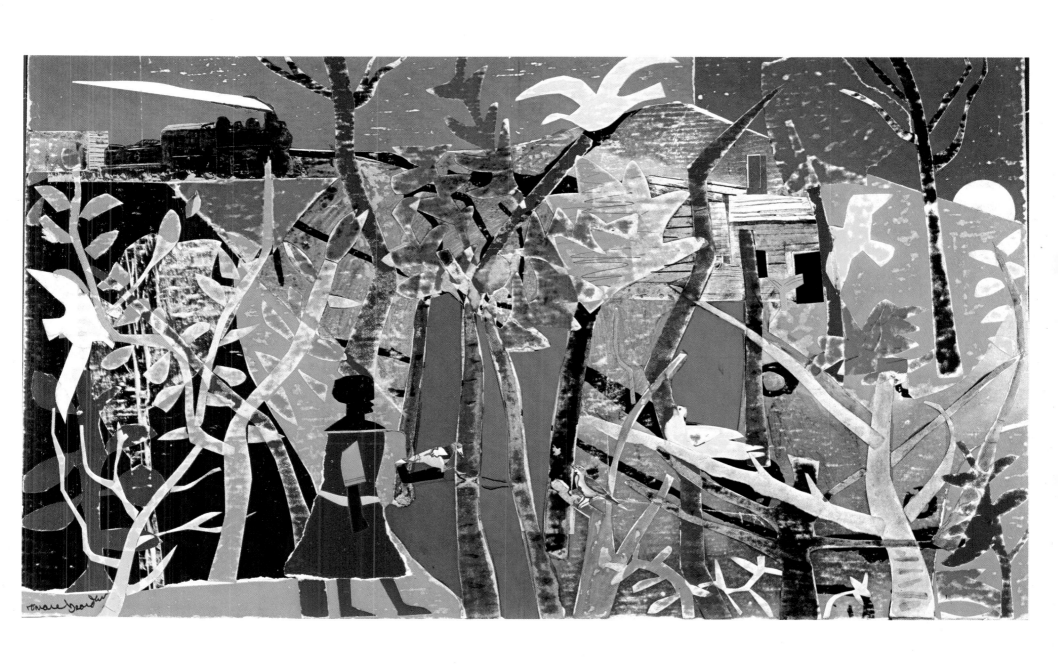

PLATE 85

CYPRESS MOON. 1970. COLLAGE AND MIXED MEDIUMS, 11 3/8 × 15 1/2". SHOREWOOD PUBLISHERS, NEW YORK CITY

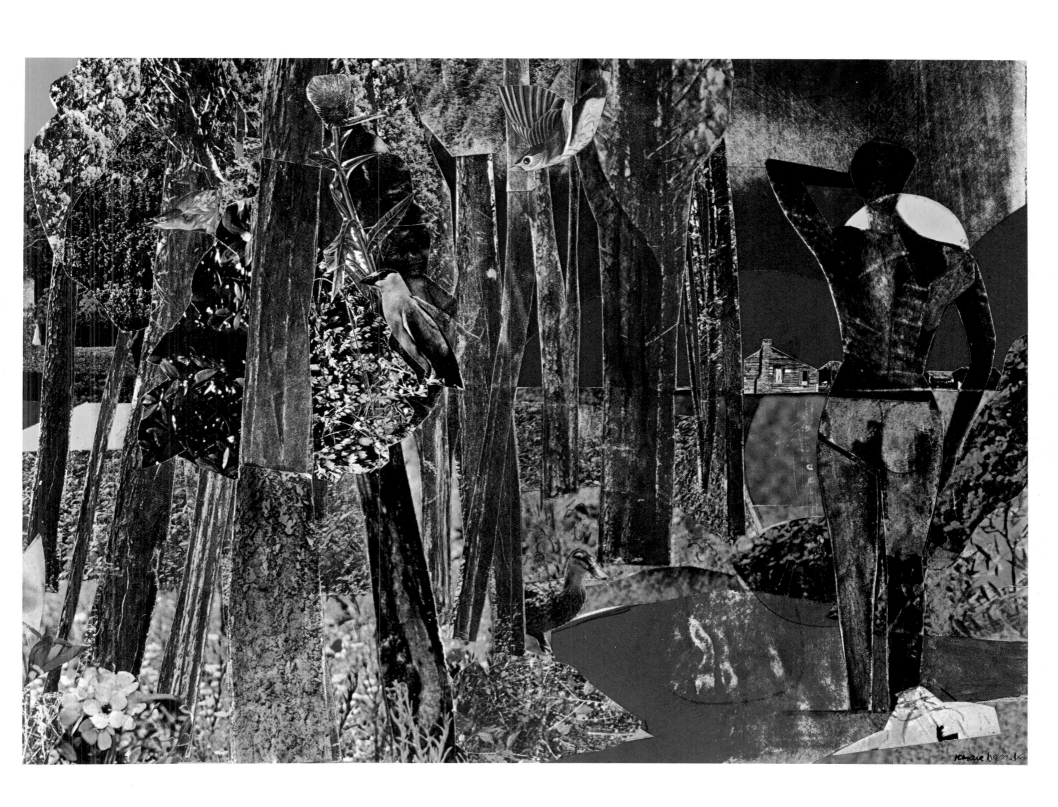

PLATE 86

GREEN TIMES REMEMBERED (THE WISHING POND). 1970.
COLLAGE AND MIXED MEDIUMS, 21 3/4 × 32″.
SHOREWOOD PUBLISHERS, NEW YORK CITY

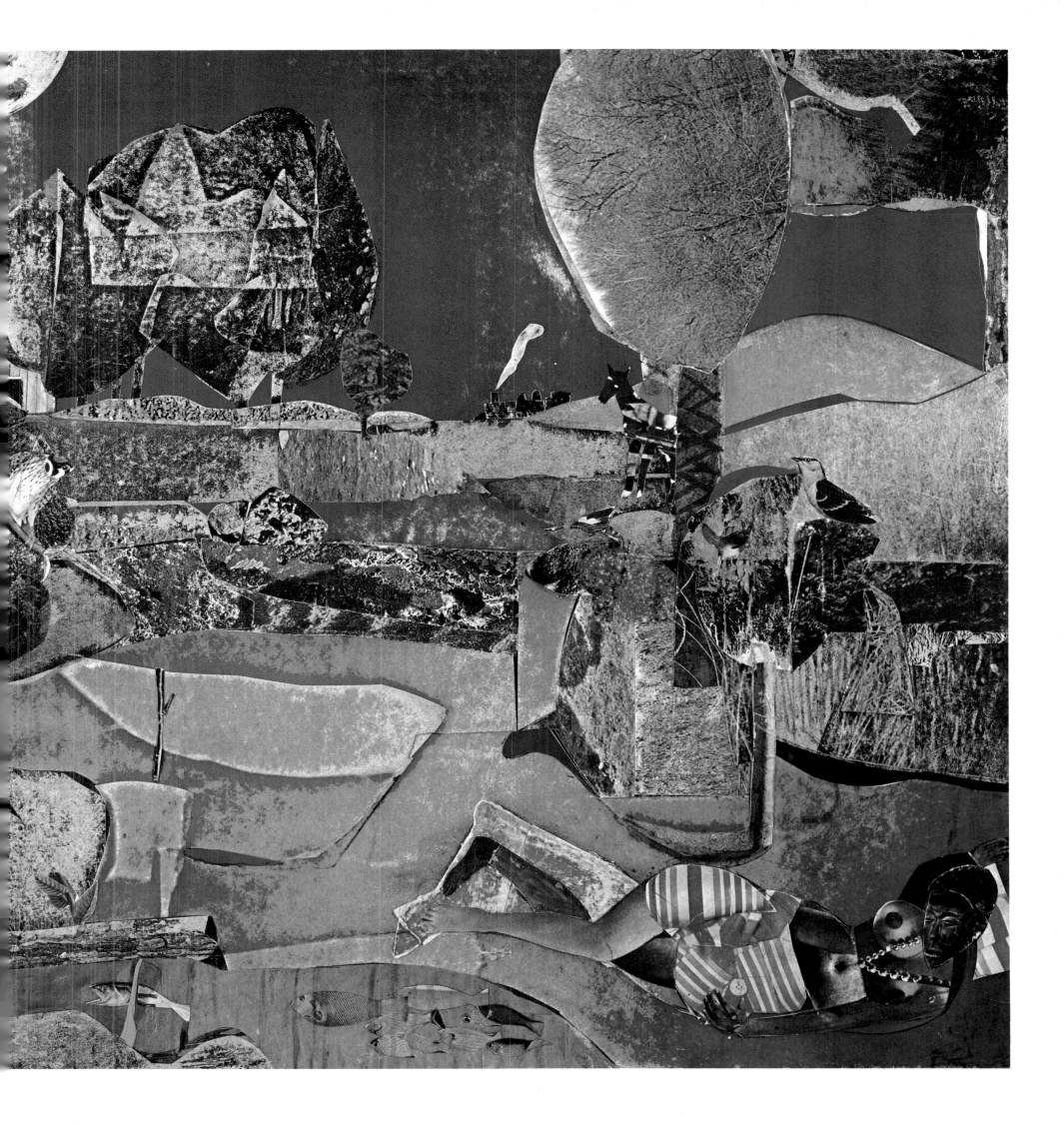

PLATE 87

APRIL GREEN. 1970. COLLAGE, 14 1/4 × 18 7/8″. SHOREWOOD PUBLISHERS, NEW YORK CITY

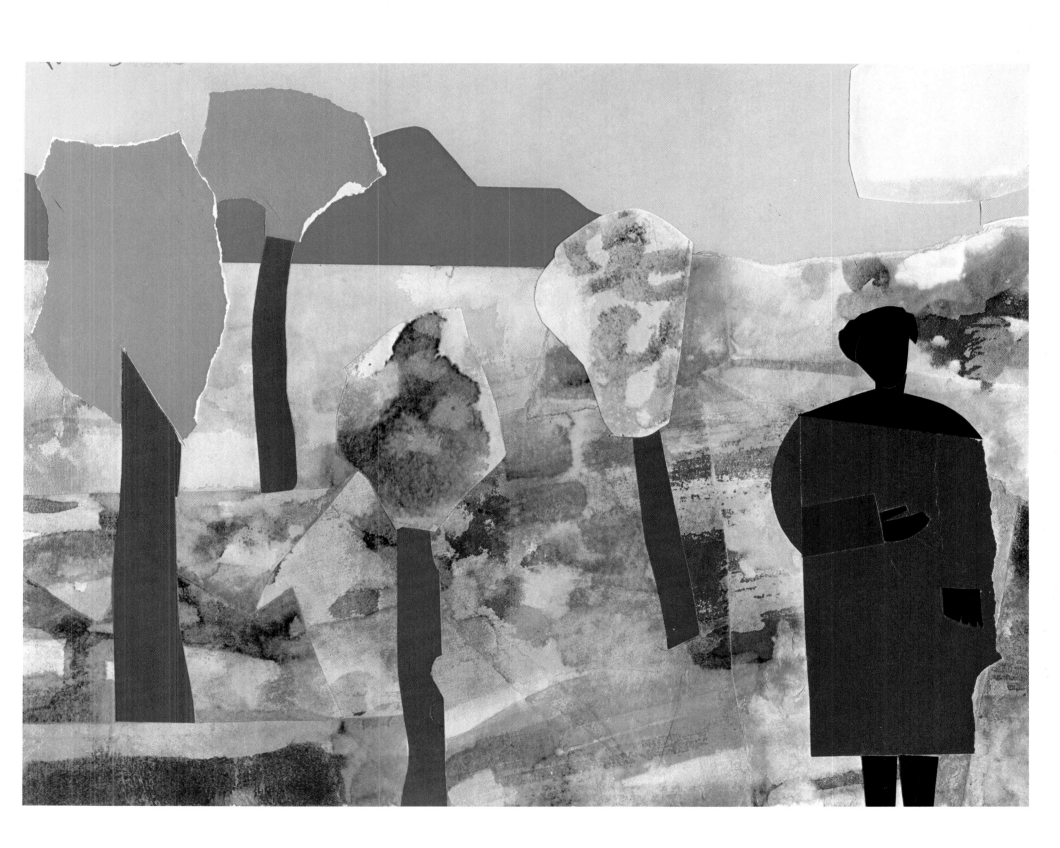

PLATE 88

JUNCTION. 1971. PIQUETTE, 92 × 68″. COURTESY CORDIER & EKSTROM GALLERY, NEW YORK CITY

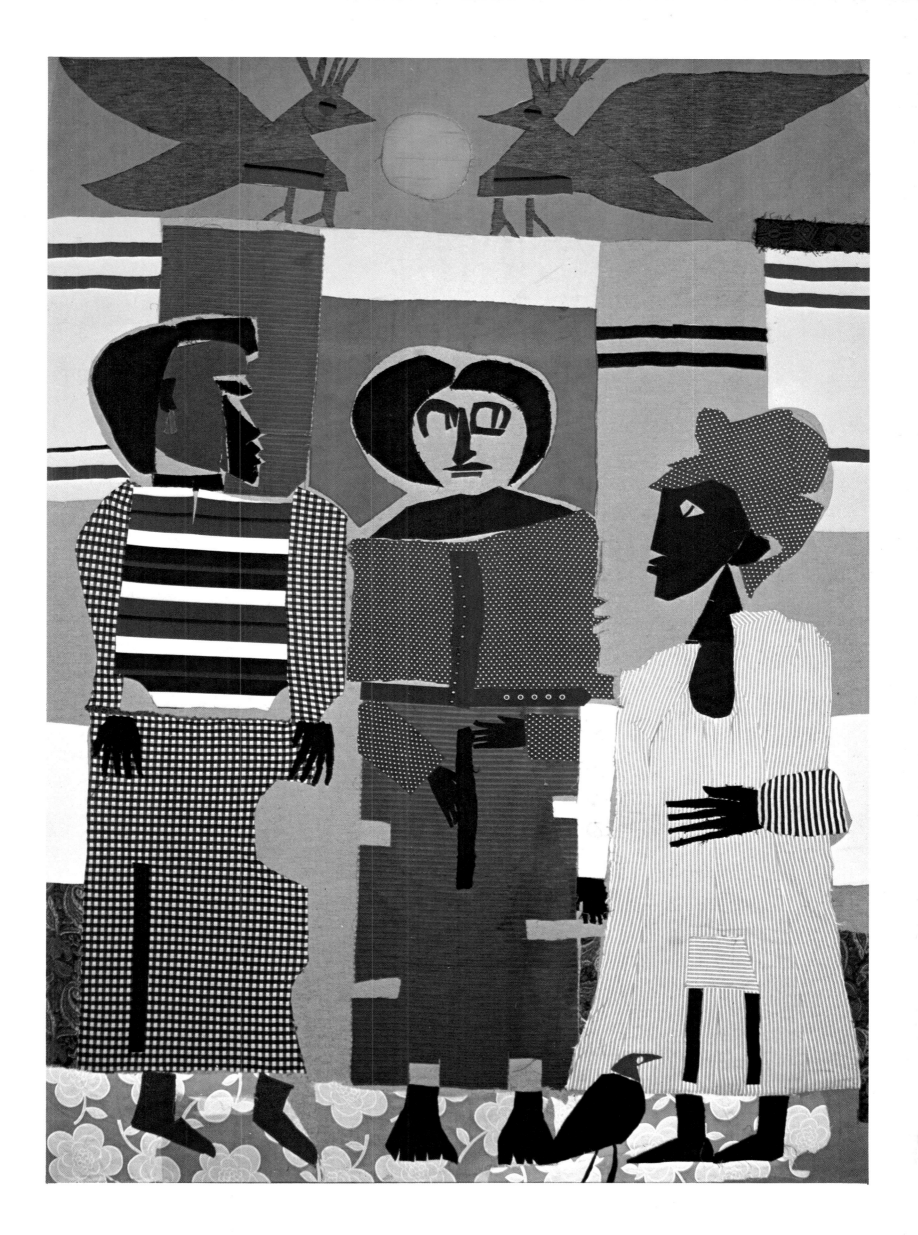

PLATE 89

CONJUNCTION. 1971. PIQUETTE, $69 \times 56''$. COURTESY CORDIER & EKSTROM GALLERY, NEW YORK CITY

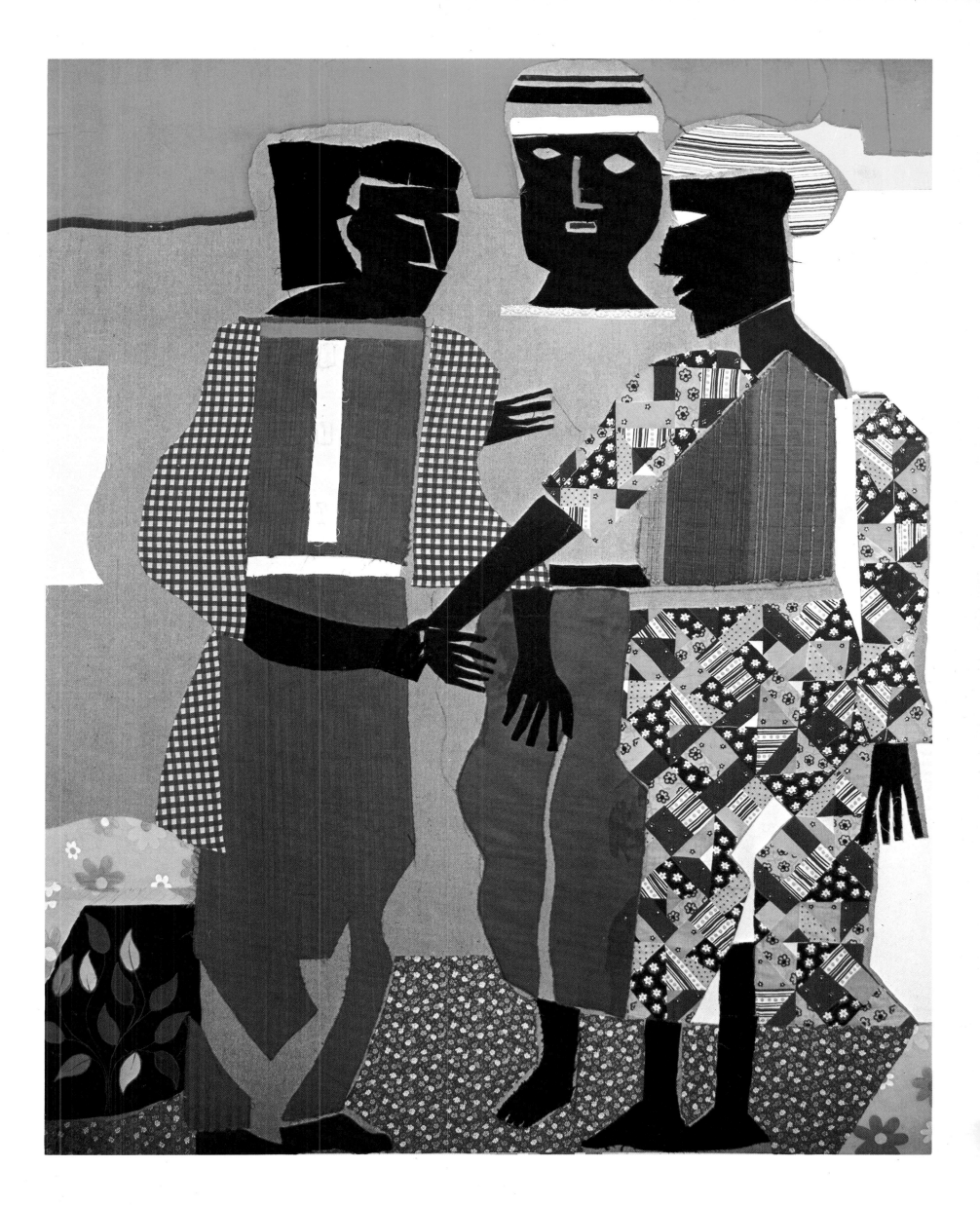

PLATE 90

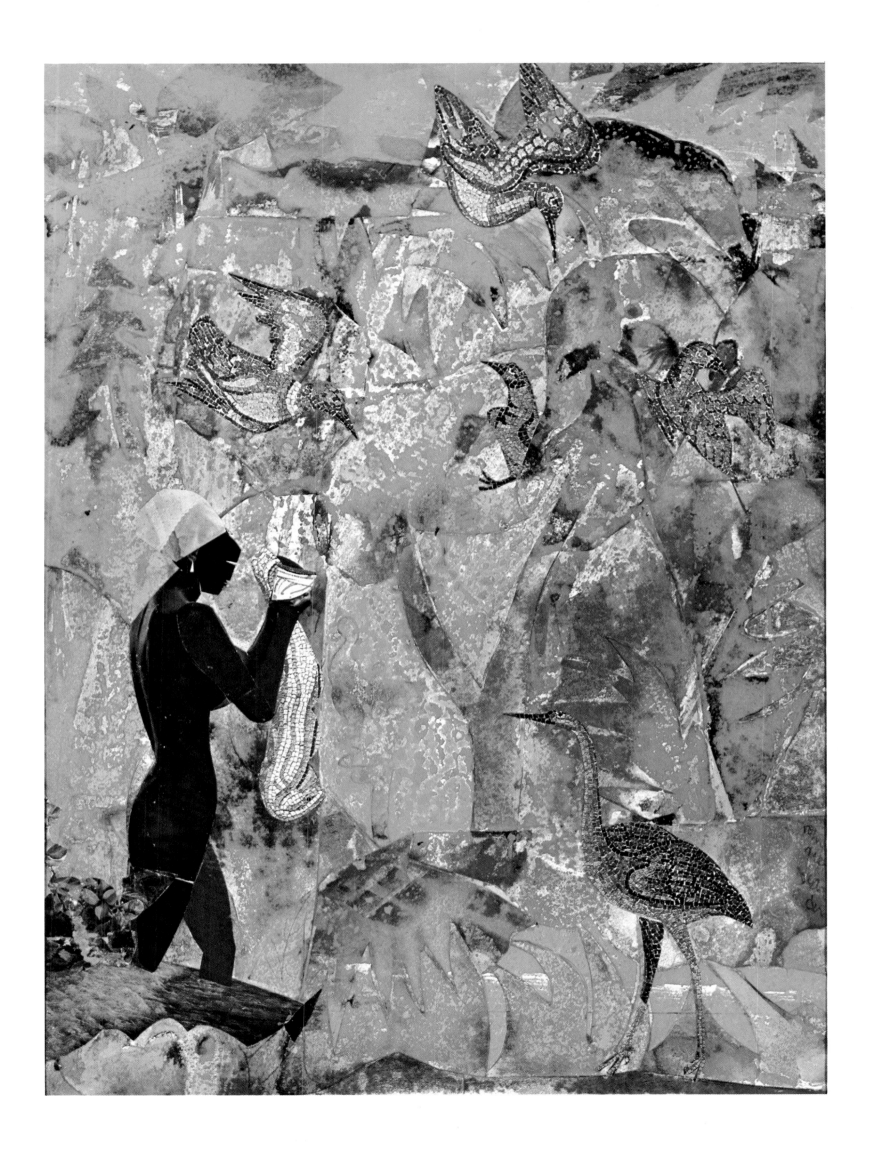

PLATE 91

BLUE SNAKE. 1971. COLLAGE ON BOARD, $36 \times 23 \ 3/4''$. PRIVATE COLLECTION, PHILADELPHIA

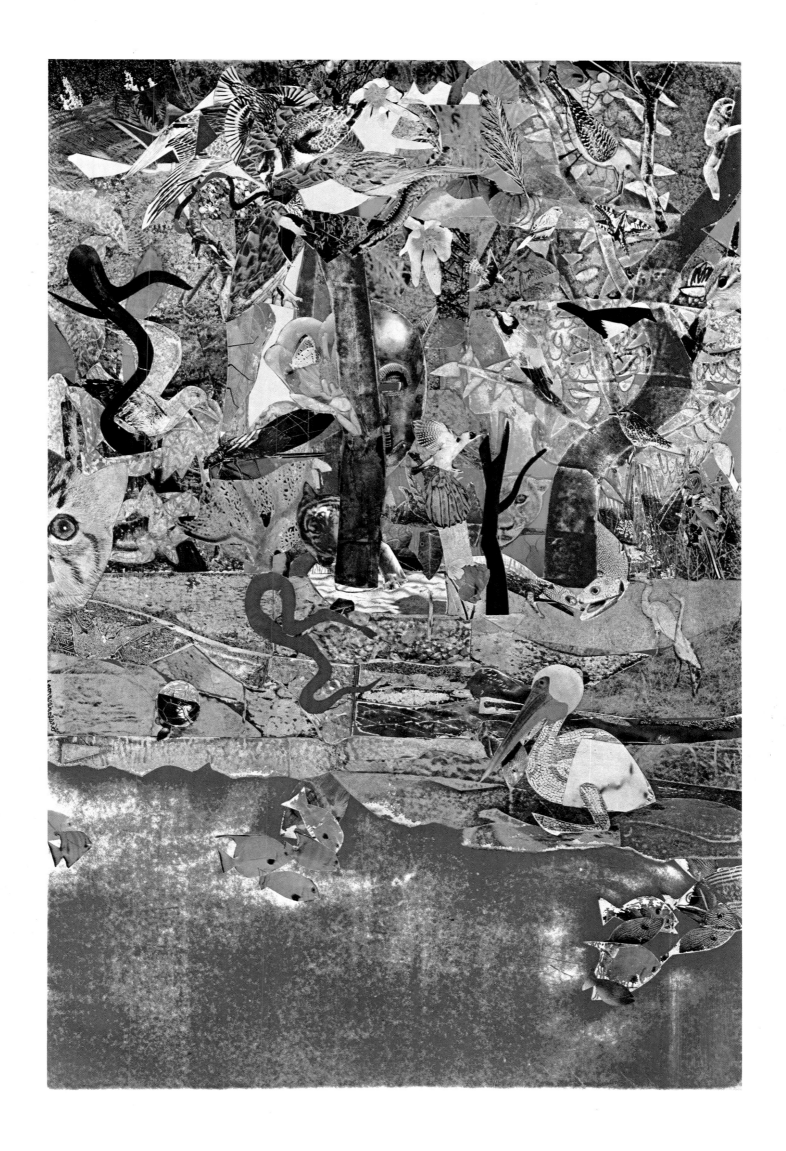

BIOGRAPHICAL OUTLINE

1914 Born, Charlotte, N.C., September 2

1925 Graduated from Public School 139, 140th Street and Lenox Avenue, New York City

1929 Graduated from Peabody High School, Pittsburgh

1935 Graduated from New York University with a Bachelor of Science degree in mathematics

1936–37 Studied at the Art Students League, New York City, with George Grosz as instructor.

Became closely associated with the "306 Group," an informal organization of artists living in Harlem who gathered at the studios of artists Henry Bannarn and Charles Alston at 306 West 141st Street. Other artists in the group included Gwendolyn Bennett, Robert Blackburn, Ernest Crichlow, Frederick Coleman, Ronald Joseph, Norman Lewis, Richard Lindsay, Jacob Lawrence, Francisco Lord, and O. Richard Reid.

Most of these artists were also members of the Harlem Artists Guild, probably the largest organization of Negro artists until that time. The Guild was most active during the middle thirties, until the outbreak of World War II. The first president of the Guild was Aaron Douglas.

Bearden showed in several exhibitions at the Harlem YWCA and the Harlem Art Workshop

1940 Took a studio at 33 West 125th Street, directly over the studio of Jacob Lawrence. Poet and novelist Claude McKay, who had a studio on Bearden's floor, was a great inspiration to both Bearden and Lawrence in the widening of their horizons.

Bearden continued his close friendship with Charles Alston and was also friendly with Add Bates, William Attaway, and composers Frank Fields and Joshua Lee.

Bates took Bearden down town to meet a number of artists; Stuart Davis, Walter Quirt, Paul Burlin, Alonzo Hauser, and Manuel Telegian were among those he became well acquainted with.

First one-man show at the studio of Add Bates, 306 West 141st Street

1941 Appeared in group shows of Negro artists at the McMillen Gallery and the Downtown Gallery, New York City.

Moved to studio at 243 West 125th Street

1942 Painting reproduced in *Fortune* magazine

1942–45 Served in U.S. Army, 372nd Infantry

1945 One-man show at the G Place Gallery of Caresse Crosby and David Porter, Washington, D.C.

Showed at the Devoluy Gallery, Paris, with Pietro Lazzari

1945–47 Several one-man shows at the Samuel M. Kootz Gallery, New York City

1945–49 Participated in numerous group exhibitions, among them the Whitney Annuals, 1945–46, New York City, and the State Department traveling shows of American artists, in Europe and South America. His works were shown in most leading museums in the United States at this time

1950 Studied at the Sorbonne, under the G.I. Bill. In Paris, through letters of introduction from his dealer Samuel Kootz and his friend Carl Holty, Bearden became acquainted with a number of European artists, including Brancusi, Helion, Braque, and Reichel. He also became acquainted with a number of Americans who were living in Paris under circumstances similar to his own; poet Samuel Allen, painters Paul Keene and William Rivers, novelists James Baldwin and Albert Murray, and engineer Jim Mosley were special friends.

Took part in a national competitive exhibition, *American Painting Today*, at the Metropolitan Museum of Art, New York City

1954 Returned to the United States. Painted only intermittently and, along with Larry Douglas, Fred Norman, and David Ellis, devoted a great deal of time to songwriting. Eventually became a member of ASCAP.

Returned to painting on the advice of his friend the philosopher Heinrich Bluecher.

Married Nanette Rohan, New York City

1955 Showed in the Whitney Annual and in the Pyramid Club Annual, Philadelphia

1961 One-man show at the Cordier and Warren Gallery, New York City

1963 Spiral Group formed at Bearden's studio. Spiral concerned itself with the problems of the Negro artist and his relevance in the continuing struggle for freedom, the nature of his identity in relation to his heritage and his own consciousness, and his relation to his craft. Norman Lewis was Spiral's first chariman. Other members were Charles Alston, Emma Amos, Calvin Douglass, Perry Ferguson, Reginald Gammon, Alvin Hollingsworth, Felrath Hines, William Majors, Richard Mayhew, Earle Miller, Merton Simp-

son, Hale Woodruff, and James Yeargans

1964　One-man show at the Cordier & Ekstrom Gallery, New York City, and part of group exhibition at Fairleigh Dickinson University, Madison, N.J.

1965　One-man show at the Corcoran Gallery, Washington, D.C., and part of group exhibition at the Spiral Gallery, New York City

1966　One-man show at the Carnegie Institute of Technology, Pittsburgh. Appeared in group exhibitions at the New School for Social Research and the National Institute of Arts and Letters, New York City

1967　One-man shows at the Cordier & Ekstrom Gallery and at the J.L. Hudson Gallery, Detroit. Appeared in group exhibition at the New School for Social Research.

Co-directed an exhibition, *The Evolution of Afro-American Artists: 1800–1850*, at the City College of New York

1968　Appeared in international poster exhibitions in Warsaw, Poland, and Sofia, Bulgaria.

One-man shows at Spelman College, Atlanta, and at the Art Gallery of the State University of New York, Albany. Part of group exhibitions at the Minneapolis Institute of Arts, the Harlem Studio Museum, and the Visual Arts Gallery, New York City.

Designed cover of January issue of *Fortune* magazine (and poster) and Martin Luther King poster, "I Have Seen the Mountaintop"

1969　One-man shows at the Williams College Art Museum, Williamstown, Mass., and the State University of Iowa Museum, Iowa City. Appeared in group exhibitions at the Museum of Modern Art, the Whitney Museum of American Art, the New School for Social Research, and the Finch College Museum, New York City, the Detroit Museum, the J. L. Hudson Gallery, Detroit, Cranbrook Academy of Art, Bloomfield Hills, Mich., Lincoln University, Lincoln University, Pa., and Mount Holyoke College, South Hadley, Mass.

Did covers for *New York Times*, *Tuesday*, and *Amistad* magazines, and for "Afro-American Artists Since 1950," Brooklyn College. Also did covers for two portfolios: *Contemporary Art of Afro-Americans* and *Works by Black Artists*; and a poster for the Board of Missions of the United Methodist Church

1970　One-man show at the Cordier & Ekstrom Gallery. Guggenheim fellow

1971　One-man show at the Museum of Modern Art, New York City

1973　One-man show at the Cordier & Ekstrom Gallery

EXHIBITIONS

GROUP EXHIBITIONS

1941 McMillen Gallery, New York City. *Contemporary Negro Art*
Downtown Gallery, New York City. *American Negro Art*

1944 Baltimore Museum of Art. *New Names in American Art*

1945 Albany Institute of History and Art, traveling show. *The Negro Artist Comes of Age*
Devoluy Gallery, Paris. *The Passion of Christ* (two-man show with Pietro Lazzari)

1945–46 Whitney Museum of American Art, New York City. *Whitney Annual*

1946 Durand-Ruel Galleries, New York City
Clearwater Art Museum, Clearwater, Fla.

1945–49 State Department traveling shows of American artists, Europe and South America

1947 La Tausea Art Competition, New York City

1948 Barnett Alden Gallery, Washington, D.C.
Art Institute of Chicago

1950 Metropolitan Museum of Art, New York City. *American Painting Today*

1955 American Federation of Artists, New York City. *World at Work/An Exhibition of Paintings and Drawings* (commemorating the twenty-fifth anniversary of *Fortune* magazine) Pyramid Club,

Philadelphia. *Pyramid Club Annual*
Whitney Museum of American Art, New York City. *Whitney Annual*

1956 University of Michigan Museum of Art, Ann Arbor. *Eight New York Painters*

1961 Carnegie Institute, *Pittsburgh. The 1961 Pittsburgh International Exhibition of Contemporary Painting and Sculpture*

1964 Fairleigh Dickinson University, Madison, N.J. *Morris County Tercentenary Committee Exhibition*

1965 Spiral Gallery, New York City

1966 Academy Art Gallery, National Institute of Arts and Letters, New York City. *An Exhibition of Contemporary Painting, Sculpture, and Graphic Art*
Art Center, New School for Social Research, New York City. *Contemporary Urban Vision*
UCLA Art Galleries, Los Angeles. *The Negro in American Art*

1967 City College of New York. *The Evolution of Afro-American Artists: 1800–1850* (co-directed by Bearden)
Forum Gallery, New York City. *The Portrayal of the Negro in American Painting*
Art Center, New School for Social Research, New York City. *Protest and Hope: An Exhibition of Contemporary Art*

1968 International Biennale of Posters, Warsaw, Poland
International Exhibition of Posters, Sofia, Bulgaria
Harlem Studio Museum, New York

City. *Invisible Americans—Black Artists of the Thirties*

Minneapolis Institute of Arts. *Thirty Contemporary Black Artists*

Visual Arts Gallery, New York City. *One Print One Painting*

1969 Detroit Museum. *Project Outreach*

J. L. Hudson Gallery, Detroit. *Twentieth Century American*

Finch College Museum, New York City. *Posters by Artists*

Cranbrook Academy of Art, Bloomfield Hills, Mich. *Sixth Biennial National Religious Art Exhibition*

Lincoln University, Lincoln University, Pa. *Centennial Exhibition*

Mount Holyoke College, South Hadley, Mass. *Ten Afro-American Artists*

Museum of Modern Art, New York City. *The First Generation*

Museum of Modern Art, New York City. *Homage to Martin Luther King*

Graduate Center, New School for Social Research, New York City. *Inaugural Exhibition*

Whitney Museum of American Art, New York City. *New Acquisitions*

Whitney Museum of American Art, New York City. *Contemporary American Painting*

ONE-MAN SHOWS

1940 Studio of Add Bates, New York City

1944 G Place Gallery, Washington, D.C.

1945 G Place Gallery, Washington, D.C.

Samuel M. Kootz Gallery, New York City

1946 Samuel M. Kootz Gallery, New York City

1947 Samuel M. Kootz Gallery, New York City

1948 Niveau Gallery, New York City

1955 Barone Gallery, New York City

1960 Michel Warren Gallery, New York City

1961 Cordier and Warren Gallery, New York City

1964 Cordier & Ekstrom Gallery, New York City

1965 Corcoran Gallery, Washington, D.C.
Rockford College, Rockford, Ill. *Festival of the Arts*

1966 Bundy Art Gallery, Waitsfield, Vt.
Carnegie Institute of Technology, Pittsburgh

1967 Cordier & Ekstrom Gallery, New York City
J. L. Hudson Gallery, Detroit

1968 Art Gallery, State University of New York, Albany
Spelman College, Atlanta

1969 State University of Iowa Museum, Iowa City
Williams College Art Museum, Williamstown, Mass.
Cordier & Ekstrom Gallery, New York City

1970 Cordier & Ekstrom Gallery, New York City

1971 Museum of Modern Art, New York City

1973 Cordier & Ekstrom Gallery, New York

SELECTED BIBLIOGRAPHY

WRITINGS BY ROMARE BEARDEN

"The Negro Artist and Modern Art," *Opportunity* (December, 1934).

"Problems of the Negro Artist," *Critique* (October, 1948).

"The Artist's Imagination," *Pyramid Club Annual* (May, 1956).

"Rectangular Structure in My Montage Paintings," *Leonardo* (January, 1969).

"The Artist and His Education," *Harvard Art Review* (Spring, 1969).

The Painter's Mind (in collaboration with Carl Holty). New York: Crown, 1969.

Six Black Masters of American Art (with Harry Henderson). Garden City: Doubleday, 1972.

A Biography of Henry O. Tanner. New York: Farrar, Straus & Giroux (in progress).

ARTICLES AND REVIEWS

Amsterdam News, New York (May 2, 1941).

James W. Lane, "Afro-American Art on Both Continents," *Art News* (October, 1941).

New York Sun (October 24, 1941).

"Art by Negroes," *The New Masses* (December 30, 1941).

Ben Wolf, "Bearden—He Wrestles with Angels," *Art Digest* (October 1, 1945).

"The Passing Shows," *Art News* (October 15, 1945).

Nora Holt, "Romare Bearden Wins High Praise for Exhibition, 'The Passion of Christ,'" *Amsterdam News* (October 27, 1945).

"Romare Bearden, Bullfight Inspiration," *Art News* (April, 1946).

Edward Allen Jewell, "In Abstract Vein—Exhibitions Range from Nonobjective to Expressionist and Surrealist," *New York Times* (March 2, 1947).

William Carlos Williams, "Woman as Operator," *Women—A Collaboration of Artists and Writers.* New York: Samuel M. Kootz Editions, 1948.

"Bearden Paints *The Iliad*," *Art Digest* (November 11, 1948).

"Bearden, Gerard Display Paintings," *New York Times* (November 12, 1948).

Don Bishop, "Modern Art Has Unique Place, Says Bearden," *Charlotte Observer* (August 3, 1952).

"About Art and Artists," *New York Times* (November 11, 1955).

Carlyle Burrows, "Bearden's Return," *New York Herald Tribune* (January 24, 1960).

Edith Burckhardt, "Reviews and Previews," *Art News* (February, 1960).

J. R. M., "Bearden," *Arts* (February, 1960).

"Bearden Painting in Presidential Suite," *Amsterdam News* (January 7, 1961).

"Art: O'Keeffe Exhibition. Her Pictures Displayed at the Downtown. O'Doherty, Bearden, and Resnick Works on View," *New York Times* (April 11, 1961).

"Kennedy to Arrive Here Today: Pre-Inaugural Suite Prepared," *New York Times* (October 4, 1961).

Brian O'Doherty, "Art: Year-End Review," *New York Times* (December 16, 1961).

Marie Smith, *Washington Post* (September 13,

1962).

Charles Childs, "Bearden: Identification and Identity," *Art News* (October, 1964).

"Romare Bearden," *Time* (October 16, 1964).

"Tormented Faces," *Newsweek* (October 19, 1964).

Dore Ashton, "Romare Bearden—Projection," *Quadrum*, no. 17 (1965).

Fritz Neugas, "Foto-Montagen und Collagen erzielen hohe Preise," *Foto*, Munich (February, 1965).

Frank Getlein, "Confrontation at the Corcoran," *Washington Star* (October 14, 1965).

James A. Porter, "Afro-American Art at Floodtide," *Arts in Society* (1967).

Henri Ghent, "A Powerful Spokesman for the Negro—With His Brush," *Elegante* (March, 1967).

Charles Childs, "The Artist Caught Between Two Worlds," *Tuesday* (April, 1967).

Lucille Roberts, "A Gallery of Eight," *Topic*, no. 5 (May, 1966).

Grace Glueck, "New York Gallery Notes," *Art in America* (September–October, 1967).

John Canaday, "Art: Themes and the Usual Variations," *New York Times* (September 30, 1967).

Ralph Pomeroy, "Black Persephone," *Art News* (October, 1967).

John Canaday, "Romare Bearden Focuses on the Negro," *New York Times* (October 14, 1967).

Sally Hammond, "Closeup: Of Form and Color," *New York Post* (October 23, 1967).

"Patchwork Nostalgia," *Time* (October 27, 1967).

Cathy Aldridge, "Bearden's Collages Sold Though Exhibit Goes On," *Amsterdam News* (November 4, 1967).

Harriet Doar, "Charlotte Native Is in New York Art World Spotlight," *Charlotte Observer* (November 12, 1967).

"People Are Talking About . . . ," *Vogue* (November 15, 1967).

"The Arts and the Black Revolution," *Arts in Society* (1968).

Carroll Greene, Jr., "Afro-American Artists: Yesterday and Now," *Humble Way* (1968).

Mike Steele, "The Black Artist—At Last, Whites Are Looking," *Minneapolis Tribune* (October 13, 1968).

"Afro-American Art, 1800–1850," *Ebony* (February, 1968).

Peg Churchill, "Brush Marks," *Schenectady Gazette* (December, 1968).

T. H. Littlefield, "Art," *Albany Times Union* (December, 1968).

Louise Bruner, "Outreach Exhibitions Geared to Active Community Participation," *Toledo Blade* (February 9, 1969).

Henri Ghent, "And So It Is," *School Arts* (April, 1969).

"Religious Painting," *Eccentric* (April 3, 1969).

"Romare Bearden," *Christian Science Monitor* (December 30, 1969).

June Jordan, *Who Look at Me*. New York: Crowell, 1969.

"The Black Artist in America," symposium moderated by Romare Bearden; panelists: Sam Gilliam, Jr., Richard Hunt, Jacob Lawrence, Tom Lloyd, William Williams, Hale Woodruff, *Metropolitan Museum of Art Bulletin* (January, 1969).

"The World of Black Culture," *Tuesday* (February, 1970).

Hilton Kramer, "Black Experience and Modernistic Art," *New York Times* (February 14, 1970).

Mail Bag, *New York Times* (February 18, 1970).

Lawrence Campbell, "Bearden at Cordier & Ekstrom," *Art* (March, 1970).

Ralph Ellison, "Romare Bearden: Paintings and Projections," *Crisis* (March, 1970).

"Romare Bearden at Cordier & Ekstrom Gallery," *Art News* (March, 1970).

New York Times Magazine, special issue (April 14, 1970).

EXHIBITION CATALOGUES

New York City. Studio of Add Bates. *Romare Bearden: Oils, Gouaches, Watercolors, Drawings, 1937–1940.* May 4–11, 1940.

New York City. McMillen Gallery. *Negro Art: Contemporary.* October 16–November 7, 1941.

New York City. Downtown Gallery. *American Negro Art.* December 9, 1941–January 3, 1942.

Washington, D.C. G Place Gallery. *Ten Hierographic Paintings by Sgt. Romare Bearden.* Introduction by Dr. James Porter. February 13–March 3, 1944.

Washington, D.C. G Place Gallery. *The Passion of Christ.* June, 1945.

New York City. Samuel M. Kootz Gallery. *Romare Bearden.* October 8–27, 1945.

New York City. Durand-Ruel Galleries. *Modern Religious Paintings.* January 9–February 2, 1946.

Clearwater, Fla. Clearwater Art Museum. *Exhibition of Contemporary American Painting, Seventh Annual Southeastern Circuit, 1945–46.* January 27–February 10, 1946.

New York City. Samuel M. Kootz Gallery. *Bearden: Paintings and Watercolors Inspired by Garcia Lorca's "Lament for a Bullfighter."* March 25–April 13, 1946.

New York City. Samuel M. Kootz Gallery. *In the*

Sun. September 4–28, 1946.

Paris. Galerie Maeght. *Introduction à la peinture moderne américaine sous le patronage des United States Information Services: Baziotes, Bearden, Browne, Gottlieb, Holty, Motherwell.* Introduction by Harold Rosenberg. 1947.

New York City. Samuel M. Kootz Gallery. *New Paintings by Bearden.* Introduction by Barrie Stavis. February 24–March 15, 1947.

Chicago. Art Institute of Chicago. *Abstract and Surrealist American Art.* November 6, 1947–January 11, 1948.

New York City. Niveau Gallery. *"The Iliad," 16 Variations by Romare Bearden.* November 9–25, 1948.

New York City. Metropolitan Museum of Art. *American Painting Today: 1950.* December 8, 1950–February 25, 1951.

New York City. Whitney Museum of American Art. *Roy and Marie Neuberger Collection.* Foreword by John I.H. Baur. Introduction by Marie and Roy Neuberger. November 17–December 19, 1954. Exhibition traveled during 1955.

New York City. Barone Gallery. *Romare Bearden.* October 31–November 24, 1955.

New York City. Whitney Museum of American Art. *Annual Exhibition of Contemporary American Painting.* November 9, 1955–January 8, 1956.

Ann Arbor, Mich. University of Michigan Museum of Art. *Eight New York Painters.* July 1–31, 1956.

New York City. Michel Warren Gallery. *Bearden.* January 20–February 19, 1960.

Pittsburgh. Carnegie Institute. *The 1961 Pittsburgh International Exhibition of Contemporary Painting and Sculpture.* October 27, 1961–January 7, 1962.

New York City. Cordier & Ekstrom Gallery. *Romare Bearden Projections*. October 6–24, 1964.

Rockford, Ill. Rockford College. *Festival of the Arts*. March 3–7, 1965.

New York City. Art Center, New School for Social Research. *Contemporary Urban Vision*. January 25–February 24, 1966.

Los Angeles. UCLA Art Galleries. *The Negro in American Art*. October, 1966.

Waitsfield, Vt. Bundy Art Gallery. *Romare Bearden: Six Panels on a Southern Theme*. April 2–May 29, 1967.

New York City. Cordier & Ekstrom Gallery. *Romare Bearden*. October 10–November 4, 1967.

New York City. Art Center, New School for Social Research. *Protest and Hope: An Exhibi-tion of Contemporary Art*. October 24–December 2, 1967.

Detroit. J. L. Hudson Gallery. *Romare Bearden Collages*. Text by John Canaday. November 11–30, 1967.

Minneapolis. Minneapolis Institute of Arts. *Thirty Contemporary Black Artists*. October, 1968.

Albany. Art Gallery, State University of New York. *Romare Bearden: Paintings and Projections*. December, 1968.

New York City. Cordier & Ekstrom Gallery. *Romare Bearden: Recent Collages*. February 11–March 7, 1970.

New York City. Museum of Modern Art. *Romare Bearden: The Prevalence of Ritual*. Introductory essay by Carroll Greene. March 25–June 9, 1971. Exhibition traveled during 1971–72.